CHAPEAU!

PIERRE TOROMANOFF

CHAPEAU!

Der ultimative Guide für
den modernen Gentleman mit Hut

The Ultimate Guide to Men's Hats

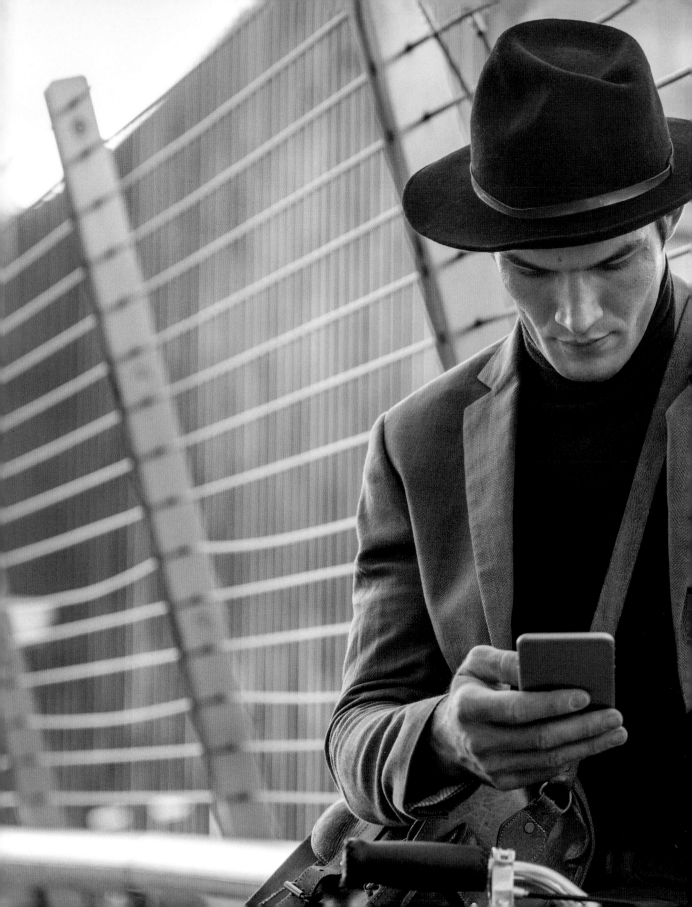

Inhalt

Content

Einleitung

Ein Touch von zeitloser Männlichkeit

Jeder ist sich bewusst, dass ein paar Bartstoppeln besonders männlich wirken. Die Stoppeln betonen die Konturen und lassen einen legerer wirken als perfekt frisch-rasiert, und wirken auch nicht so haarig wie ein Vollbart. Männer mit Stoppeln wirken weder zu pedantisch noch vollkommen wild, sondern man hält sie für fähig, die feine Gratwanderung zwischen Milde und Männlichkeit zu bewältigen. Wieso trägt aber eigentlich ein Hut ebenfalls zur Männlichkeit bei? Schließlich sind Hüte keine ausschließlichen Herrenaccessoires, Damen tragen ebenfalls Hüte, und viele Hüte werden sowohl von Herren als auch Damen getragen. Die Antwort auf diese Frage ist vielfältig. Ein Mann, der Hut trägt, lässt den größten Teil seiner Haare unter dem Hut verschwinden, wir konzentrieren uns als mehr auf sein Gesicht. Statt seine Frisur zu betrachten, betrachten wir seine Gesichtszüge, gleichmäßig oder nicht, Ausdruck der Augen, die Form seiner Lippen. Ein Hut steht wie die Schuhe, ein bestimmter oder eine Armbanduhr für einen persönlichen Stil. Ein Hut wirkt im Unterschied zu Schuhen, Mänteln und Armbanduhren abenteuerlich, aber auch kultiviert. Er weckt die selbstverständliche Neugier der anderen, denn er verweist, und das ist das Wichtigste, auf Bilder in unserem kollektiven Gedächtnis und aus dem großen Kino: Bilder von Männern der Tat, seien sie Banditen, Cowboys, Detektive, Segler, Soldaten oder Gentlemen. Männer, die Hüte tragen, assoziieren wir mit einem dynamischen Lebensstil. Sie gehen Risiken ein, und bei ihnen ist mit allem zu rechnen. Macht dieser Mann Pause, nimmt er vielleicht den Hut ab, aber ruft ihn die Pflicht, setzt er ihn sofort wieder auf und stellt sich dem nächsten Abenteuer.

Introduction

A timeless touch of masculinity

Everyone is aware of the touch of masculinity that stubble adds to a face: the short hairs underline its contours and convey a slightly neglected look that is halfway between the hairless perfection of a daily shave and the hairiness of a full beard. Men with a stubble beard appear neither too neat nor completely wild, but capable of playing a subtle balance between gentleness and virility. But why does the hat also bring a distinctive touch of masculinity? After all, hats are not exclusively male accessories, women also wear hats, and many hat styles are worn by both sexes. The answer to this question lies in several elements. For example, the man who puts a hat on his head conceals part of his hair so we therefore tend to focus our attention on the rest of his face: instead of noting his hairstyle, we observe his features, be they regular or not, the expression of his eyes, or the shape of his mouth. In addition, the man chooses to wear an accessory that, like shoes, an overcoat or a watch, denotes a personal style. But the hat, more than any of the others, adds something sophisticated or adventurous to the wearer's look. It intrigues and sparks innate curiosity from onlookers, for, and this is the main point, the hat refers us to images forged by collective memories and cinema: that of men of action, whether bandits, cowboys, detectives, sailors, soldiers or gentlemen. Men who wear hats are associated with dynamic lifestyles, they are risk-takers and full of the unexpected. The man at rest may take off his hat, but as soon as duty calls him, he immediately puts it back on. He's off on another adventure. Hats on!

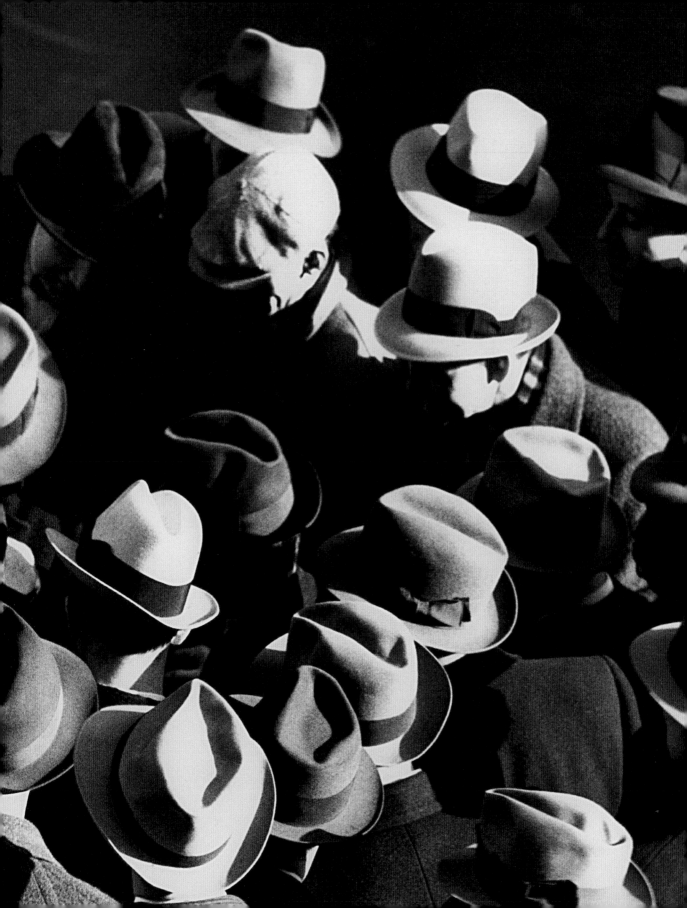

HISTORY
AND
RULES

GESCHICHTE
UND
REGELN

Vom goldenen Zeitalter der Männerhüte bis zur hutlosen Welt. Eine kurze Geschichte des Hutes vom frühen 20. Jahrhundert bis zur Gegenwart

Schauen Sie sich einfach ein beliebiges Foto (oder ein Stück Filmmaterial) an, das eine Straßenszene vom Anfang des 20. Jahrhunderts zeigt, und eines ist sofort klar: Alle Männer tragen Hut oder Mütze. Bis weit in die 1950er Jahre wurde es als ebenso unpassend angesehen, ohne Hut auf die Straße zu gehen, wie im Winter barfuß auszugehen. Es gab mindestens drei Gründe, warum das Tragen eines Hutes als eine Notwendigkeit angesehen wurde. Der erste hing mit den Schwankungen des Wetters zusammen, was bedeutete, dass man seinen Kopf vor Windböen und strömendem Regen, vor Schneefall und glühender Sonne und manchmal sogar vor Sandstürmen und Hagel schützen musste. Der zweite Grund war ästhetischer Natur: Damit ein Mann elegant wirken konnte, musste er einen modischen Hut tragen, der zu seinem Outfit passte. Wie seine übrige Kleidung war auch der Hut an die Tageszeit, den Ort und die Jahreszeit angepasst. Das Tragen eines hellen Hutes in der Stadt kam ebenso wenig in Frage wie das Tragen eines Strohhutes im Winter! Guter Geschmack erforderte zum Beispiel einen formelleren Hut für den Abend, egal ob man Gast auf einer Party war oder zu einer Show ging. Der dritte Grund war die vorherrschende gesellschaftliche Konvention: Der Hut wurde nicht nur aus praktischen oder ästhetischen Gründen getragen, sondern auch als Symbol der Zugehörigkeit zur Gesellschaft. Ein Mann ohne Hut erregte instinktiv Verdacht: Hatte er ihn verpfändet, um eine Spielschuld zu begleichen? Vielleicht hatte er das Haus seiner Geliebten in Eile verlassen? Oder war er das Opfer eines Windstoßes geworden, der seinen Hut wegwehte? Die immer wiederkehrenden Missgeschicke, die die Hüte der Detektive Schulze und Schultze in *Die Abenteuer von Tim und Struppi* trafen, geben Einblick in die Gefahren, denen Hüte und ihre Besitzer ausgesetzt waren: Wenn Hüte auf die Straße wehten, konnten sie von Autos, Karren oder Schlammpfützen beschädigt werden; der Stuhlgang von Vögeln verschonte sie nicht, und ein Windstoß reichte aus, um sie wegzufegen. In einer Welt, in der das Ziehen des Hutes zur Begrüßung von Frauen und Männern, denen man auf der Straße begegnete, eine übliche Höflichkeit war, stellte das Fehlen einer Kopfbedeckung oder die Unschicklichkeit eines verschmutzten Hutes eine Quelle höchster Peinlichkeit dar. Bis in die 1930er Jahre besaß ein Gentleman mindestens ein Dutzend verschiedener Hüte, um der Mode und den gesellschaftlichen Konventionen gerecht zu werden, welche sorgfältig gepflegt werden mussten. Die Hutmacher wetteiferten jede Saison um neue Designs: die Höhe der Krone, die Breite der Krempe, die Tiefe des Kniffs und die Farbe des Bandes waren alles Elemente, die dem Filzhut, dem Homburg oder dem Porkpie einen Hauch von Originalität verliehen. Werbeplakate betonten die Aura der Verführung und Männlichkeit, die ein gut gewählter Hut seinem Besitzer verleihen sollte. Eine amerikanische Tradition aus den 1910er

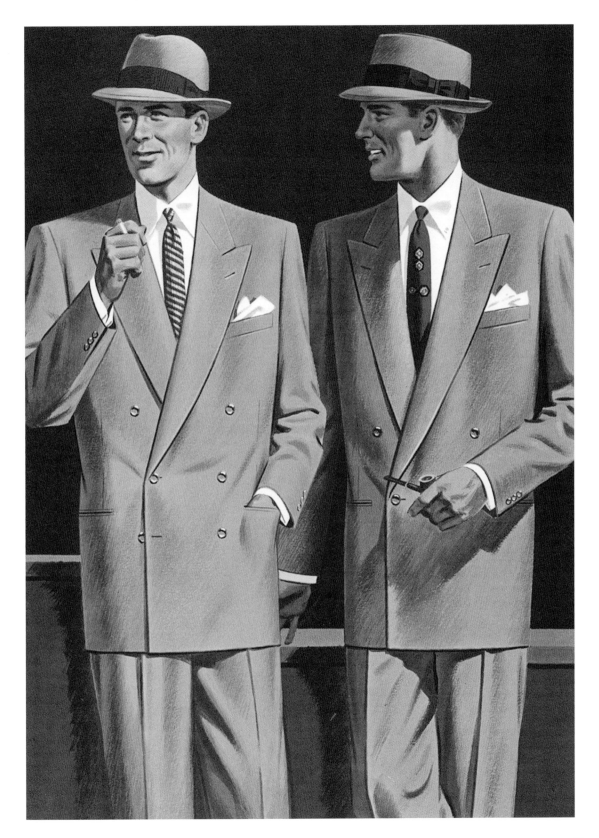

Jahren führte sogar einen Strohhut-Tag ein, in der Regel Anfang Mai: An diesem Tag gaben die Männer feierlich ihren Filz- oder Pelzhut ab und setzten einen Strohhut auf, um das gute Wetter zu feiern. Mitte September verzichteten die Männer an einem ähnlichen Tag auf ihre Strohhüte und setzten ihre winterlichen Hüte auf. Anders als Winterhüte wurden Strohhüte oft nur eine Saison lang getragen, was für die Hutmacher von Vorteil war, da sie sich darauf verlassen konnten, dass ihre Kunden jedes Jahr wiederkommen und erneut einen Strohhut kaufen würden. Der Hut war auch ein Symbol westlicher Werte: In diesem Sinne erließ Atatürk, der Gründer der modernen Türkei, 1925 ein Gesetz, das das Tragen des Fez verbot, welcher als Relikt des Osmanischen Reiches angesehen wurde, und das seine Mitbürger verpflichtete, als Zeichen des Modernismus der Türkei Hüte im europäischen Stil zu tragen.

Erst gegen Ende des Zweiten Weltkriegs zeigten sich erste Anzeichen für den Niedergang des Hutes. Dafür gab es zahlreiche Ursachen, und in Kombination beschleunigten sie zweifellos den Wandel in den 1960er Jahren: Der weit verbreitete Gebrauch von Automobilen machte Hüte weniger notwendig als das Hut-Tragen auf der Straße und erwiesen sich zudem für Hutträger als unpraktisch, da die aerodynamischeren Automobile nicht genügend Kopffreiheit für das Tragen eines Hutes während der Fahrt hatten. Darüber hinaus trug ein Wandel in der täglichen Körperpflege dazu bei, dass das Haar als Gesichtsschmuck zunehmend in den Vordergrund rückte. Die Bilder von Helden des Babybooms wie James Dean oder John Fitzgerald Kennedy, meist ohne Hut und gebräunt abgebildet, zeigten junge Männer, die die Traditionen in Frage stellten. Die Ablehnung des Hutes wurde somit zum Schlachtruf der Jugend, die sich nach Glück sehnte, im Gegensatz zu den älteren Generationen, die es versäumt hatten, die Welt zu einem besseren Ort zu machen.

Langes, üppiges Haar wurde en vogue. Der Hut wurde schließlich als ein Überbleibsel der Vormoderne wahrgenommen, als die ultimative Form des bürgerlichen Konformismus oder als das Vorrecht älterer, eleganter Männer.

Ohne das Kino wäre der Hut wahrscheinlich noch stärker in Vergessenheit geraten. Die Filmindustrie schuf viele männliche Helden, die mit einem bestimmten Hutstil assoziiert wurden, wie etwa Humphrey Bogart und sein Fedora in *Casablanca* oder Patrick Macnee und seine Melone in *The Avengers*, und sie erfand immer wieder neue Figuren mit Hüten, sei es Indiana Jones oder Michael Corleone, um zwei der beispielhaftesten zu nennen. In einer überraschenden Wendung der Ereignisse wurde der Hut so zum Attribut des bösen Jungen und des böhmischen Musikers, zwei verführerische, wenn auch leicht belanglosen Figuren. In jüngster Vergangenheit haben Fernsehserien wie *Mad Men* den Hut wieder zum Herzstück männlicher Eleganz gemacht. Die globale Erwärmung hat den Sommerstrohhut in einer Unisex-Form zurückgebracht – dem eines Trilby, einem Hut, der den Vorteil hat, nicht allzu formell auszusehen. Während es illusorisch ist, sich die Rückkehr des Hutes für alle Männer vorzustellen, so ist es doch ermutigend zu sehen, dass immer mehr Männer die praktischen und ästhetischen Qualitäten der Kopfbedeckung für sich wiederentdecken, die sie zu einem so gefälligen Modeaccessoire machen.

US-Männermode-Illustration, 1950er Jahre

US men's fashion illustration, 1950s

From the golden age of men's hats to the hatless world. A short history of modern hats from the early 20th century to the present

Just take a look at any photo (or bit of film footage) showing a street scene from the beginning of the 20th century, and one thing is immediately obvious: all the men are wearing hats or caps. Until the 1950s, going out in the street without a hat would have seemed as incongruous as going out barefoot in winter. There were at least three reasons why wearing a hat was considered a necessity. The first was related to variations in weather, which meant that one had to protect one's head from gusts of wind and pouring rain, from melting snow and blazing sun, and sometimes even from sandstorms and hail. The second reason was aesthetic: for a man to appear elegant, he had to wear a fashionable hat that matched his outfit. Like the rest of his clothing, the hat was adapted to the time of day, place and season. Wearing a light-colored hat in the city was out of the question, nor would any decent man wear a straw hat in the winter! Good taste required, for example, a more formal hat for the evening, whether you were a guest at a party or going to a show. The third reason was the prevailing social convention: the hat was not only worn for practical or aesthetic reasons, but also as a symbol of belonging to society. A man without a hat would instinctively arouse suspicion: had he pawned it to settle a gambling debt? Perhaps he had to leave the home of his mistress in a hurry? Or was he the victim of a gust of wind that blew his hat away? The recurring misadventures that hit the hats of the detectives Thomson and Thompson in *The Adventures of Tintin* offer insight into the dangers to which hats and their owners were exposed: if they fell on the road, they could be damaged by cars, carts or mud puddles; defecations from birds did not spare them, and a gust of wind was enough to make them roll away. In a world where tipping one's hat to greet the women and men one met on the street was common courtesy, the absence of headgear or the solecism of a soiled hat was a source of embarrassment. Until the 1930s, to be perfectly in line with fashion and social conventions, a gentleman had to own at least a dozen different hats that had to be carefully maintained. Hatmakers competed to create new designs each season: the height of the crown, the width of the brim, the depth of the crease and the color of the band were all elements that gave a touch of originality to the fedora, the homburg or the porkpie hat. Advertising posters emphasized the aura of seduction and masculinity that a well-chosen hat was supposed to bestow on its owner. An American tradition rooted in the 1910s even established a *Straw Hat Day*, usually at the beginning of May: on this particular day, men would solemnly abandon their felt or fur hats and put on a straw hat to celebrate the good weather. In mid-September, a similar day saw the men abandon their straw hats to put on their fall hats. Unlike winter hats, straw hats were often worn for one season only, which was an advantage for hatmakers who could count on their customers coming back every year to buy a new straw hat.

The hat was also a symbol of Western values: in this spirit, Atatürk, the founder of modern Turkey, enacted a law in 1925 prohibiting the wearing of the fez, which was perceived as a relic of the Ottoman Empire, and obliging his fellow-citizens to wear European-style hats as a sign of Turkey's modernism.

It wasn't until the end of WWII that the first signs of the hat's decline became apparent. The causes were multiple and their conjunction undoubtedly accelerated the change during the 1960s: the widespread use of automobiles making hats less necessary than on the streets, and even impractical, since the more aerodynamic car models did not have enough headroom for wearing a hat while driving. In addition, progress in daily personal hygiene was helping to change the focus to hair as the ornament of the face. The images of baby boom heroes such as James Dean or John Fitzgerald Kennedy, hatless and tanned, depicted young men challenging the traditions. The rejection of the hat thus becomes the rallying cry of youth longing for happiness, in opposition to the older generations who have failed to make the world a better place. Long, abundant hair is *en vogue*. The hat is then perceived as a vestige of the pre-modern era, the ultimate form of bourgeois conformism, or the prerogative of elderly, elegant men.

Without the cinema, the hat would probably have fallen into even greater oblivion. The film industry created many male heroes associated with a particular style of hat, such as Humphrey Bogart and his fedora in *Casablanca*, or Patrick Macnee and his bowler hat in *The Avengers*, and it continued to invent new characters with hats, such as Indiana Jones and Michael Corleone to name the most emblematic ones. In a surprising turn of events, the hat thus becomes the attribute of the bad boy and of the bohemian musician, two seductive, albeit slightly marginal figures. In the recent past, television series such as *Mad Men* have put the hat back at the heart of men's elegance. Global warming has brought back the summer straw hat in a unisex form—that of the trilby, a hat that has the advantage of not looking too formal. While it would be illusory to imagine the return of the hat for everyone, it is encouraging to see more and more men rediscover the practical and aesthetic qualities of this headgear that make it such a pleasing fashion accessory.

Straw hat stand at Le Printemps *department store, Paris, 1922*

Strohhut-Stand im Kaufhaus Le Printemps, *Paris, 1922*

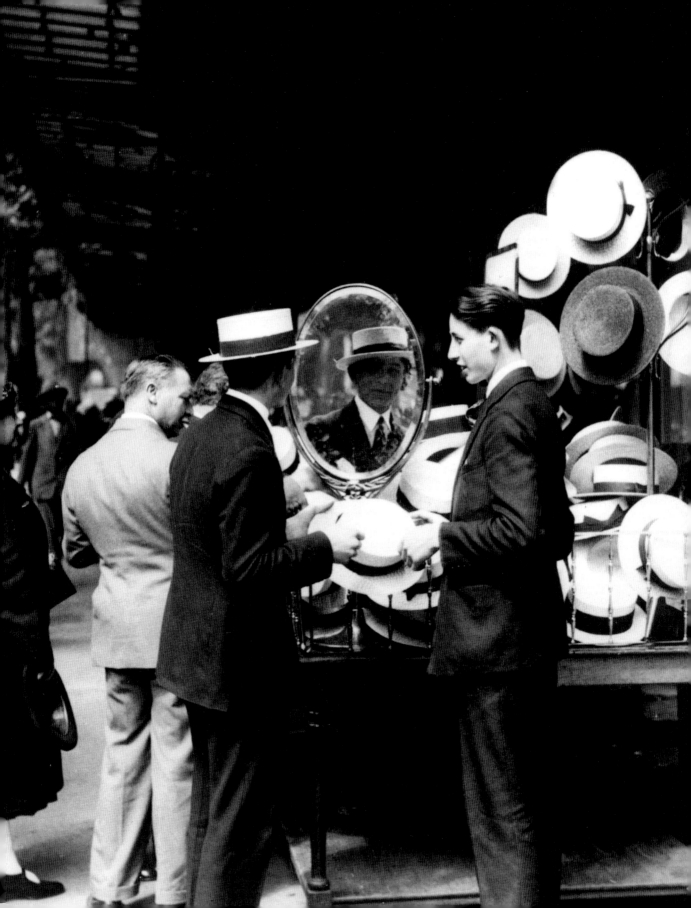

Die Anatomie des Hutes.
Terminologie

KREMPE heißt der breite horizontale Teil des Hutes. Ihre Unterseite ist die Unterkrempe.

Der vertikale Teil des Hutes ist die **KRONE** (auch Hutkappe), also der Teil über der Krempe, der den Kopf bedeckt. Er kann viele verschiedene Formen haben.

Die Oberseite der Krone heißt **KRONENDACH** oder **PLATTE**.

KNIFF oder **DELLE** heißt die Einkerbung vorne oder seitlich der Krone, die das Aufsetzen oder Abnehmen des Hutes erleichtert.

Das **HUTBAND** an der Unterkante der Krone dient zur Dekoration, aber auch (wie die Hutschnur) zur Stabilisierung. In das Hutband können Federn geschoben und Hutnadeln gesteckt werden.

Das **SCHWEISSBAND** befindet sich im Innern der Krone oberhalb der Unterkrempe.

Das **FUTTER** im Innern der Krone besteht meist aus Satin oder Seide.

Federn, Schnallen und Hutnadeln sind übliche **HUTDEKORATIONEN**.

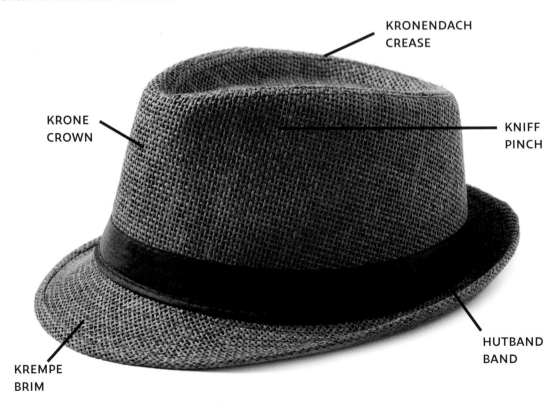

KRONENDACH
CREASE

KRONE
CROWN

KNIFF
PINCH

HUTBAND
BAND

KREMPE
BRIM

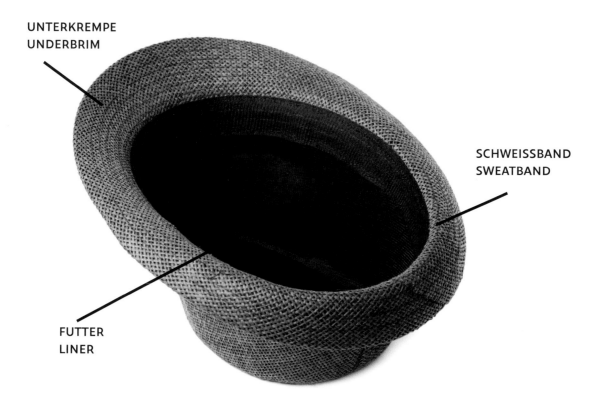

UNTERKREMPE
UNDERBRIM

SCHWEISSBAND
SWEATBAND

FUTTER
LINER

Hat anatomy and its terminology

The **BRIM** is the wide, horizontal part of a hat. Its underside is correspondingly called the **UNDERBRIM**. A brim that is turned up in the back and down in the front is called a **SNAP BRIM**.

The **CROWN** is the vertical part of a hat, the area above the brim that covers your head. There are many possible crown shapes as you will see below.

The **CREASE**, also called **DENT**, refers to the indentations on the top of the crown.

The **PINCH** is the indentation at the sides of the crown.

The **BAND** is a decorative ribbon encircling the bottom of the crown. It can be adorned with feathers or pins.

The **SWEATBAND** is the hat's inner band, located inside the crown just above the underbrim.

The **LINER** is the interior lining of the hat, often made of satin or silk.

Feathers, trims, pins, and buckles are usual hat **DECORATIONS**.

Kronenformen Crown shapes

KNIFF in der Mitte von vorne nach hinten. Kann mit Dellen vorne kombiniert werden.

CENTRE CREASE (CENTRE DENT). A crown with a simple crease running from the front to the back is called a centre crease crown. It can be combined with pinches at the front.

RAUTENFÖRMIG. Mit vier Spitzen.

DIAMOND. As the name suggests, the top of the crown is diamond-shaped, with one point at the front and three at the back.

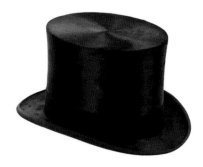

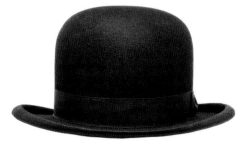

OBEN FLACH. Beispielsweise beim Zylinder.

FLAT TOP. It is the crown used for top hats and has a perfectly flat top.

OFFENE KRONE. Die Krone ist rund, ohne jeden Kniff, wie bei einer Melone.

OPEN CROWN. The crown is round, without any crease, like a bowler hat.

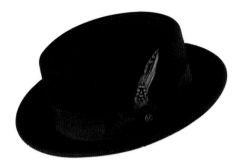

TEARDROP. Diese Form ist der einer Raute relativ ähnlich, hat aber einen runden Rücken anstelle von drei Spitzen.

TEARDROP. This shape is relatively similar to the diamond's but has a rounded back instead of three points.

Der platte Deckel kann am Rand eine **TELESKOP-RINNE** haben wie beispielsweise beim Porkpie.

TELESCOPE. The crown has a simple circular indentation around a flat top. It is commonly seen on pork pie hats.

Einige der Formen können miteinander kombiniert werden: Porkpie oder Trilby mit einer **TELESKOP-KRONE** und einem Diamanten sind relativ häufig.

You can also find variants of these main shapes, such as the **BUBBLE**, which is similar to a centre crease, but has a bubble-like shape in its middle.

Der **CATTLEMAN** ist eine weitere Variante der Mittelfaltenkrone, mit Kniff in der Mitte der Seiten.

The **CATTLEMAN** is another variation of the centre crease crown, with pinches in the middle of the sides.

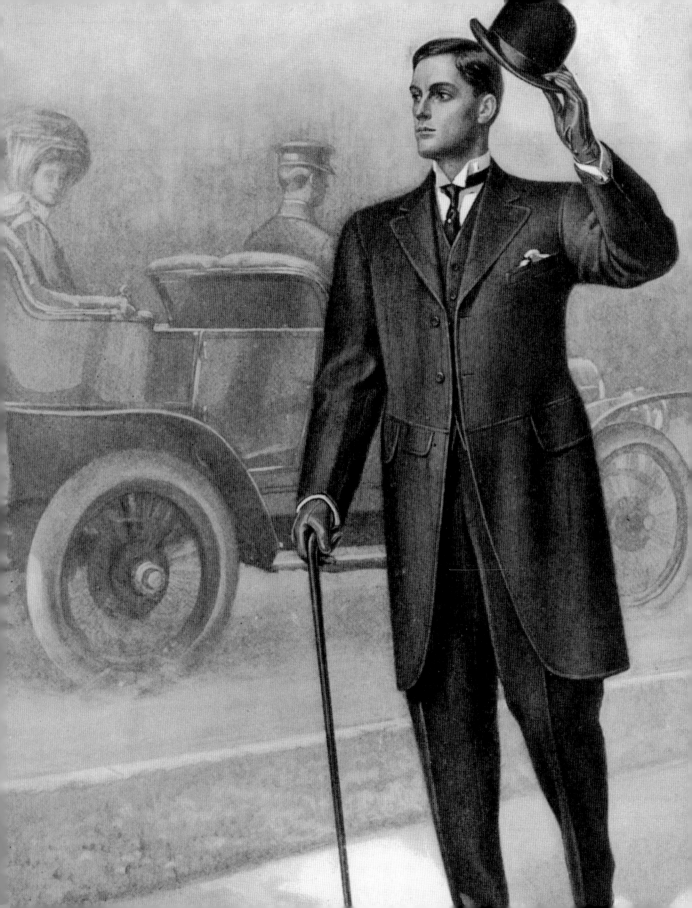

Die Hut-Etikette

Die Hüte betreffende Regeln und Konventionen entwickelten sich im 19. Jahrhundert und in der Belle Époque. Diese Regeln passten sich technischen Neuerungen wie Fahrstühlen und öffentlichen Verkehrsmitteln an. Diese Etikette bestand aus einer Kombination aus praktischen, sozialen und modebedingten Erwägungen, die sich meist leicht nachvollziehen lassen.

FARBE UND DEKORATION

Bis Homburg und Fedora in Mode kamen, waren die Hüte der Städter meist schwarz, was Ernst und Bescheidenheit symbolisierte. Schwarz wird noch heute mit Zylindern und Melonen assoziiert, aber es sind auch graue Zylinder erhältlich. Diese allgemein beachtete einheitliche Farbe könnte man als Folge des militärischen Ursprungs moderner Hüte interpretieren, hatte aber zweifellos auch einen praktischen Aspekt: Auf Schwarz sind Flecken nicht zu sehen. Schwarz ist pflegeleicht. Bunte Hüte gibt es erst seit Ende des 19. Jahrhunderts. Graue, braune, marineblaue und dunkelgrüne Herrenhüte wirkten in der kalten Jahreszeit phantasievoller, schwarz war zur Abendgarderobe jedoch weiterhin *de rigueur*. Der Panama-Hut und Strohhüte im Allgemeinen, die an Sommertagen getragen wurden, kontrastierten mit den dunklen Standardhüten.

Zierrat wie Federn, Hutnadeln und Schnallen wird links getragen, bei Damenhüten ist es jedoch umgekehrt. Damen tragen Hutschmuck rechts von der Krone. Da Herren den Hut oft ziehen mussten, und zwar mit der rechten Hand, wenn sie jemandem auf der Straße

The hat etiquette

The social rules and conventions related to wearing a hat evolved throughout the 19th century and the Belle Époque, and adapted to new situations in everyday life, such as the development of public transport or elevators. The etiquette surrounding hats was mainly dictated by a combination of practical, social and fashion considerations that are often easy to trace.

COLOUR AND DECORATION

Until the Homburg and Fedora hats became fashionable, the dominant colour of city hats was black, a colour that denoted both seriousness and modesty. Black is still associated with top hats and bowlers today, although grey top hats are not uncommon. The uniformity of colour that was observed could be seen as a remnant of the modern hat's military origins, but it is undoubtedly the practical aspect that prevailed here: black is, by definition, the colour that does not show stains, and the easiest to take care of. The emergence of new colours began in the last decades of the 19th century, with grey, brown, marine blue and dark green adding a touch of fantasy to men's hats during the colder seasons, whereas black was *de rigueur* in the evenings. The Panama hat, and straw hats in general worn during summer days, offered a stark contrast to the darkness of standard hats.

Ornaments, such as bird feathers, pins, or buckles, were always worn on the left side, unlike decorations on women's hats that would be worn on the right side of the crown. As men had to lift their hats with their right hand frequently when greeting others on the street, one can

begegneten, ist anzunehmen, dass es schlichtweg einfacher und sicherer war, sowohl für den Hutschmuck als auch für die Handschuhe, Hutschmuck links zu tragen. Damen brauchten ihre Hüte nicht zu ziehen, deswegen spielte die Positionierung des Hutschmucks für sie nur eine untergeordnete Rolle.

assume that it was simply easier and safer – both for the decorations and for the gloves – to have the ornamental part on the left side. Women were not expected to lift their hats in public, therefore practicality played a more minor role in their case.

HUT TRAGEN ODER ABNEHMEN?

Wann trägt ein Herr seinen Hut, und wann nimmt er ihn ab? Die allgemeine Regel lautet, dass ein Herr seinen Hut in der Öffentlichkeit auf dem Kopf trägt und in Privaträumen abnimmt. In der Praxis gibt es jedoch drei Unterscheidungen: offener öffentlicher Raum, geschlossener öffentlicher Raum und Privaträume.

Straßen sind offene öffentliche Räume par excellence, hier darf von einem Herrn erwartet werden, dass er einen Hut trägt. Hüte wurden dafür hergestellt, auf der Straße getragen zu werden und ihre Besitzer vor Windböen und extremen Temperaturen, sei es Kälte oder Sommerhitze, zu schützen. Bis Mitte des 20. Jahrhunderts fiel ein Herr, der barhäuptig, also ohne Hut, die Straße entlangging, auf. Es konnte passieren, dass er deswegen verspottet wurde.

HAT ON OR HAT OFF

When is a man expected to "don" his hat, and when is he supposed to "doff" it? The general rule states that a man should "wear his hat in public and take it off in private spaces". In practice, however, three scenarios can be observed: open public spaces, covered public spaces and private spaces.

The streets, as open public spaces par excellence, are places where a man is expected to wear a hat. Hats were made to be worn on the street and thus protect their owners from gusts of wind, dust, and excessive temperatures, whether extreme cold or summer heat. Until the middle of the 20th century, a man walking around the street bare-headed, or "hatless ", to use the terminology of the time, raised questioning glances from his fellow men and exposed himself to the mockery of the less

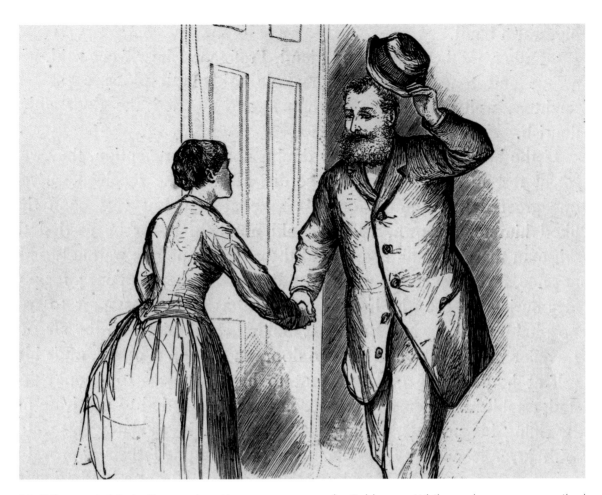

Die Etikette schrieb das Tragen eines Hutes auf der Straße vor und diktierte, wann dieser Hut zu ziehen oder ganz abzunehmen war. Um einen Bekannten zu grüßen, mit einer Dame zu sprechen, einem Leichenzug oder einer Prozession seine Hochachtung zu erweisen oder dem Abspielen einer Nationalhymne zuzuhören, musste der Hut abgenommen werden. In Monarchien muss den Hut abnehmen, wer dem Gefolge des Königs begegnet. Er demonstriert so seine Unterwerfung vor dem Staatsoberhaupt. Wer eine Rede hält, hat ebenfalls den Hut abzunehmen, außer das Wetter ist so schlecht, dass es sinnvoll ist, den Hut aufzubehalten. Was für Straßen gilt, gilt auch für öffentliche Gärten und Parks, Märkte (sowohl Plätze als auch Markthallen), Pferderennbahnen und Stadien.

charitable ones. While good manners prescribed the wearing of hats in the street, they also dictated the occasions to lift or remove one's hat: to greet an acquaintance, to speak to a lady, to honour a funeral cortege or a religious procession, or whenever a national anthem is played.
In monarchies, you are required to take your hat off to greet the royal escort and thus demonstrate your personal submission to the sovereign. If you deliver a speech in public, the custom is to take your hat off, unless the weather is so adverse that keeping your hat on is sensible. The requirement of wearing a hat on the street also extended to public gardens and parks, to markets (both open-air and covered) and malls, as well as to racecourses and stadiums.

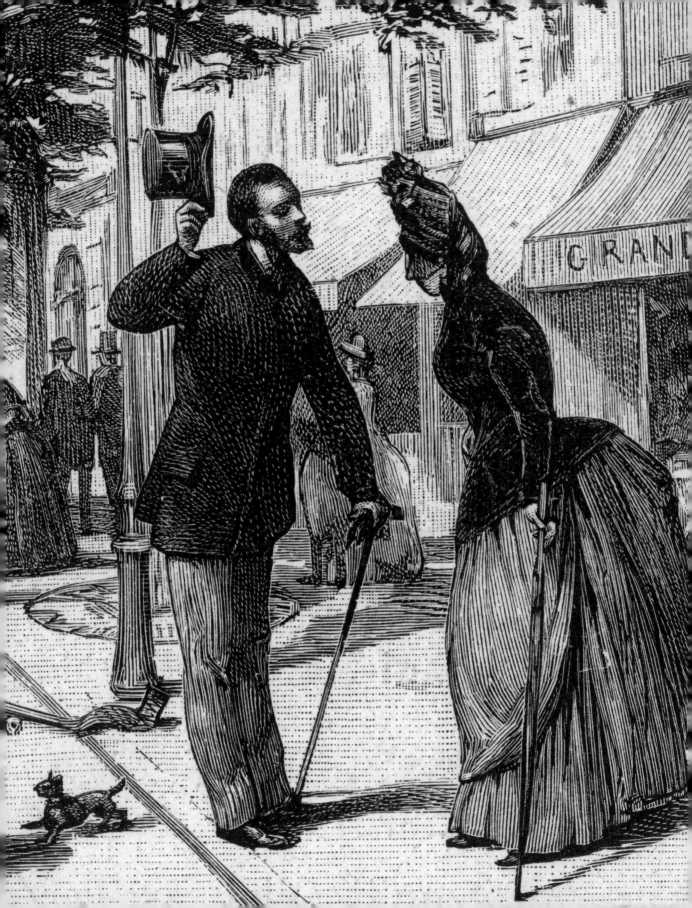

In überdachten öffentlichen Räumen hing das Huttragen von der Art dieses Raums ab. Handelte es sich um einen Durchgangsraum wie eine Hotellobby, einen Bahnhof, einen Flughafen, eine Unterführung oder auch nur einen Fahrstuhl, dann war es Sitte, den Hut aufzubehalten. Das galt auch für Läden und öffentliche Verkehrsmittel, sofern man nicht saß, denn dann konnte man seinen Hut auf den Knien ablegen. Bemerkenswert war, dass ein Herr seinen Hut im Aufzug abnehmen musste, wenn eine Dame zugegen war, ganz gleichgültig, ob er sie kannte oder nicht. In allen anderen überdachten öffentlichen Räumen mussten Männer ihre Hüte abnehmen und sie entweder in der Hand halten oder sie an der Garderobe abgeben. Restaurants, Cafés und Theater gehörten zu dieser Kategorie und Gotteshäuser mit Ausnahme von Synagogen, in denen Kopfbedeckungen getragen werden müssen. In Schulen, Krankenhäusern, Bibliotheken, Gerichten und Rathäusern sind Hüte abzunehmen.

Privaträume waren nicht nur Häuser und Wohnungen, sondern auch Clubs, Wohnwagen und Wohnmobile. Sobald man einen Privatraum betrat, hatte man aus Respekt vor seinen Gastgebern seinen Hut abzunehmen und in der Hand zu halten, bis man gebeten wurde, ihn auf die Hutablage zu legen oder einem Dienstboten auszuhändigen. In Frankreich hielt man seinen Hut, wovon der Gastgeber jedoch ausgenommen war, allerdings mit einer wichtigen Ausnahme. Daran erinnert uns Marcel Proust: Wenn der König zu Besuch ist, ist der Herr des Hauses nur noch ein Besucher in seinem eigenen Wohnzimmer, da der König überall zu Hause ist.

In covered public spaces, the wearing of hats depended mainly on the nature of the place: if it was a transit space, such as a hotel lobby, railway station, airfield, underground corridor or even an elevator, the custom was to keep your hat on your head. This was also the case in shops and public transport, unless you were seated, which allowed you to put your hat on your lap. Remarkably, a man was supposed to take off his hat in an elevator if a lady was present, whether he knew her or not. In all other covered public spaces, men had to take off their hats - either to hold them in their hands or to leave them in the cloakroom. Restaurants, cafés, and theatres naturally fell into this category, as did religious buildings, with the exception of synagogues, where headgear was required. You are also expected to remove your hat in schools, hospitals, libraries, courthouses, and town halls.

Private spaces included not only houses and apartments, but also clubs, caravans and mobile homes. As soon as you entered a private home, it was customary to take off your hat as a sign of respect for your hosts and hold on to it until you were asked to hang it on the coat rack or leave it in the care of a servant. In France, visitors usually held their hats, while the host was exempted, except, as Marcel Proust reminds us, "when the king came, since the king being everywhere at home, the master of the house is now only a visitor in his own living room."

DIE KUNST, SEINEN HUT ZU ZIEHEN

Den Hut nur ein wenig anzuheben, um jemanden zu begrüßen, zählt zu den konventionellen Höflichkeitsgesten. Man fasst den Hut mit der Rechten an der Krone an und hebt ihn nur ein wenig von der Stirn. Dabei nickt man und lächelt, um anzudeuten, was für eine Freude einem diese Begegnung bereitet. Früher zog jeder Herr, wenn er einem Bekannten begegnete, seinen Hut oder seine Mütze. Der Status des anderen spielte dabei keine Rolle. Benimmbücher betonten, dass auf Vermögen und Rang keine Rücksicht zu nehmen sei. Jemanden nicht zu beachten, ließ sich bestenfalls als Zerstreutheit auslegen, schlimmstenfalls als Ausdruck unangemessener Überheblichkeit. In Begleitung eines Freundes, war man gezwungen, alle zu grüßen, die der Freund kannte, auch wenn man ihnen nicht vorgestellt wurde. Das Hutziehen konnte auch dazu dienen, sich bei Fremden zu bedanken, die einem behilflich gewesen waren oder einem den Weg erklärt hatten.

In einigen Fällen reichte das kurze Ziehen des Hutes jedoch nicht aus. Gute Manieren forderten das Abnehmen des Hutes, der dann auf Armeslänge Abstand gehalten wurde. Das galt in folgenden Situationen:

- Wenn man einer Dame begegnete und eine Unterhaltung mit ihr begann. Hatte man vor, nur ein paar Worte mit ihr zu wechseln, genügte es, den Hut vor die Brust zu halten, um ihr zu verstehen zu geben, man habe vor, sofort weiterzugehen. Bei Regen, war damit zu rechnen, dass sie einen dazu aufforderte, den Hut wieder aufzusetzen, um sich vor dem unfreundlichen Wetter zu schützen.

- Als Ausdruck des Respekts, wenn man auf der Straße einem Geistlichen, hohen Beamten oder einer Person, die alt genug war, um der eigene Vater zu sein, begegnete.

- Wenn man jemandem vorgestellt wurde. Dann nahm man nicht nur den Hut ab, sondern verbeugte sich auch und gab dem anderen die Hand.

- Wenn eine Nationalhymne (die eigene oder die einer anderen Nation) gespielt oder wenn eine Fahne gehisst wurde. Im Regelfall musste bis zum Ende der Hymne oder der Flaggenzeremonie abgewartet werden.

- Bei einem Trauerzug oder einer Prozession. Bei einem Begräbnis mussten nur die nächsten Verwandten die Hüte abnehmen, wenn sie hinter dem Sarg hergingen. Die anderen Trauergäste behielten die Hüte auf.

- Der Hut war immer so zu halten, dass nur die Außenseite, nicht aber das Futter zu sehen war.

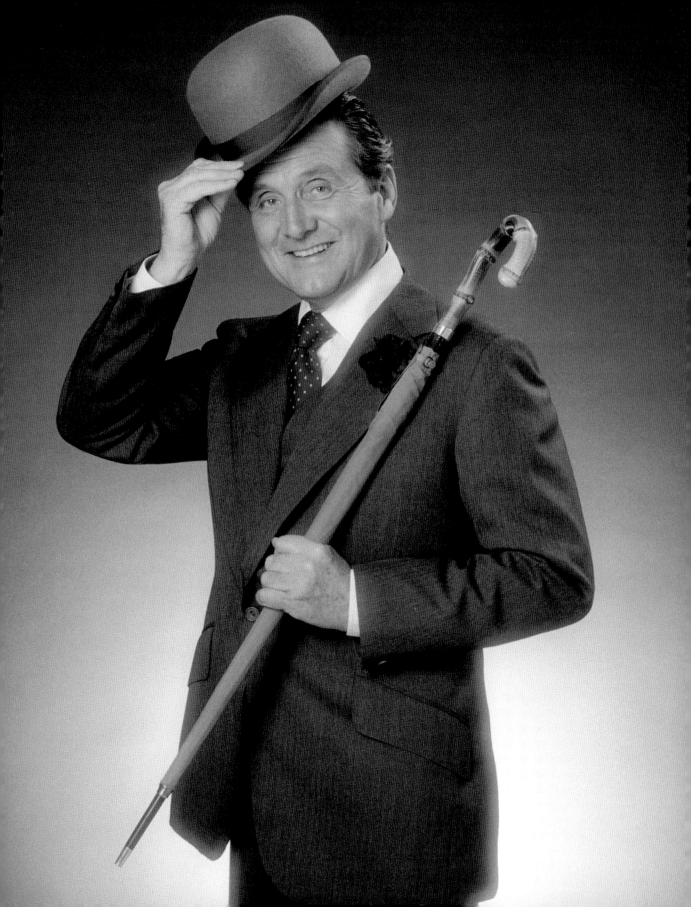

THE ART OF TIPPING YOUR HAT

Slightly lifting your hat to greet people you know is a conventional gesture of courtesy. "Tipping" consists of barely lifting your hat off your forehead and holding it up by the crown with your right hand for a short instant. It should be accompanied by a nod and a smile to show the pleasure the encounter brings you. In the past, a man would tip his hat, or cap, whenever he met someone he knew, regardless of his social status or reputation. The etiquette manuals regularly stressed the importance of saluting one's acquaintances without distinction of fortune or social rank. Not paying attention to a person was considered at best a sign of distraction, at worst an expression of misplaced pride. If you were walking with a friend, you would be required to greet people your friend knew, even if you were not introduced to them. Tipping would also be used to thank strangers who helped you, or whenever you asked a stranger for directions.

In a number of cases, tipping your hat wasn't enough. Good manners required taking off your hat and holding it at arm's length when:

• You met a lady and engaged in a conversation with her. If you intended to exchange only a few words, you would hold your hat at chest height, as a sign that you planned to keep going. On rainy days, a lady would normally ask you to put your hat back on your head to protect you from the inclement weather conditions.

• You met and started a conversation with a clergyman, a high-ranking official, or anyone old enough to be your father, as a sign of respect.

• You were introduced to a new person. Not only would you take your hat off, but also courteously bow and shake hands.

• A national anthem (yours or any other country's) was playing, or during a flag raising ceremony. You would normally stop walking until the end.

• A funeral cortege or a religious procession was crossing your way. At funerals, only the close relatives were required to walk with their hats in hand as a sign of mourning. Other mourners would keep their hats on.

• A monarch or any person of a royal family was passing in a carriage.

Men were supposed to hold the removed hats by the brim in such a way that only the outside, and never the lining, was visible.

DEN HUT SCHWENKEN

Obwohl davon in Benimmbüchern nur selten die Rede ist, war das Hüteschwenken als Ausdruck der Freude sehr verbreitet und verdient daher unsere Aufmerksamkeit. Meist wurde Hüte geschwenkt, wenn einem Helden zugejubelt wurde, einem Politiker, Sportler, Filmstar oder Sänger. Die Person, der der Jubel galt, schwenkte ebenfalls ihren Hut in Armeslänge in der Höhe. Das war zu beobachten, wenn Ozeandampfer ablegten oder Züge einfuhren. Die Reisenden schwenkten ihre Hüte, um die Versammelten zu grüßen, die ihnen alles Gute wünschten. Diese elegante Geste hatte auch praktische Vorteile. Ein geschwenkter Hut flog nicht weg, denn auf Bahnsteigen und in Häfen wehte häufig starker Wind. Wichtige Ereignisse, ein unerwarteter Sieg im Krieg oder die Unterzeichnung eines Waffenstillstands, führten auch zu großen Freudenbekundungen in der Öffentlichkeit. Hüte wurden geschwenkt oder auch schon mal zu Hunderten in die Luft geworfen. Diese Begeisterung muss die Hüte ziemlich beschädigt haben. Vemutlich hatten die Hutmacher am Tag darauf viel zu tun. Alle, deren Hüte durch das nicht der Etikette entsprechende Verhalten beschädigt worden waren, beeilten sich dann vermutlich, diese zu ersetzen.

WAVING YOUR HAT

Although rarely mentioned in etiquette books, the practice of waving your hat as a sign of joy has always been widespread and deserves attention. This practice often accompanies the cheers of a jubilant crowd paying tribute to its hero of the day, whether it is a politician, sports champion, film star or singer. The person to whom the tribute is paid will respond in the same way by greeting the crowd with his hat up at arm's length and waving in all directions. The same gesture could be observed when an ocean liner or a train departed or arrived: those travelling waved their hats to greet those who had gathered to wish them well. A practical aspect was added to the spontaneous elegance of the gesture: by holding one's hat with a firm hand, one avoided seeing it fly away, carried away by the wind that often blows around ship docks or station platforms. Significant events such as an unexpected victory in a war or the signing of an armistice, also gave rise to demonstrations of popular joy that saw hats being waved, or even being tossed into the air by the hundreds. One can imagine the damage this frenzy caused to the hats and the joy of the hatters the day after such scenes: customers rushed to replace their hats distorted by this practice, which challenged the proper use of hats and basic rules of etiquette.

U.S.-Präsident Dwight "Ike" Eisenhower schwenkt seinen Hut bei einem Besuch in Genf, 1955

US President Dwight "Ike" Eisenhower waving his hat during a visit to Geneva, 1955

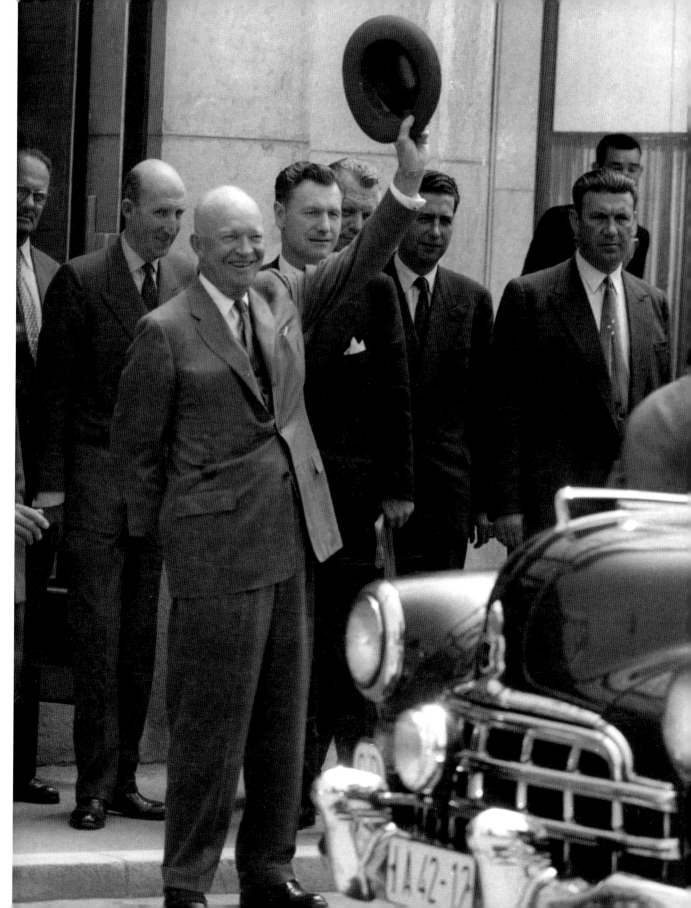

Wie man einen Hut pflegt

Einen Hut pflegen ist ebenso einfach wie Schuhputzen. Es ist nur sehr geringer, allerdings regelmäßiger Aufwand nötig. Man sollte einige einfache, sehr einleuchtende Regeln beachten:

▪ Legen Sie ihren Hut auf einer flachen Oberfläche ab, dann mit der Krempe nach oben und der Krone nach unten, also umgekehrt, andernfalls wird die Krempe flach und verliert ihre ursprüngliche Form.

▪ Sie können Ihren Hut an einen Haken hängen. Stellen sie sicher, dass seine Spitze abgerundet ist, damit der Hut nicht versehentlich eingedrückt wird. Wenn Sie den Hut zu lange hängenlassen, dann verliert er irgendwann seine Form. Denken Sie daran: Der beste Ort für Ihren Hut ist Ihr Kopf!

▪ Falls Sie noch die Originalschachtel des Hutes besitzen, dann bewahren Sie den Hut darin auf, wenn Sie beabsichtigen, ihn mehrere Monate lang nicht zu tragen. Sie können Ihre Sommerhüte im Winter, und ihre Winterhüte in den wärmeren Monaten sicher in ihren Schachteln verwahren. Wie alle andere Kleidung sollte ein Hut an einem trockenen Ort in Zimmertemperatur gelagert werden. Ein Lavendelsträußchen oder ein Stück Zedernholz hält Motten fern.

▪ Falls Sie einen Hut in einen Koffer packen müssen, dann füllen Sie die Krone mit Socken oder Unterwäsche, damit sie nicht aus der Form gerät. Achten Sie auch darauf, dass die Krempe nicht zerknickt. Verpacken Sie einen Hut nie in eine Plastiktüte.

▪ Lassen Sie ihren Hut nie an einem heißen Ort wie einem Auto, das in der Sonne steht, zurück. Übermäßige Hitze verformt den Hut oder lässt ihn schrumpfen. Falls Sie mit ihrem Strohhut in starken Regen geraten sind, dann lassen Sie ihn einfach trocknen. Verwenden Sie keinesfalls einen Föhn und legen Sie ihn nicht auf die Heizung. Sorgen Sie dafür, dass das Schweißband nach unten geklappt ist.

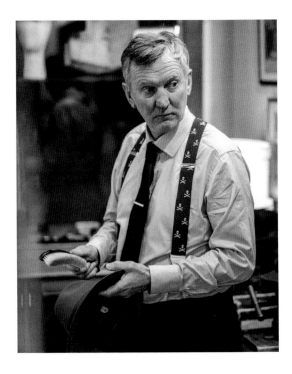

▪ Achten Sie darauf, dass Sie saubere Hände haben, wenn Sie Ihren Hut anfassen.

Filzhüte sollten regelmäßig mit einer Bürste mit weichen Borsten (vorzugsweise aus Rosshaar) gebürstet werden, um Staub und leichte Verschmutzungen zu entfernen. Zusätzlich kann man den Hut mit einem angefeuchteten Lappen abwischen. Haare und Fussel lassen sich mit Fusselroller entfernen. Für Flecken verwendet man ein Spezialspray beispielsweise Scout Filzhutreiniger.
Ein Strohhut kann man mit einem Tuch reinigen, das man leicht mit kaltem Seifenwasser angefeuchtet hat.
Erde oder Staub von Tweed- oder Wollmützen werden mit einem Lappen oder einer sehr weichen Bürste entfernt. Lassen Sie die Mütze gründlich trocknen und stopfen Sie sie mit einem Handtuch oder Zeitung aus, damit sie nicht aus der Form geht.

How to take care of a hat

Taking care of your hat is as easy as shining your shoes. It requires minimal but regular effort. To get started, just remember a few simple, common sense rules:

- When placing your hat on a flat surface, make sure that the brim is on top and the crown is at the bottom, that is, place your hat upside down. Otherwise, the brim may flatten and lose its original shape.
- You can hang your hat on a coat hanger or a hook, but make sure the hook's end is rounded to prevent the hat from being accidentally dented. If the hat is left hanging in one place for too long, it will eventually lose its shape. Remember that your head is the best place for your hat.
- If you have kept the original hat box, this can be used to store it when you don't intend to wear it for several months. You can keep your summer hats during the cold season and your winter hats during the warmer months safely stored in their boxes. Like all other clothing, a hat should be kept in a dry place at room temperature. A bunch of lavender or a piece of cedar wood will keep unwanted bugs away.
- If you need to pack a hat in a suitcase, fill the crown with underwear or socks to keep it in shape. Also take care of the brim so that it is not creased. Never use a plastic bag to wrap your hat.
- Never leave your hat in a hot place, such as a car parked in the sun, as excessive heat may distort or shrink the hat. If your straw or felt hat has been exposed to heavy rain, let it dry naturally without using a hairdryer or heater. And be sure to turn the sweatband out.
- Make sure your hands are clean whenever you touch your hat.

Felt hats should be regularly brushed with a soft-bristled cloth brush (preferably a horsehair brush) to remove the dust and light dirt. In addition, you can wipe your hat with a slightly damp cloth. Hair and fuzz can be cleaned off with adhesive tape. For stains, use a special spray such as Scout Felt Hat Cleaner.

A straw hat can be cleaned with a cloth slightly dampened with cold soap water.

For tweed or woollen caps, use a cleaning cloth and a very soft brush to remove mud or dust. Allow enough time for the cap to air dry completely and fill the inner part with towels or newspapers to keep the shape.

Einige unerwartete Verwendungen von Hüten

Hüte sind fast gänzlich aus dem öffentlichen Raum verschwunden und wirken eher alt-modisch, es gibt jedoch Bereiche, aus denen sie nicht wegzudenken sind und die beweisen, dass sie immer noch einen Platz in unserer Welt beanspruchen können.

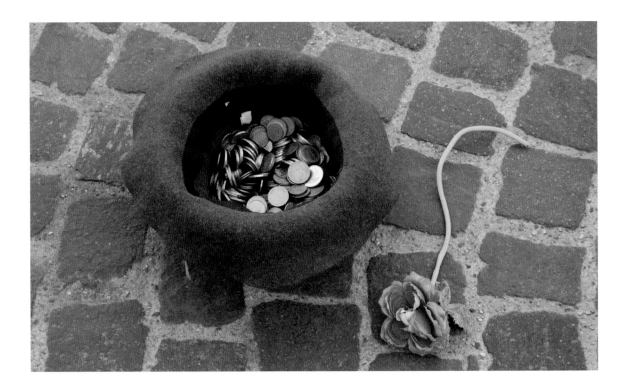

Der Zylinder des Zauberers

Der Zylinder gehört zu den wichtigsten Requisiten des Zauberers: Aus ihm zaubert er sein Kaninchen hervor. Neben dem Zauberstab symbolisiert er die Magie. Der Zylinder ist eine moderne Variante des spitzen Hutes, der von den Magiern getragen wurde, und der wie der Zylinder dazu verwendet wurde, Gegenstände auftauchen und wieder verschwinden zu lassen. Was aus dem Hut auftaucht, sei es ein Kaninchen oder ein anderer Gegenstand, steckt nicht in einem doppelten Boden, sondern der Zylinder des Zauberers besitzt eine Öffnung, normalerweise im Deckel, die es ihm erlaubt, Gegenstände aufzunehmen, die sich unter dem Tisch befinden, auf dem er den Hut ablegt. Der Tisch besitzt eine unauffällige Öffnung, durch die diese Gegenstände verschwinden.

Der Hut des Straßenmusikers

Straßenmusiker brauchen einen Hut, um beim Publikum Münzen einzusammeln. Der Hut wird weitergereicht, und die Münzen sind in der Krone des Hutes sicher, höflich ist der Musiker auch, denn das Hutziehen ist immer ein Ausdruck der Höflichkeit. Solisten verwenden hin und wieder Gitarren- und Geigenkästen zum Sammeln der Zuwendungen, so dass sie den Hut ziehen und sich verbeugen können, um die Passanten zum Spenden zu ermuntern.

Das Sechsfarben-Denken oder die Edward-de-Bono-Theorie, wie man am effektivsten nachdenkt

Psychologe und Arzt Dr. Edward de Bono propagiert in seinem 1986 erschienene Bestseller das laterale Denken, um Diskussionen zu stimulieren. Teilnehmer einer Besprechung werden angehalten, über eine Frage nachzudenken. Dabei soll das Gehirn stimuliert und das Projekt von verschiedenen Seiten und mit unterschiedlichen Strategien angegangen werden. Edward de Bono schlägt vor, sich die Phasen des Denkprozesses als sechs Hüte unterschiedlicher Farben vorzustellen: Weiß steht dabei für Fakten und Zahlen, Rot für die emotionale Herangehensweise, Schwarz für Schwierigkeiten und Herausforderungen, Gelb für Chancen und positives Denken, Grün für Kreativität und Innovation und Blau für den gesamten Denkprozess und die Synthese verschiedener Meinungen. Internationale Unternehmen nutzten *Das Sechsfarben-Denken* als Handbuch, um Besprechungen effektiver und kreativer zu gestalten.

Der Hut von Uncle Sam

Uncle Sam verkörpert seit über 150 Jahren die Tapferkeit der Amerikaner. Meist wird er mit einem Zylinder dargestellt, dessen Hutband die Sterne der amerikanischen Flagge zieren. Von Uncle Sam ist auch in dem Song *Yankee Doodle* die Rede, der im amerikanischen Unabhängigkeitskrieg entstand, es hat jedoch den Anschein, dass sich der Name und die Figur erst während des Britisch-Amerikanischen Krieges 1812 endgültig durchsetzten. Uncle Sam wurde mit Samuel Wilson, der die US-Truppen in New York mit Dosenfleisch belieferte, assoziiert. Seine Arbeiter nannten ihn Uncle Sam, und er könnte als Vorlage für den späteren Uncle Sam, weil er auf Fotos mit seinem weißen Backenbart große Ähnlichkeiten mit diesem aufweist. Seit dieser Zeit haben sich die Darstellungen von Uncle Sam kaum verändert: Er trägt nach wie vor rot-weiß-gestreifte Hosen, einen langen Frack und seinen auffälligen Zylinder mit blau-weißem Sternenband.

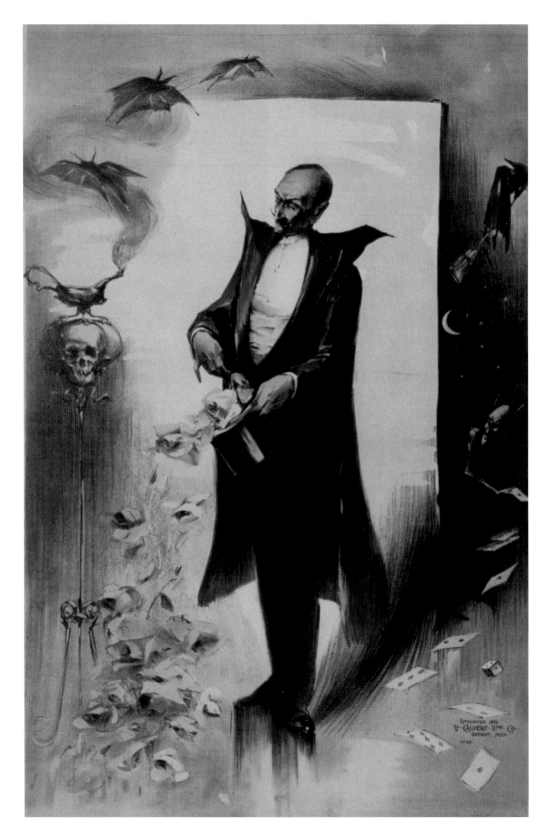

Some unsuspected uses of hats

While the hat has almost disappeared from the public space and its image seems rather old-fashioned, its use is still firmly present in a number of activities. We have chosen some of the most original ones that prove the persistence of the hat in the world around us:

The magician's top hat

The top hat used by stage magicians for performing basic tricks – to produce a rabbit, generally – has become, along with the magic wand, a symbol for magic. The top hat thus becomes a modern version of the pointed hat traditionally worn by wizards and which, like the magician's top hat, is used to make objects appear and disappear.

What emerges from the hat, be it a rabbit or other object, has not been hidden in a false bottom, in fact, the magician's hat has a concealed opening (usually in the top of the hat) that allows him to extract objects previously hidden under the table on which he places the hat. The table itself is equipped with a discreet opening for the passage of objects.

The street musicians' hat (old and worn)

Street musicians frequently use a hat or cap for collecting coins from onlookers. The gesture of passing the hat combines practicality - the coins are safe at the bottom of the hat - with courtesy, since keeping the hat low is a sign of politeness to the audience. However, solo musicians might also use the musical instrument's case for receiving coins so that they can continue playing while still encouraging passers-by to donate.

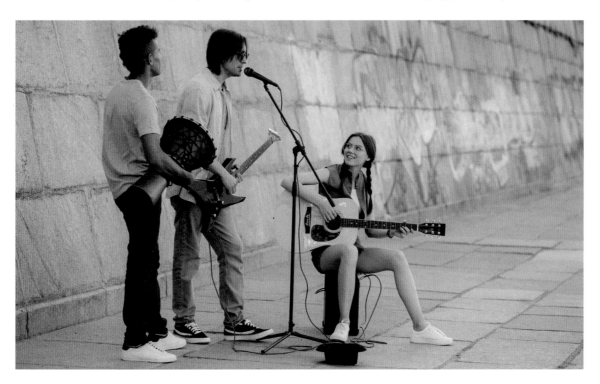

The six thinking hats, or Edward de Bono's theory about how to make the best use of one's thinking skills

Another unsuspected use of hats can be found in the best-selling book *Six Thinking Hats* by psychologist and physician, Dr Edward de Bono, which introduces the notion of lateral thinking as a way of stimulating discussion and encouraging participants in a meeting to think through an open question. The basic idea is to motivate the brain to think about a project from different angles and with alternative approaches. Edward de Bono therefore proposes to guide the group reflection by visualising the various phases and stages of thinking with the help of six different coloured hats: white represents objective facts and figures, red is for the emotional approach, black is to detect difficulties and challenges, yellow is for opportunities and positive thinking, green is for creativity and innovations, blue is meant for organizing the thinking process and synthesizing the opinions. Published in 1985, the *Six Thinking Hats* has become a reference book used both in the educational community and by major international corporations to conduct meetings in an efficient and creative manner.

Uncle Sam's hat

Uncle Sam, the man who has personified "the bravery and fortitude of the American spirit" for more than 150 years, is often depicted wearing a top hat decorated with a star similar to those on the US flag. The name Uncle Sam is mentioned in the song "Yankee Doodle" and dates back to the American Revolutionary War, but it seems that the name and effigy came to prominence a few years later during the Anglo-American War of 1812. This allegory of America became associated with Sam Wilson, a supplier of canned meat for the US troops stationed in New York. Nicknamed "Uncle Sam" by his workers, Wilson might indeed have been the prototype for the iconic Uncle Sam, as his photographs show similar facial features, including white whiskers. The depiction of Uncle Sam has not changed much since then: he is still dressed in red and white striped trousers, a dress coat with long tails and wearing his prominent top hat with a blue and white star banner.

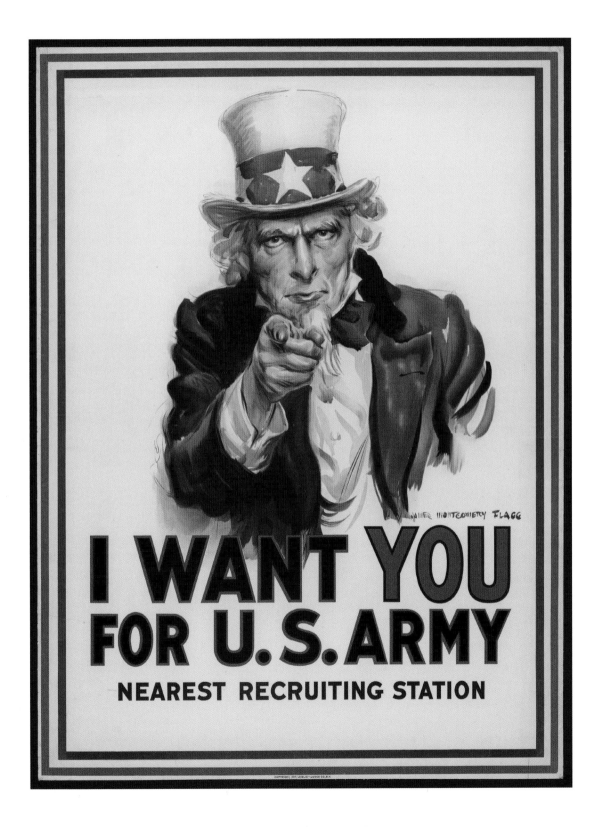

STYLES

HUT-TYPEN

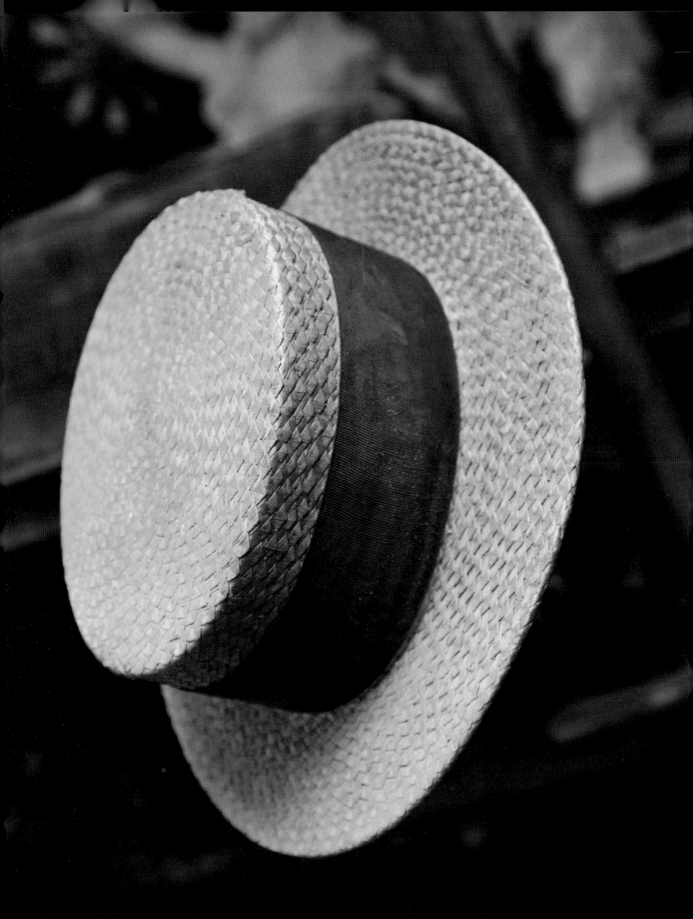

Der Strohhut

Der Anblick eines Strohhuts lässt an Sommer und Ferien denken. Er kam in der zweiten Hälfte des 19. Jahrhunderts in Mode und verdankte den Namen „Boater" im englischen Sprachraum dem Umstand, dass er anfänglich von den Schiffern (Boatmen) auf der Seine getragen wurde, die erholungsuchende Pariser transportierten. Renoir und andere Impressionisten haben die Guinguettes, wie die von diesen Schiffern frequentierten Gasthöfe an den Ufern der Seine heißen mit ihren Gemälden unsterblich gemacht. Schiffer in Strohhüten stehen zwischen herausgeputzten und fröhlichen Parisern. Seine Einfachheit und Eleganz ließen diesen Hut rasch zu einer beliebten Sommerkopfbedeckung für Frauen und Kinder, aber auch Männer, werden. Er stellte das Gegenstück zu den weniger förmlichen Winterhüten wie die Melone oder den Homburg dar. Er konnte zu einem Anzug, aber auch zu weniger förmlicher Kleidung getragen werden. Männer in Badeanzügen trugen Strohhüte, ohne lächerlich zu wirken. Ein buntes Band um die Krone verlieh diesem Hut einen persönlichen Touch. Er wurde wie alle Strohhüte zu Beginn des 20. Jahrhunderts von Ostern bis Anfang November getragen. Seine positiven Assoziationen machten sich der französische Sänger Maurice Chevalier und die amerikanischen Schauspieler Buster Keaton und Fred Astaire zunutze. Coco Chanel zog sein schlichtes Design den riesigen und unpraktischen Damenhüten vor, die die Haute Couture zu Beginn des 20. Jahrhunderts dominierten. Heutzutage schätzen Fans historischer Kleidung und Dandys den Boater wegen seiner Retro-Anmutung. Er stellt als Herrenkopfbedeckung in den wärmeren Monaten eine originale Alternative zum Panama-Hut, zum Trilby aus Stroh oder dem Baseballcap dar. Der Boater eignet sich sehr gut für Leute mit rundem Gesicht, kann aber auch von allen anderen getragen werden. Eine kurzärmelige Marinière (einem blauweißgestreiften Pullover) und der Boater ist die Uniform venezianischer Gondolieri.

The boater

The sight of a boater hat inevitably conjures up images of summer fun and relaxation. The fashion for this straw hat with its rounded brim and crown, and unmistakable flat top took off in the second half of the 19th century. The hat was initially worn by boatmen on the river Seine, in France, who ferried Parisians seeking fresh air and a few moments of Sunday rest along the banks of the river and its tributaries. Renoir and the other Impressionist painters, who frequented the "guinguettes" (drinking establishments on the waterside), immortalized these boatmen adorned with their straw hats in the midst of the dressed-up and cheerful Parisians. The simplicity and elegance of the boater quickly made it a popular summer hat for ladies and children as well as men. It was the counterpart of semi-formal winter hats such as the bowler hat or the homburg and could be worn with lounge suits as well as more casual clothing. Men in bathing suits could be seen wearing their boaters without looking awkward. A coloured ribbon around the wreath gave a more personal touch to this headgear that was worn, like all straw hats, from Easter to the beginning of November. In the 20th century, the joyful allure it conferred was put to good use by artists such as the French singer Maurice Chevalier or the American actors Buster Keaton and Fred Astaire. Coco Chanel preferred its clean design as opposed to the sophisticated and impractical ladies' hats that dominated women's fashion at the beginning of the 20th century. Nowadays, the boater provides a retro touch appreciated by proponents of period costume and dandies. More broadly, it offers an original alternative to the Panama hat, straw trilby, or baseball cap for covering a man's head during the warmer months. The boater is ideal for round faces, but it is suitable for all face types. Along with the short-sleeved marinières, the boater is one of the distinctive features of the Venice gondoliers.

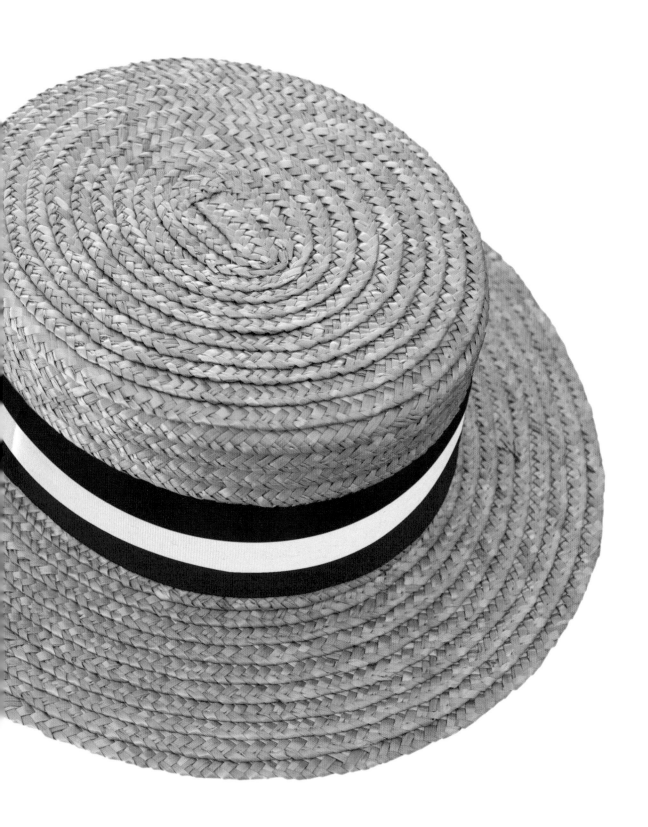

Die Melone (auch Bowler oder Derby)

Als James und George Lock von der Hutmacherfirma Lock & Co. in der St. James Street in London den Auftrag erhielten, für die Wildhüter von William Coke III. Hüte zu entwerfen, wussten die beiden nicht, dass einmal führende Politiker und Banker, aber auch Kutscher und Arbeiter diese Hüte mit runder Krone und schmaler Krempe tragen würden. Die Hüte waren das Markenzeichen der Komiker Charlie Chaplin, Stan Laurel und Oliver Hardy, aber auch Teil der Volkstracht der Aymara-Frauen in Bolivien. Kein anderer charakteristischer Hut, nicht einmal der Fedora oder Panama, hat eine so einzigartige Geschichte wie die Melone.

Im Jahr 1849 bestellte Lord William Coke III. einen stabilen Filzhut, der sich besser für die Jagd im Wald eignen würde als der Zylinder, der bis dahin auf der Jagd getragen wurde. Der neue Hut sollte robust, aber auch elegant sein und gut sitzen. Die runde Krone ging offenbar auf einen Vorschlag des Kunden zurück. Die Lock-Brüder beauftragten ihre Hutmacher, die Brüder Thomas und William Bowler, einen Prototyp anzufertigen. Seine Stabilität überzeugte Lord Coke. Absichtlich trat er auf den Hut, der anschließend seine ursprüngliche Form zurückschnellte. Die Stabilität der Melone und die Tatsache, dass sie unverrückbar auf dem Kopf ihres Trägers saß, trugen zu ihrem enormen Erfolg bei Reitern bei. Deswegen heißt die Melone in England auch Derby, weil sie beim jährlichen Pferderennen in Epsom (benannt nach dem Gründer, dem 12. Earl of Derby) getragen wird.

Auch die Städter nahmen diesen Hut rasch an. Sie tauschten ihre unpraktischen Zylinder gegen diesen Hut ein, weil er gentlemanlike und modern wirkte. Er entsprach sowohl dem Dresscode als auch dem allgemeinen Trend, sich durch einen individuellen Stil auszuzeichnen. Innerhalb von wenigen Jahrzehnten trugen alle Melonen. Die ursprünglich flache Krempe war inzwischen leicht nach oben gebogen, um eleganter zu wirken. Dieses Modell war eines der Symbole der Belle Époque: Die Melone war der Lieblingshut eines der bekanntesten Pariser Maler dieser Zeit, Henri de Toulouse-Lautrec.

Es heißt, dass eine für englische Eisenbahningenieure in Bolivien bestimmte Lieferung Bowler-Hüte zu klein ausgefallen war und deswegen an Frauen des Aymara-Stammes verkauft worden war. Diese hielten die Hüte für den letzten Schrei der Damenmode. Dass die Hüte so klein gewesen waren, könnte erklären, dass die Aymara-Frauen die Hüte weit oben auf dem Kopf und nicht wie eigentlich üblich in die Stirn gezogen tragen.

Viele Komiker trugen Melonen, um den Mann von der Straße lustig zu verspotten. Die Landstreicher-Verkörperung Charlie Chaplins

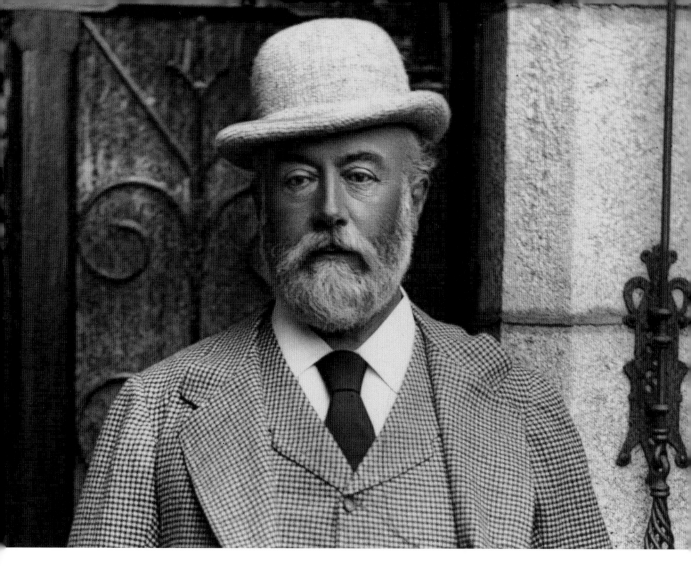

Gestrickte Melone,
1890er Jahre

Knitted bowler, 1890s

wurde von dieser Tradition inspiriert, aber der Spazierstock verlieh seiner Figur die Anmutung eines Gentlemans, der bessere Tage erlebt hat. Dieselben Accessoires werden von John Steed in der Fernsehserie *Mit Schirm, Charme und Melone* als Verkörperung des perfekten britischen Gentlemans verwendet. In Stanley Kubricks *Uhrwerk Orange* sind Melone und Stock die Uniform der Droogs, der Bande Alex DeLarges, die gegen die bestehende Ordnung rebellieren. Die Männer auf den Gemälden Rene Magrittes tragen Melonen und vermitteln als Medien zwischen Wirklichkeit und der Traumwelt des Surrealismus. Estragon und Wladimir in Samuel Becketts *Warten auf Godot* tragen sie ebenfalls.

Auch Londoner Banker tragen keine Melone mehr. Die Melone steht sie am Übergang zwischen klassischem und modernerem Hut wie Fedora oder Homburg. Diese beiden lösten in der ersten Hälfte des 20. Jahrhunderts ihren runden Rivalen ab.

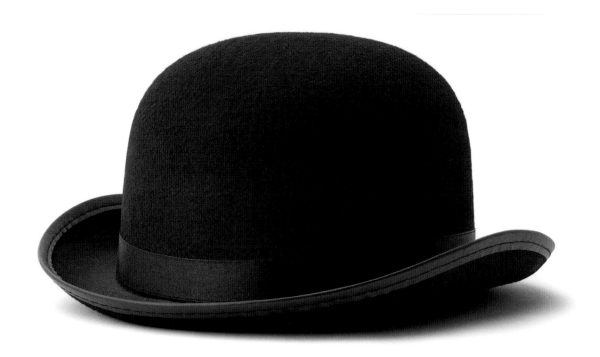

The bowler (aka Derby)

When James and George Lock, of the Lock & Co. hat shop at 6 St. James Street, were commissioned to create headwear for the gamekeepers of Lord William Coke II, they had no idea that this new hat, with its rounded crown and narrow brim, would one day be worn not only by leading politicians and bankers, but also by ordinary workers and cabdrivers; that it would become the distinctive signature of such famous comic artists as Charlie Chaplin or Laurel and Hardy; that it would, stranger still, be adopted as part of the costume of the Aymara women in Bolivia. No other iconic hat, not even the fedora or the Panama, has a story as singular as that of the bowler hat.

It was in 1849 that Lord William Coke III ordered a hard, felt hat that would be better adapted for hunting in the forest than the top hat that was then in use. The new hat had to be strong, elegant, and fit snugly. The idea of a round crown was apparently suggested by the client himself. The Lock brothers commissioned their hat-makers, brothers Thomas and William Bowler, to produce a sample. The sample passed the test of solidity imposed by Lord Coke who deliberately strode on it: the hat returned to its natural shape. The strength of the bowler hat and the fact that it always remained firmly on the wearer's head contributed to its initial success with horse-riders.

As a result, the bowler hat is also known as the "Derby" because it was the most common headgear at Epsom Downs horse races.

It was quickly adopted by the townspeople who exchanged their rather impractical top hats for the new hat that gave an air of respectability and modernity to those who wore it. It satisfied both the need to conform to the social codes of the time and the trend towards a more distinctive style. Within a few decades the bowler hat became everyone's headgear. With the passing of fashions, the original flat brim was embellished with a slight upward bend. This model with the curved brim became one of the symbols of the Belle Époque: it was the favourite hat of Henri de Toulouse-Lautrec, one of the most emblematic Parisian painters of this period.

It is said that a shipment of bowler hats destined for English railway engineers based in Bolivia did not find a buyer among the expatriates due to the hat's small circumference. In order to sell their merchandise, the importers decided to promote the hats to women of the Aymara tribe, who thought they had acquired the latest fashionable ladies' hat. This commercial ruse might explain why Bolivian women wear the bowler hat sitting on top of their heads rather than being worn further down onto the skull. Many comic artists added the hat to their repertoire in order to mimic and mock the ordinary man.

Charlie Chaplin's tramp is clearly inspired by this tradition, although the addition of a cane gives the character the air of a gentleman who has seen better days. In a completely different vein, the same accessories are found in a cult television series: *The Avengers*, where John Steed adopts the bowler hat and cane as symbols of the perfect British gentleman. Unlike in Stanley Kubrick's *A Clockwork Orange*, where the bowler hat and stick that make up the uniform of the *droogs*, Alex DeLarge's band, are symbols of rebellion against the established order. Also worth noting are the men in bowler hats painted by Rene Magritte as mediums between the ordinary world and the dreamlike universe of surrealism, and the characters in Samuel Beckett's *Waiting for Godot* who also wear bowler hats.

Although it has now fallen out of fashion, even among bankers in the City of London, the bowler has played a pivotal role between the very formal topper and more modern hats such as the Fedora or the Homburg, which both grew in popularity throughout the first half of the 20th century partly at the expense of their rounded rival.

Der Fedora (auch Borsalino)

Dieser Hut hätte den Namen „König der Hüte" verdient, weil er für den Mann zeitlose Eleganz verkörpert. Er wurde allerdings 1882 für eine Frau, für die Schauspielerin Sarah Bernhardt in der Rolle der Prinzessin Fédora Romazoff aus dem gleichnamigen Theaterstück von Victorien Sardou entworfen.

Der Fedora ist mühelos an seiner breiten Krempe und an der nach unten geknickten und an der Vorderseite beidseitig eingekniffenen Krone zu erkennen. Ein Hutband unterschiedlicher Breite (schmaler in Europa, breiter in Nordamerika) und zur Farbe des Hutes passend schmückt die Krone. Dieser neue

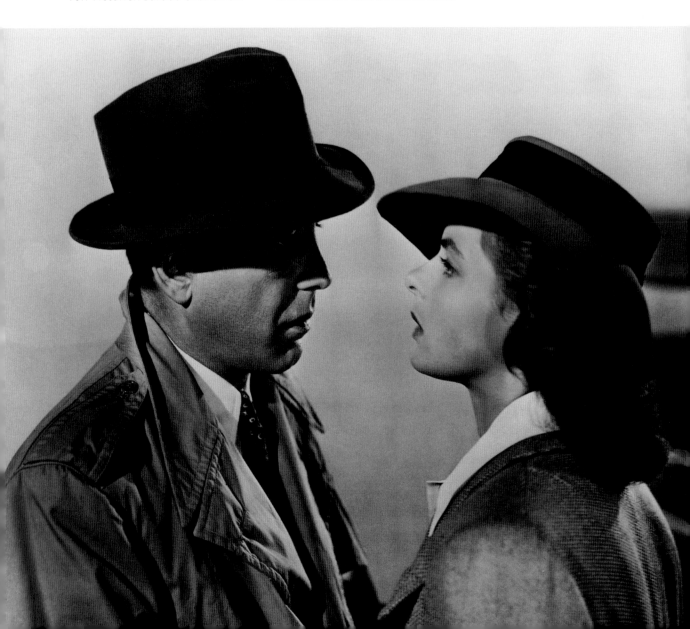

Hut begeisterte Oscar Wilde, einen der elegantesten Männer seiner Zeit. Er trug einen Fedora auf seiner überaus erfolgreichen Vorlesungsreise durch die USA in den Jahren 1882 bis 1883. Es dauerte jedoch bis in die 1920er Jahre, bis der Fedora die Melone ablöste. Dafür war ein anderer englischer Dandy verantwortlich, Prinz Edward von Wales, der zukünftige Herzog von Windsor. Der modische Hut setzte sich bei den unterschiedlichsten Kreisen durch, bei den orthodoxen Juden, die seither immer einen schwarzen Fedora tragen, bei den Gangstern der Prohibitionsära wie Al Capone und seiner Gefolgschaft und bei Hollywoodregisseuren, die die Hauptdarsteller mit ihm ausstaffierten. Auch schon vor Humphrey Bogarts legendärem Fedora (und seinem nicht weniger ikonischem Trenchcoat) in *Casablanca* von 1942 trugen Hauptdarsteller ab etwa 1920 Fedora, unter anderem Fred Astaire, Cary Grant, James Cagney, George Raft, Peter Lorre, Henry Fonda und Gary Cooper. Bis 1940 verkaufte die Firma Stetson, eine der führenden Hutfabriken der USA über zwei Millionen ihrer Playboy-Fedoras, die in über dreißig verschiedenen Farben gefertigt wurden. Sie wurden als Hut für „Sportler, Anwälte und Ärzte, Geschäftsleute, College-Professoren, Hollywood-Stars und die Kaffeehaus-Klientel" beworben, also die gehobene Mittelklasse.

Der Fedora büßte wie alle anderen klassischen Hüte in den 1960er Jahren an Beliebtheit ein, erlebte aber schneller als alle anderen in den frühen 1980er Jahren ein Revival. Was besonders den Blues Brothers, dem Filmhelden Indiana Jones mit seinem staubigen braunen Fedora und dem charakteristischen schwarzen Fedora Michael Jacksons zu verdanken war. In *Smooth Criminal* hebt Jackson nicht nur die Gesetze der Schwerkraft auf, indem er sich 45 Grad nach vorne lehnt, er tut das noch dazu mit einem weißen Fedora mit einem schwarzen Band.

Einer der Vorteile des Fedora ist seine zeitlose Vielseitigkeit. Abhängig vom Modell kann die Größe der Krone, die Tiefe der Kniffe, die Breite und Farbe des Hutbands unendlich variieren. Jeder wird einen Fedora finden, der ihm gefällt. Die häufigsten Farben sind grau, blau, grün, dunkelbraun oder schwarz, ein buntes Hutband kann dem Hut einen originellen Touch und Einzigartigkeit verleihen. Einen Fedora kann man sowohl zu Jeans und T-Shirt als auch zu einem Dreiteiler tragen. Der Fedora passt sich allen Stilen an und wirkt nie unvereinbar mit der übrigen Kleidung. Der Fedora wird wegen des authentischen Vintage-Looks gerne in 2nd-Hand-Läden erstanden. Filz ist der Wolle vorzuziehen. Alle Hutfabriken produzieren Fedoras, die berühmtesten sind jedoch die des italienischen Herstellers Borsalino. In etlichen europäischen Ländern wird der Name Borsalino synonym mit Fedora verwendet.

The fedora (aka Borsalino)

The fedora would rightly deserve the nickname "king of men's hats" as it embodies timeless male elegance. And yet the hat was first designed for a fictional female character, Princess Fédora Romazoff, the title role in a play by Victorien Sardou, which was performed by the famous French actress Sarah Bernhardt in 1882.

The hat is easily recognisable by its rather wide brim and its crown, which is both creased and pinched on the front sides. A circular ribbon of variable width (narrower in Europe, wider in North America) in a colour matching the hat adorns the bottom of the crown. The new hat immediately attracted the attention of Oscar Wilde, one of the most elegant men of his time, who wore one on a triumphant lecture tour of the United States in 1882 and 1883. However, it wasn't until the 1920s that the fedora took over men's fashion at the expense of the bowler hat, partly under the influence of another English dandy, Prince Edward of Wales, the future Duke of Windsor. This newly fashionable hat conquered audiences as diverse as orthodox Jews, who have since worn a black fedora, gangsters enriched by Prohibition, such as Al Capone and his gang, and Hollywood directors who chose it to style the leading actors of the time. Even before Humphrey Bogart's legendary fedora (and no less iconic trench) in *Casablanca* elevated it to the status of a must-have in men's elegance, most of Hollywood's leading male actors from the 1920s to 1950s were spotted with fedoras, including, but not only, Fred Astaire, Cary Grant, James Cagney, George Raft, Peter Lorre, Henry Fonda, and Gary Cooper. By 1940, Stetson, one of America's leading hat makers had sold more than two million of his *Playboy* fedora and offered it in more than thirty different hues. It was advertised as the hat for "sportsmen, professional men, businessmen, college men, Hollywood stars, and café society", thus embracing most of the upper-middle class.

The fedora suffered the same decline as other classic hats in the 1960s, but picked up again more quickly than the others in the early 1980s, thanks in particular to the Blues Brothers, to the character of Indiana Jones with his trademark dust-covered brown fedora, and to Michael Jackson, whose black fedora became a signature style. In *Smooth Criminal*, Jackson not only defies gravity by leaning forward at a 45-degree angle, but so does his white fedora with a black band.

One of the advantages of the fedora is its timeless versatility: depending on the model, the size of the crown, the depth of the pinches, the width and colour of the headband can all vary infinitely. Everyone will find a fedora to his or her taste. The most

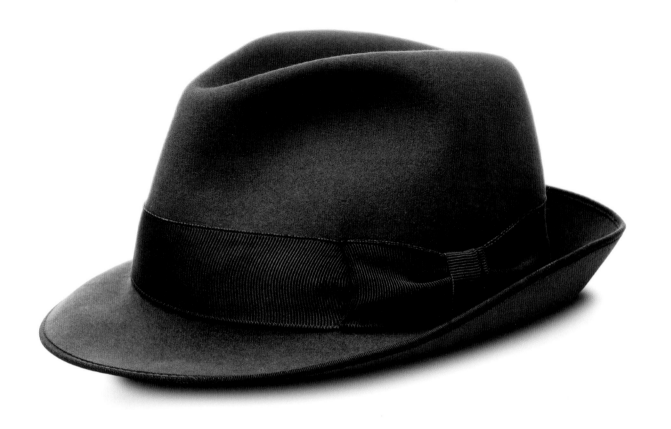

common colours are grey, blue, green, dark brown or black, however a bright hue, for example on the headband, can add a touch of originality and singularity. The fedora can be worn with a t-shirt and jeans as well as with a three-piece suit, it adapts easily to all styles without appearing inconsistent with the rest of your clothing. Some men choose their fedora in second-hand shops for the vintage and authentic look of an old felt fedora, a material that should be favoured over wool. Although all hat-makers have fedoras in their portfolio, the most famous are those of the Italian company Borsalino, whose name has actually become synonymous with fedora in several European countries.

Der Gaucho-Hut

Die Viehtreiber in Argentinien und Uruguay tragen diesen Hut seit Ende des 18. Jahrhunderts. Er besteht aus drei gerundeten Elementen: einer flachen, breiten gerundeten Krempe, einer flachen leicht gerundeten Krone, und einem gerundeten Deckel. Traditionell wird er aus schwarzem Filz hergestellt und mit einem schlichten Band, ebenfalls in Schwarz, dekoriert. Er hat zwei Bänder, die unter dem Kinn zusammengebunden werden, damit er dem Reiter, der über die Ebene galoppiert oder von einer eine Windbö überrascht wird, nicht davonfliegt. Sein breiter Rand bietet willkommenen Schatten auf der Steppe, der Pampa, beeinträchtigt jedoch nicht die Sicht seines Trägers. Der Filz ist wasserabweisend und schützt besser vor Regen und Staub als ein Sombrero, dem Hauptkonkurrenten des Gaucho-Huts im ländlichen Lateinamerika. Der Gaucho-Hut wird manchmal auch als Bolero bezeichnet, obwohl dieser eher die Damenversion dieses Hutes ist, der die Sängerin Beyoncé zu einer Renaissance verholfen hat. Der Gaucho-Hut lässt seinen Träger nicht nur exotisch und schwungvoll erscheinen, sondern wegen seiner einfachen und symmetrischen Gestaltung auch zeitlos-elegant. Diese Eigenschaften haben ihn zur charakteristischen Kopfbedeckung Zorros, dem legendären maskierten Rächer, gemacht. Er wurde 1920 von Douglas Fairbanks auf der Leinwand und anschließend von Tyrone Power, Guy Williams in der bekannten Disney-Serie und schließlich 1998 erneut im Kino von Antonio Banderas dargestellt. Das Tragen eines Gaucho-Huts garantiert Eleganz und Originalität, aber manch einer könnte auf den Gedanken kommen, dass man sich auf dem Weg zu einem Kostümball befindet.

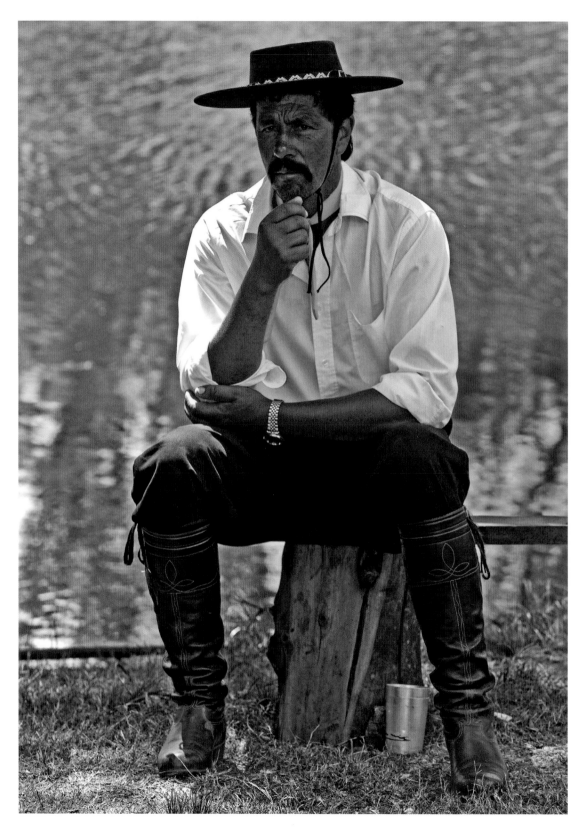

The gaucho hat

Worn since the end of the 18th century by cowhands in Argentina and Uruguay, the Gaucho hat consists of three rounded elements: a flat, wide brim, a shallow, sometimes slightly conical crown, and a flat top. It is traditionally made of black wool felt and soberly decorated with a ribbon of the same colour. Two straps allow it to be tied under the chin to secure it for galloping across the plains or to protect against gusts of wind. Its wide edge provides welcome shade in the grasslands and plains, while not obstructing the wearer's view. Its felt fends off rain and dust more effectively than does a sombrero, its main rival in rural Latin America. The Gaucho hat is sometimes known as the "bolero" although the latter is more associated with the female version of the hat that singer Beyoncé has revived. While it confers an exotic air and a certain panache to its wearer, the Gaucho hat is also timelessly elegant thanks to its simple and proportionate shape: all these qualities have made it the emblematic headgear of Zorro, the legendary masked vigilante played successively on the screen by Douglas Fairbanks in 1920, then by Tyrone Power, by Guy Williams in the iconic Disney series, as well as by Antonio Banderas in 1998. Wearing a Gaucho hat guarantees a certain amount of stylish originality, even if some people might think you're going to a fancy-dress ball.

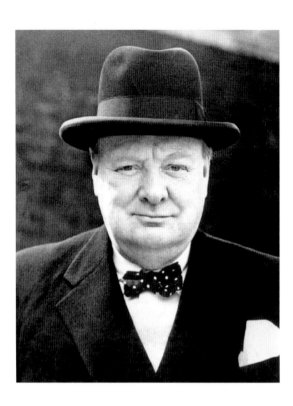

Während der junge Politiker Winston Churchill Zylinder bevorzugte, sah man den späteren korpulenteren Premierminister oft mit einem Homburg

While young politician Winston Churchill favoured top hats, the more corpulent Prime Minister was often seen sporting a Homburg

Der Homburg The Homburg Hat

Um 1880 war der Kurort Bad Homburg vor der Höhe in der Nähe von Frankfurt am Main beim europäischen Hochadel sehr beliebt. Zu den Kurgästen gehörten der zukünftige deutsche Kaiser Wilhelm II. und der Prinz von Wales, Albert Edward, der zukünftige Edward VII., der sich bereits als Wegbereiter der Mode einen Namen gemacht hatte, was seine eher asketische Mutter, die Queen Victoria, wenig erfreute. Albert Edward, dessen Vater Albert ein Prinz von Sachsen-Coburg und Gotha gewesen war, trank das berühmte Heilwasser und genoss

In the early 1880s, the spa town of Bad Homburg von der Höhe, near Frankfurt, was a popular destination for the European aristocracy. Guests included the future German Emperor, Wilhelm II, and the then Prince of Wales, Albert Edward (the future Edward VII), who had already earned the status of fashion icon for his particular elegance, to the dismay of his rather austere mother, Queen Victoria. Albert Edward, whose father Albert was from the German princely house of Saxe-Coburg and Gotha, equally enjoyed the famous healing waters and the social gatherings

die Geselligkeit. Im August 1882 besuchte der Prinz die 1806 in Bad Homburg von Philipp Möckel gegründete exklusive Hutfabrik, in der man ihm einen Hut zum Geschenk machte, der einem traditionellen deutschen Jägerhut glich, wie sie sein Neffe Wilhelm schätzte. Statt des üblichen ländlichen Grün war der neue Hut städtischgrau und hatte eine charakteristische Form: die große runde Krone hat einen Mittelkniff und die eingefasste Krempe ist elegant hochgebogen. Albert Edwards neuer Hut wurde vom Adel sofort begeistert angenommen, und wurde *de rigueur* für Adelige, Politiker und Diplomaten. Man assoziierte ihn allgemein eher mit älteren Männern. Der junge elegante Winston Churchill trug häufig einen Zylinder, aber als älterer Premierminister einen Homburg. Konrad Adenauer, der erste Kanzler der Bundesrepublik verhalf dem schwarzen Homburg zu seinem Durchbruch und beeinflusste vermutlich Präsident Dwight D. Eisenhower, der nach seiner Wahl im Januar 1953 nicht wie alle seine Vorgänger am Tag seines Amtsantritts einen Zylinder trug, sondern den weniger altmodischen Homburg.

Unter den fiktiven Gestalten in Homburg ist Agatha Christies Hercule Poirot vermutlich der berühmteste. Im *Paten* trägt der junge Al Pacino einen hellgrauen Homburg mit einem schwarzen Band mit Schleife, der anschließend auch als der Hut des Paten bezeichnet wurde. In *Downtown Abbey* trägt

Robert Crawley, der Earl of Grantham eine Homburg-Variante, einen Hut dessen Krone seitlich eingedrückt ist und dessen Krempe keine Borte hat, dieser Hut wird als „Lord's Hat" bezeichnet.

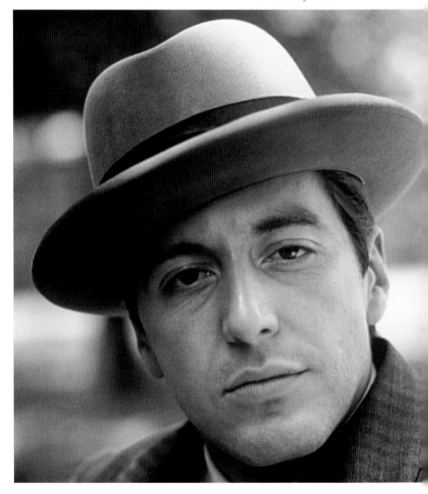

Al Pacino trug zu einer kurzen Wiederbelebung des Homburger Hutes bei, so dass er in den frühen 1970er Jahren in "Der Hut des Paten" umbenannt wurde

Al Pacino contributed to a short revival of the Homburg hat, re-branded "The Godfather's hat" in the early 1970s.

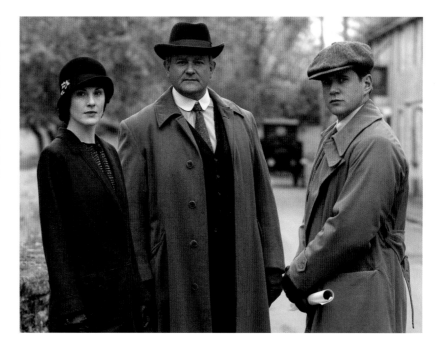

the town offered. During one of his stays, in August 1882, the Prince of Wales was reported to have visited the exclusive hat factory founded in 1806 by Philipp Möckel in the town, where he was presented with a hat that resembled traditional German hunting hats, of which Albert Edward's nephew, Wilhelm, was particularly fond: but instead of the traditional countryside-green colour, the new hat was urban-grey, with its characteristic "gutter crown" formed by its centre crease on its tall, round crown, and an elegantly curled-up brim. Albert Edward's new hat was instantly adopted by the gentry, and became the headgear *de rigueur* for aristocrats, politicians, and diplomats, and its look was generally associated with older men. Young and elegant Winston Churchill would frequently wear a top hat, while as an ageing prime minister he invariably was sporting his iconic homburg. Germany's

first post-war chancellor, Konrad Adenauer, made black homburg hats fashionable, thus probably influencing President-elect Dwight D. Eisenhower, who, in January 1953, decided to break with tradition and replace the black top hats, all US presidents before him wore on their inauguration days, with a less outdated homburg.

Among fictional characters Agatha Christie's Hercule Poirot is arguably among the most famous homburg hat wearers. In *The Godfather*, young Al Pacino is seen in a pale grey homburg with a black band and bow, which was subsequently called "The Godfather's hat". In *Downton Abbey*, Robert Crawley, Earl of Grantham, wears a variant of the Homburg hat with its crown pinched on its sides, and without an edge ribbon: it is – quite conveniently – known as the "Lord's hat".

Der Panamahut

Der Panamahut, der auch als „Prinz der Strohhüte" gilt, hat einen irreführenden Namen, da er ursprünglich aus Ecuador oder noch genauer aus der Küstenregion zwischen den Hafenstädten Manta und Guayaquil kommt. Die Kleinstadt Jipijapa wird oft als Geburtsort des Panamahutes genannt. Dort wurde er bereits im 17. Jahrhundert hergestellt. Heute kommen die besten Hüte aus dem Dorf Pile unweit von Manta, die Montecristi. Sie werden von Hand gewebt und bestehen aus dem Stroh des Toquilla (Carludovica palmata), einer Pflanze, die bis zu zweieinhalb Meter hoch werden kann. Als erstes wird immer die Krone und deren Mittelrosette gewebt. Die Hutmacher brauchen zum Weben der besten Hüte mehrere Monate. Bei der Ausführung des Gewebes wird zwischen fino und superfino unterschieden. Das Stroh muss außerdem einheitlich elfenbeinfarben sein. Einen guten Panamahut kann man falten, ohne dass er beschädigt wird. Es heißt, die besten Panamahüte hätten sich in großen Streichholzschachteln verwahren lassen. Das sollte man jedoch besser nicht ausprobieren. Seit dem frühen 19. Jahrhundert erfreute sich der Panamahut in Zentralamerika, Kuba und im Süden der Vereinigten Staaten großer Beliebtheit. Nach Europa kam er durch die Weltausstellung in Paris im Mai 1855 mit einem französischen Geschäftsmann, der in Panama lebte. Dieser Philippe Raimondi verkaufte innerhalb weniger Tage alle seine Hüte. Der unmittelbare Erfolg beweist das große Faible der Pariser für diese elegante sommerliche Kopfbedeckung. Der Panamahut, wie der neue Hut getauft wurde, erfreute sich auch bei den Royals großer Beliebtheit. Kaiser Napoleon III. und der zukünftige König Edward VII. trugen ihn mit Begeisterung. Der Panamahut war der perfekte Schmuck in den schicken Badeorten an der französischen Riviera, auf Capri, in Griechenland und Ägypten, wo auch immer die Wohlhabenden der Belle Époque sein geringes Gewicht und den Schutz vor der heißen Sonne zu schätzen wussten. In der ersten Hälfte des 20. Jahrhunderts erfreute sich der Hut zunehmender Beliebtheit und machte in den 1940er Jahren in Ecuador dem Kakao den Rang als wichtigster Ausfuhrartikel streitig. Ein Panamahut mit einem schwarzen Hutband ließ sich an Eleganz nicht übertreffen. Viele Hollywoodschauspieler wie Clark Gable und Humphrey Bogart trugen exklusive Panamahüte. Preise für einen Montecristi bewegen sich im vierstelligen Bereich, da es nur noch wenige Weber gibt, die die schwierige Technik des Handwebens beherrschen. Die Panamahüte, die in Cuenca, 400 km südlich von Quito hergestellt werden, sind weitaus erschwinglicher und nicht weniger elegant.

The Panama hat

The Panama hat, which has earned the title of "Prince of Straw Hats", has a somewhat misleading name: it actually originates from Ecuador or, more precisely, from the coastal region bounded by the port cities of Manta and Guayaquil. The small town of Jipijapa is often considered the birthplace of the Panama hat, where it was woven as early as the 17th century. Nowadays, it is in the village of Pile, near Manta that the finest pieces, the Montecristi, are produced. Woven by hand, the Montecristi are made from the straw of the toquilla (Carludovica palmata), a native plant that can grow up to 2.5 metres (8 ¼ ft) high. The weaving invariably begins with the crown, whose central rosette is

assembled first. Craftsmen some-times need several months to weave the best hats, which can be recognized by the fineness of the weave (fino or superfino) as well as by the uniform ivory colour of the straw. An authentic Panama hat can be folded and unfolded without being damaged: it is even said that the best specimens can be stored in a large matchbox, although no one is likely to try this. Popular headgear throughout Central America, Cuba and the southern United States since the beginning of the 19th cen-tury, the Panama hat was launched in Europe at the Universal Exhibi-tion in Paris in May 1855, thanks to a French businessman living in Panama, Philippe Raimondi, who sold all the pieces he had brought with him within a few days. This im-mediate success is testimony to the infatuation of Parisians for this light and elegant summer headgear. The Panama hat, as the new fashionable accessory was called, conquered even royal heads: Emperor Napo-

leon III, as well as the future King Edward VII, enthusiastically adopt-ed it. It was the perfect adornment at the fashionable resorts of the French riviera, to Capri, Greece or Egypt, where the wealthy classes of the Belle-Époque enjoyed the hat's lightness and shelter from the hot sun. The Panama enjoyed a grow-ing popularity throughout the first half of the 20th century such that it competed with cacao as Ecuador's leading export product in the 1940s: wearing a Panama with a band of black cloth around its crown was the epitome of elegance, and many Hollywood actors, including Clark Gable and Humphrey Bogart, were known for sporting exquisite Panama hats. While the Montecristi can reach a 4-digit-price, since few weavers are able to master the del-icate art of hand-weaving hats, the Panama hats produced in Cuenca, a city 400 kilometres (250 miles) south of Quito, offer a more afford-able, but no less elegant option for an authentic Panama.

Der Porkpie

Dieser Hut ist an seiner niedrigen Krone, schmalen Krempe und am Rand eingekerbten platten Deckel zu erkennen. Die Krone ziert ein Hutband. Er verdankt seinen Namen der Ähnlichkeit mit der Pastete, die im 18. und 19. Jahrhundert in England sehr beliebt war. Eine kleinere Version wurde von Damen getragen, bevor sich der Hut ab Mitte des 19. Jahrhunderts auch bei den Herren durchsetzte. Er war weniger beliebt als die Melone oder der Fedora und erlebte seine Blütezeit dank des Komikers Buster Keaton in den 1920er Jahren. Dieser machte den Porkpie zu seinem Markenzeichen so wie Charlie Chaplin die Melone. In den Vereinigten Staaten wurde der Porkpie vorzugsweise von College Studenten getragen. Sie wollten mit ihm originell und nonchalant wirken. Allerdings blieb der Boater der bevorzugte Hut für alle Freizeitaktivitäten. Der Porkpie wurde Anfang der 1930er Jahre auch von afroamerikanischen Jazz- und Bluesmusikern getragen, der Zeit der Prohibition und das goldene Zeitalter der illegalen Bars in den USA. In den 1940er und 1950er Jahren war der Jazz-Saxophonist Lester Young einer der bekanntesten Porkpie-Träger. Kurz nach seinem Tod komponierte der Bassist seiner Band den Song *Good Bye Pork Pie Hat*. Der Porkpie war bis in die frühen 1970er Jahre in Mode: Robert De Niro trug ihn in im Film *Hexenkessel* und Gene Hackman in *Brennpunkt Brooklyn*. Nach einer Pause von fast dreißig Jahren hat der Porkpie dank der Hipster ein dauerhaftes Comeback erlebt. Der Hersteller von Luxushüten Optimo aus Chicago hat sogar in einer begrenzten Auflage von 150 Exemplaren den von dem Architekten Frank Lloyd Wright getragenen Porkpie hergestellt.

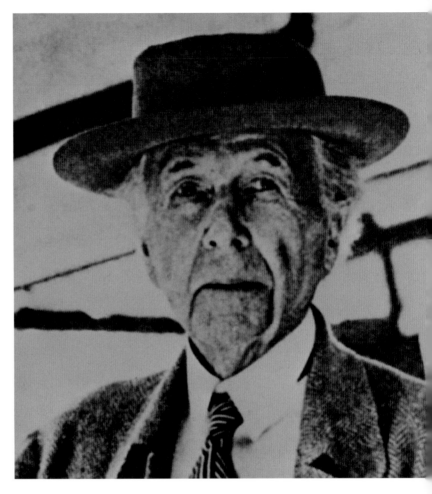

Der unverkennbare Porkpie des Architekten Frank Lloyd Wright

Architect Frank Lloyd Wright's iconic porkpie hat

The porkpie hat

This round hat is easily recognizable by its rather short brim and low crown. A circular, or sometimes diamond-shaped crease runs around the inside of the flat top edge and a ribbon adorns the crown. It owes its name to its likeness to a pork pie, a popular English savoury in the 18th and 19th centuries. It was worn by ladies, in a smaller version (truly resembling a portion of pork pie) for a long time before becoming a men's hat from the middle of the 19th century. Although less popular than the bowler or the fedora, the pork pie hat had its heyday in the 1920s thanks to the comic actor, Buster Keaton, who made it his trademark accessory, like Charlie Chaplin's bowler. In the United States, the pork pie was the favourite headgear of college students. It gave them an air of originality and nonchalance, as if the roundness of the pork pie not unlike that of the boater, the hat of leisure activities

par excellence. The hat was later adopted by African American jazz and blues musicians during the Jazz Age of the early 1930s, which also coincided with the period of prohibition and the golden age of speakeasies. In the 1940s and 1950s, jazz saxophonist Lester Young was one of the most famous jazzmen who wore a pork pie. Shortly after Young's death, his fellow bassist, Charles Mingus, even composed an elegy to him called *Goodbye Pork Pie Hat*. It was still in fashion in the early 1970s: Robert DeNiro in Mean Streets and Gene Hackman in The French Connection can be seen in pork pie hats. After an eclipse of almost thirty years, the pork pie has made a lasting comeback in men's clothing thanks to hipsters. The Chicago-based, luxury hat maker Optimo has even reissued an iconic pork pie, the one worn by famous architect Frank Lloyd Wright, in a limited edition of 150 pieces.

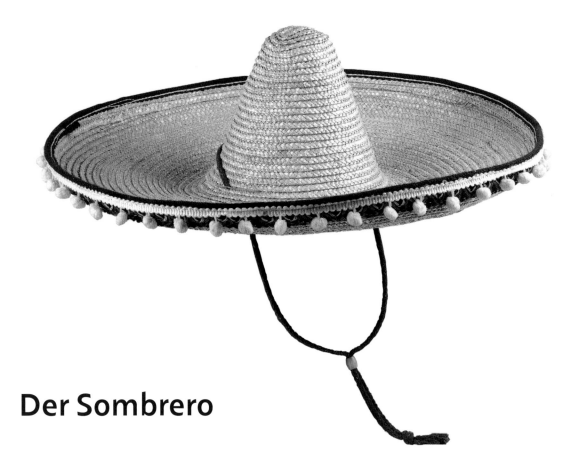

Der Sombrero

Im Zeitalter der globalen Erwärmung könnte sich dieser Hut, das Wahrzeichen Mexikos, bald überall auf Welt durchsetzen. Der Sombrero eignet sich perfekt für sonnige, trockene Gefilde und für jede Wüste oder Halbwüste dieser Erde. Seine Krempe ist sehr breit und am Rand leicht hochgebogen. Er schützt nicht nur den Kopf, sondern auch Schultern und Oberkörper vor den starken Sonnenstrahlen. Die konische Form der Krone entspricht der des Kopfes. Mit zwei Bändern lassen sich unter dem Kinn zur Schleife binden, was bei starkem Wind Tagen oder auf dem Pferderücken sehr nützlich sein kann. Sombreros werden aus Stroh oder aus Filz hergestellt. Strohsombreros werden je nach der Anzahl der verarbeiteten Strohstreifenpaaren eingeteilt. Die üblichsten heißen Quiciano, sie bestehen aus bis zu 15 Streifenpaaren, Qualitätssombreros wie der Veintiuno oder der Veintisiete bestehen aus 21 bzw. 27 Paaren. Flechtmuster bei Strohsombreros und Stickereien auf Filzsombreros werden besonders von mexikanischen Mariachi-Musikern geschätzt. Der Sombrero eignet sich hervorragend für Tage am Strand, für Bergwanderungen, beim Reiten in der Ebene und bei längerer Gartenarbeit. In der Stadt kann ein Sombrero selbst im Hochsommer exzentrisch wirken.

The sombrero

In an age of global warming, the sombrero, Mexico's national headgear, may become just as popular outside of Mexico. The hat is perfectly suited to sunny and arid regions, in fact, for any desert or semi-desert area around the globe. Its very wide brim with slightly upturned ends not only protects the head, but also shields the shoulders and the entire torso from the strong sun. The sombrero's conical crown fits the shape of the skull well. In addition, two straps allow the sombrero to be secured under the chin, which is very useful on windy days or horseback riding. Sombreros are made of straw or felt. Straw sombreros fall into different categories according to the number of pairs of straw strips used: the most common, the Quiciano, is made up of fifteen pairs of strips; while a high-quality sombrero, such as the Veintiuno or Veintisiete, will have twenty-one and twenty-seven pairs respectively. Ornamental patterns on straw sombreros and embroidery on felt sombreros add a certain touch of refinement that is particularly valued by the traditional Mexican Mariachi musicians. The sombrero is an ideal companion for days at the seaside, for hiking in the mountains, for horse riding on open plains, or for long gardening sessions. If worn in the city, even in the middle of summer, you might be seen as eccentric.

Der Zylinder

Sofern man kein Zauberer, Bestattungsunternehmer oder Mitglied des Königshauses bei der Eröffnung eines Bahnhofs ist, wirkt man mit einem Zylinder anachronistisch und wie ein Dandy. Natürlich gibt es noch weitere Ausnahmen: Bei der eigenen Hochzeit unterstreicht ein Zylinder die Feierlichkeit des Tages, ist aber auch ein Tribut an die Ära der Romantik, an das goldene Zeitalter der Zylinder. Er wurde von den *Incroyables* getragen, den *Nouveaux Riches* und Gegnern der Revolution im Paris der 1790er Jahre während der Herrschaft des Terrors. Der Zylinder war Teil einer bizarren Mode, ein Protest gegen die schlichte Kleidung, die während der Revolution vorherrschte. Ein hoher Zylinder ließ seinen Träger größer, wichtiger und würdevoller erscheinen, was seine große Beliebtheit in der westlichen Welt erklärt. Er ersetzte für den modebewussten Mann bald den Zweispitz. Die Krempe des Zylinders war an den Seiten leicht nach oben gebogen, und er ließ sich deswegen relativ mühelos mit einer Hand ziehen, wenn das erforderlich war. Anfang des 19. Jahrhunderts wurden überall Zylinder getragen. Gemälde von Straßenszenen und Modebilder zeigten unweigerlich Männer aller Klassen mit Zylindern auf dem Kopf. Eines der berühmtesten Beispiele ist der junge Mann im Vordergrund von Eugène Delacroix' Gemälde *Die Freiheit führt das Volk* von 1830. Der teure Bieberpelzfilz der ersten Zylinder

The Top Hat

Unless you are a magician, an undertaker, or a member of a royal house on official duty, wearing a top hat today would look at best dandyish and anachronistic. There is, of course, one more exception, which is on your wedding day where it will not only underline the solemnity of the day, but also pay tribute to the romantic era; the golden age of top hats. A distinctive feature of the *Incroyables*, the class of anti-revolutionary, Parisian *nouveaux riches* that emerged after the Reign of Terror in the early 1790s, the top hat was part of the outlandish style promoted by the new generation as a protest against the austere dress code that prevailed during the Revolution. By increasing the wearer's height, the high crown conferred an air of importance and dignity, which contributed to the instant popularity of the top hat throughout the Western world. It would soon replace the bicorne as the attribute of the fashionable man. With its brim curved slightly upward on the sides, the top hat was relatively easy to raise with one hand whenever social etiquette required it. By the early 1800s, the hat had become ubiquitous: fashion illustrations and paintings of street art scenes would invariably show men of all social classes with top hats on their heads. One of the most famous examples is the young man in the foreground of Delacroix's *Liberty Leading the People* (1830). The expensive beaver fur felt that adorned the first top hats

Fred Astaire im Film Top Hat, *1935*

Fred Astaire in Top Hat, *1935*

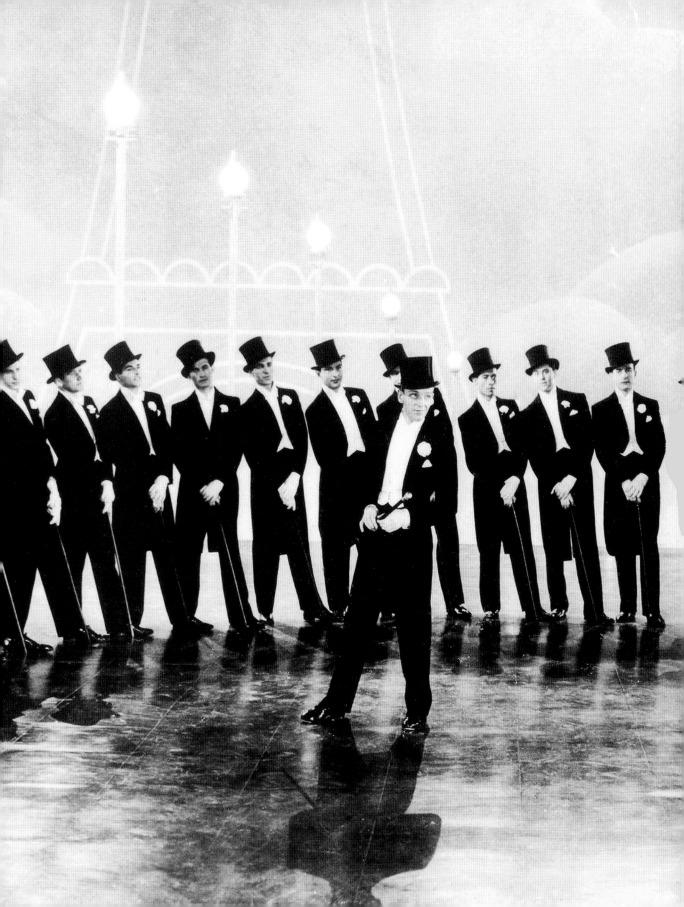

wurde allmählich von billigerer Seide abgelöst, was zu der Verbreitung der Hüte beitrug, bis sie von den bequemeren und weniger auffälligen Melonen, die von der Arbeiterklasse und Mittelklasse getragen wurden, in der Mitte des 19. Jahrhunderts abgelöst wurden. Der Zylinder war nun nicht mehr eine von allen getragene Kopfbedeckung, sondern die der Reichen und Mächtigen. Es waren die Herren der Belle Époque, die von Toulouse-Lautrec und Degas gemalt wurden, Politiker und Diplomaten trugen sie wie einen Orden. Man kann sich keinen Filmstar und Tänzer wie Fred Astaire ohne weiße Krawatte, Frack, Stock und Zylinder vorstellen. Bis in die frühen 1950er Jahre war der Zylinder die förmliche Kleidung eines Gentlemans.

In der Oper und in Music Halls war er *de rigueur*. Im Lauf der Jahrzehnte entwickelten sich zwei Zylinder: mit plattem Deckel (stovepipe hat), den Präsident Abraham Lincoln unsterblich machte, und mit nach innen gewölbtem Deckel, der sich etwas angenehmer trug. Zylinder waren allerdings nie für ihren Tragekomfort bekannt oder dafür, praktisch zu sein. Die französischen Hutmachern Antoine und Gabriel Gibus haben vermutlich den Klappzylinder erfunden, den *Chapeau claque*, der auch als Opernhut bezeichnet wurde, weil er während eines Opern- oder Theaterbesuchs bequem zu verstauen war. Der *Chapeau claque* durfte jedoch nicht bei anderen Anlässen oder am Morgen getragen werden.

The Parisian hat-makers, Gibus brothers, are credited for the invention of the chapeau-claque or opera hat

The Parisian hat-makers, Gibus brothers, are credited for the invention of the chapeau-claque or opera hat

gave gradually way to more affordable silk top hats, thus contributing further to its popularity, at least until the more comfortable, and less ostentatious bowler was adopted by the working and middle classes in the second half of the century. From the most common headgear, the topper transformed into the hat of the wealthy and powerful: the men of the Belle-Époque painted by Toulouse-Lautrec and Degas wore top hats, as would politicians and diplomats who would wear it as a badge of honour. One cannot imagine movie star and dancer, Fred Astaire, without a white tie, a tailcoat, a stick and a top hat. It was still part of the gentleman's formal attire well until the early 1950s, and *de rigueur* at operas and music halls.

The top hat is now reserved to ritual ceremonies and high society events, and is unlikely to make a comeback to the catwalks. Two styles of top hats developed over the decades: one with a straight crown, commonly known as the stovepipe hat, which President Abraham Lincoln immortalised, and the other with concave edges: the latter shape made wearing such a hat a bit easier and more comfortable, although the top hat was never reputed for its comfort, nor for its practicality. French hat-makers, Antoine and Gabriel Gibus are credited for the invention of the foldable top hat, *the chapeau-claque,* also called the opera hat, as it could be conveniently stored by the owner while attending theatre or opera. *The chapeau-claque* would, however, not be suitable on other social events, or as morning headgear.

Der Trilby

Wie der Fedora verdankt der Trilby seinen Namen einer Figur der Dichtung: Trilby O'Ferrall, der Heldin des Romans *Trilby* von George du Maurier, der erstmals 1894 in Fortsetzungen in Harper's Monthly Magazine erschien und später zum größten Bestseller der Belle Époque wurde. Es geht um junge englische Maler um 1850 in der Pariser Bohème und um ihr junges irisches Modell, Trilby, deren Schicksal den Wechselfällen des Lebens ihrer Freunde und Liebhaber folgt. Der Hut wurde für eine der vielen Aufführungen der Bühnenbearbeitungen des Romans entworfen. Er ähnelt einem Fedora, hat jedoch eine schmalere Krempe, die hinten hoch und vorne hochgebogen ist, etwa so wie ein Tirolerhut.

Die Krone ist nicht ganz so hoch wie die eines Fedora, aber der Kniff oben und die seitlichen Kniffe sind ähnlich. Weniger förmlich als andere Hüte ist ein Trilby ein Hut für die Freizeit, ein Hut der sorglosen Jugend und der Künstlerboheme. Leonard Cohen trug in fortgeschrittenem Alter einen Trilby, und Sean Connery im James Bond-Film *Goldfinger* beim Golfspielen, was seine Beliebtheit in den 1960er Jahren erklärt. Der Trilby, der nie ganz aus der Mode geraten war, erlebte in den Jahren nach 2000 sein Comeback als unisex Sommerhut aus Stoff oder Stroh. Er eignet sich weniger für förmliche Anlässe, aber hervorragend zum Freizeitgebrauch.

The trilby

Like the fedora, the trilby owes its name to a fictional character: Trilby O'Ferrall, the heroine of Trilby, a novel by George du Maurier, which was first published as a serial in Harper's Monthly magazine in 1894 and afterwards became the greatest bestseller of the Belle Époque. The plot features young English artists living in bohemian Paris around the 1850s and a young Irish model, Trilby, whose destiny follows the good and bad fortunes of her friends and lovers. The hat was designed for one of the many stage adaptations of the novel. While its general shape is similar to that of the fedora, the brim of the trilby is much narrower and upturned at the back, with a slight tilt at the front, like a Tyrolean hat. The crown of the trilby is slightly lower than that of the fedora, but the crease, the pinch, and the sloping sides are similar. Less imposing and formal than other hats, the trilby is an informal hat, emblematic of carefree youth, outdoor activities and the life of a bohemian artist. The trilby was, for instance, Leonard Cohen's signature hat in his later years. It was also the hat worn by James Bond, played by Sean Connery, on a legendary golf course with *Goldfinger*, which no doubt explains its popularity in the 1960s. The trilby, which has never really fallen into disuse, made a strong comeback in the 2000s as a unisex summer hat made of fabric or straw. While not really suitable for a more formal and elegant style of clothing, the trilby has established itself as a hat for casual style.

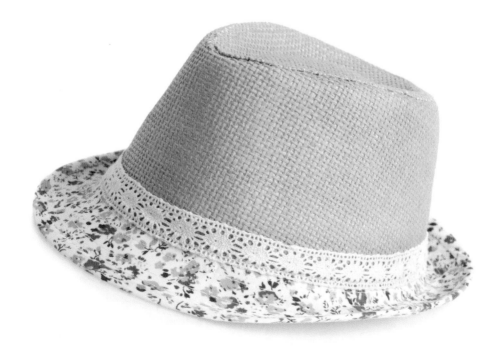

Die Ascot-Kappe

The Ascot cap (aka Cuffley cap)

Diese normalerweise einfarbige Mütze wird vom Gentleman-Farmer getragen. Sie besteht im Unterschied zu anderen Mützen aus hartem Filz. Der Schirm verschwindet unter der Vorderseite der Mütze. Diese einfache, aber elegante Mütze, die hin und wieder auch aus Tweed hergestellt wird, ist eine relativ neue Entwicklung, da sie erst seit dem frühen 20. Jahrhundert existiert. Die Mütze wurde von den Herren der Upper Class getragen, wenn sie auf dem Land waren, obwohl Mützen eigentlich eine Kopfbedeckung der Arbeiter waren. Die Prinzen Philip of Edinburgh, Charles of Wales und William of Cambridge halten die aristokratische Tradition hoch und tragen bei Jagdgesellschaften und Besuchen auf dem Land eine Ascot-Kappe.

Abhängig von der übrigen Kleidung verleiht einem die Ascot-Kappe entweder ein Retro-Image oder lässt einen besonders modern und elegant erscheinen. Sie eignet sich auch perfekt für Reisen, da man sie einfach in den Koffer packen kann. Außerdem gehört sie mit dem Basball-cap und der Beanie zu den wenigen Kopfbedeckungen, die man beim Autofahren getrost aufbehalten darf.

This rounded, one-piece cap, usually of a single colour, is an essential accessory for the gentleman-farmer. The Ascot cap has the distinctive characteristic of being made of hard wool felt. The front brim blends under the front of the cap. This simple but elegant cap, which can also be made of tweed, is a fairly recent model since it dates back to the early 19th century. It was quickly adopted by men of the upper class to affect a certain casual air while staying in the countryside, despite the fact that at the time the cap rather denoted a declared affiliation to the working class. In the United Kingdom, Princes Philip of Edinburgh, Charles of Wales, and William of Cambridge have maintained the aristocratic tradition of wearing an Ascot cap for hunting parties and visits to rural areas.

Depending on how you dress, wearing an Ascot cap will either give you a retro image or, on the contrary, a modern and trendy look. It is also perfect for travel, as it is easy to pack in a suitcase. In addition, along with the baseball cap and the beanie, it is one of the few types of headwear you can keep on your head while driving a car.

Das Baseballcap

Das Baseballcap oder kurz Basecap ist die Kopfbedeckung par excellence der USA. Neben dem „Boss oft he Plains", dem Stetson-Cowboyhut, assoziiert man diese Kappe mit der amerikanischen Lebensart. Der New York Times-Journalist Troy Peterson bezeichnet diese Kappe als die „common man's crown" (die Krone des Durchschnittsbürgers).

Baseball wird seit Anfang des 19. Jahrhunderts gespielt, aber erst 1860 erhielten die Brooklyn Excelsiors, eine Amateurmannschaft, Mützen, die später als Baseball-kappen bekannt wurden. Diese runde Mütze bestanden aus sechs dreieckigen Stoffstücken, und hatten einen Schirm aus Leder, der die Augen des Spielers davor schützte, von der Sonne geblendet zu werden. Diese Kappe, der *Brooklyn Hat*, setzte sich rasch bei Baseballspielern durch und ersetzte den Boater Hat, der bis dahin in Gebrauch gewesen war. Nach 1890 kamen Lüftungslöcher hinzu. Die erste Mannschaft, die ihre Kappen mit ihrem Logo ausstattete, waren die Detroit Tigers im Jahr 1901. Das Aufkommen von Polyester und

Siebdruck Mitte des 20. Jahrhunderts trugen zum Siegeszug des Basecaps bei: Sie wurden preiswerte Werbeartikel. Angefangen mit Ronald Reagan haben alle amerikanischen Präsidenten Basecaps getragen. Donald Trumps politisches Programm ließ sich auf seiner roten Basecap nachlesen: „Make America Great Again."

Das Basecap ist zwar noch immer das Symbol der Baseballspieler und ihrer Fans, aber auch Teil des Alltagslebens. Neben den traditionellen Kappen, die aus sechs oder acht Stoffstücken bestehen und einen leicht gewölbten Schirm haben.

Der Trucker-Hut kam in den 1970er Jahren auf und hat einen größeren Schirm, die Vorderseite ist weniger rund. Die Rückseite besteht aus Netzgewebe. Der Trucker-Hut ist bei Rappern sehr beliebt und verhilft Promis zu einer gewissen Anonymität. Die elegantere Camper Cap besteht aus fünf dreieckigen Teilen und einem platten Schirm. Eine Variante des Camper Caps wird Ohrenklappen für windige Tage angeboten und erinnert damit an die Deerstalker-Mütze. In den USA allein werden pro Jahr 120 Millionen Basecaps verkauft.

The baseball cap

The baseball cap is rightfully considered America's national hat. Along with the Boss of the Plains, Stetson's iconic cowboy hat, it's the headgear most clearly associated with the American way of life. It is so ubiquitous that it was even nicknamed "The Common Man's Crown" by journalist Troy Peterson of the New York Times.

Baseball has been played since the early 1800s, but it wasn't until 1860 that an amateur baseball team, the Brooklyn Excelsiors, was equipped with what was the first baseball cap. The rounded hat, made of six soft triangular panels joined together at the top, had a stiff leather visor (bill) to protect the player's eyes from the sun. This cap, known as the "Brooklyn Hat", was a quick success among baseball players and was adopted by all teams replacing the boater hat, which was in use until then. Air holes were added in the 1890s, and the first team to put its logo on the front was the Detroit Tigers in 1901. The rise of polyester and screen-printing in the mid-20th century contributed to the commercial success of baseball caps: they became inexpensive advertising tools for companies wanting to promote their brands. Starting with Ronald Reagan, all acting presidents of the United States have been spotted wearing baseball caps. Donald Trump's entire political agenda is even displayed on the front of his iconic red baseball cap: "Make American Great Again".

While remaining the symbol of baseball players and their supporters, the cap moved beyond the sports fields to become an object of everyday life that comes in several variations. Next to the traditional six or eight-panel cap with its slightly curved visor, the trucker, launched in the 1970s, has recently established itself as a fashionable accessory, with an elongated visor, less rounded front and mesh panels in the back, it has conquered the rap scene and offers celebrities a certain anonymity. The more elegant, structured camper cap is made of five triangular panels and a flat visor. One variation of the camper cap features earflaps for windy days and is thus similar in design to the deerstalker. In the US alone, more than one hundred and twenty million baseball caps are sold every year.

Die Baskenmütze

Die Schäfer der Pyrenäen, des großen Gebirges, das die Grenze von Frankreich zu Spanien bildet, waren die ersten, die diese flache Kopfbedeckung aus Wolle trugen. Sie stellten sie aus der Wolle ihrer Schafe her, um sich vor der extremen Kälte und dem Regen zu schützen. Wo genau die Baskenmütze entstand, darüber streiten zwei französische Regionen: Obwohl von Baskenmütze die Rede ist, entstand die Kopfbedeckung vermutlich im angrenzenden Béarn im Hochmittelalter. Wasserdicht, anschmiegsam und leicht wurde die Baskenmütze von französischen Bauern ab der Mitte des 19. Jahrhunderts getragen. Die dunkelblaue Baskenmütze ist seit langem ein Wahrzeichen des ländlichen Frankreichs, hat aber auch neue Anhänger, nicht nur Schulkinder, sondern auch bestimmte Armeeeinheiten wie Fallschirmjäger und Gebirgsjäger. Baskenmützen sind auch bei Plein-air-Malern seit den Impressionisten beliebt. Diese allgemeine Beliebtheit ist einem praktischen Aspekt zu verdanken: Sitzt der innere Band fest auf dem Kopf, dann bewegt sich die Mütze auf bei starkem Wind nicht. Schafswolle ist auch dafür bekannt, dass sie Wasser absorbiert: Wolle speichert eine Wassermenge von bis zu einem Drittel des eigenen Gewichts, und hält den Regen so von ihrem Träger fern.

Ab den 1930er Jahren war die Baskenmütze dank der Schauspielerinnen Michèle Morgan und Greta Garbo auch bei den Damen in Mode. Bei Coco Chanel hatte sie auch auf dem Laufsteg ihr Debut und eroberte die Welt der Haute Couture. Obwohl die Beliebtheit der Baskenmützen in weiten Teilen der Bevölkerung nach 1960 stark abnahm, verschwand die Baskenmütze nie ganz: für Che Guevara und die Black Panther wurde sie zum Symbol der Revolution. Baskenmützen trugen auch Ernest Hemingway und Pablo Picasso. Sie lassen einen künstlerisch und intellektuell erscheinen. Auch die legendäre Kangol 504, die 1954 auf den Markt kam, stammt von englischen, baskenmützenähnlichen Army-Baretten, die von dem Hersteller während des Zweiten Weltkriegs produziert wurden, ab. Der Schirm ist die einzige Abweichung vom traditionellen Barett.

The beret

The shepherds of the Pyrenees, the vast mountain range that stretches along the border between France and Spain, were the first to wear this flat woollen headgear, which they made from their sheep's wool to protect themselves from intense cold and rain. The exact origin of the beret is actually a source of controversy between two French regions: although it is often called the "Basque beret", it seems to have originated in neighbouring Béarn around the high Middle Ages. Waterproof, supple, and light, the beret was widely used by French peasants from the middle of the 19th century onwards. The dark blue beret has remained the emblem of rural France for a long time while conquering new followers, not only schoolchildren, but also certain army corps such as parachutists and mountain troops. It has also been the favourite headwear of outdoor painters since the Impressionists. This popular success owes much to a practical aspect: when its inner edge is placed firmly on the head, the beret does not move, even in strong winds. Sheep's wool is also known for its water-absorbing properties: it can accumulate up to a third of its weight in water, thus keeping raindrops away from the wearer.

From the 1930s onwards, the beret even became a fashionable accessory for women thanks to leading actresses such as Michèle Morgan and Greta Garbo. At the same time, under the patronage of Coco Chanel, it made its debut on the catwalks and entered the world of haute couture. Despite its rapid decline in the popular classes since the 1960s, the beret has never completely disappeared: Che Guevara and the Black Panthers made it a symbol of revolution. The beret is also associated with images of both Ernest Hemingway and Pablo Picasso. It can add an arty-intellectual touch to the way you dress. Even the legendary Kangol 504 flat cap, launched in 1954, derives from the English military berets produced by the brand during WWII. A stiff visor on the front is the only addition to the traditional beret's shape.

Der Stoffhut

Wenn Sie auf Eleganz wertlegen, dann werden Sie wohl kaum zugeben, dass ein Stoffhut eine modische Kopfbedeckung darstellt. Man assoziiert ihn zu sehr mit Anglern, Wanderern, Reisegruppen und Pilgern, um ihm überhaupt etwas abgewinnen zu können. Auch der Stoffhut Woody Allens wirkt eher selbstironisch. Er wirkt zwischen Fedoras, Panamahüten und Homburgs wie ein hässliches Entlein. Trotzdem haben die Stoffhüte in letzter Zeit die Catwalks erobert, für einige Hersteller wie Kangol stellen sie die Spitzenprodukte dar. Ursprünglich waren sie aus Öltuch und schützten Seeleute vor Regen und Stürmen. In dieser Hinsicht besaß der Stoffhut viele Vorteile: Man konnte ihn tief in die Stirn ziehen, um sich vor Windböen zu schützen, seine, nach unten geneigte Krempe war nicht im Weg und er trocknete rasch. Der Hut ließ sich in einer Manteltasche verstauen, sobald es das Wetter zuließ. Diese Eigenschaften bestachen Ende der 1940er Jahre auch die gerade gegründete israelische Armee, die die Soldaten mit Stoffmützen aus Baumwolle ausrüstete, um sie vor der Wüstensonne zu schützen. Stoffhüte wurden auch von der US-Army während des Vietnamkrieges benutzt. Trotz seines Aussehens ist es also ein Kleidungstück für den tatkräftigen Mann. Könnte es diese Assoziation mit einer gefährlichen und feindseligen Welt sein, die die Hip Hop-Stars in den späten 1970er Jahren dazu veranlasst hat, zum Stoffhut, zum Bucket Hat, zu greifen? Vielleicht war es aber auch nur der Umstand, dass man mit einem Stoffhut tanzen kann, ohne ihn zu verlieren. Für Regentage, Spaziergänge im Wald und in den Bergen und natürlich zum Segeln ist er ebenfalls erstklassig geeignet. Man kann ihn am Strand und in Badehose tragen, ohne sich lächerlich zu machen. Wenn Sie Ihre Ohren verstecken wollen, nichts leichter als das. Ziehen sie den Stoffhut einfach über die Ohren. Voilà! Der Deckel einer Stoffmütze kann ürigens gerundet oder Flach sein. Neuerdings finden auch Stoffe aus Kunstfasern Verwendung.

Der Regisseur und Schauspieler Woody Allen wird oft mit einem Stoffhut gesichtet.

Director and actor Woody Allen is often spotted wearing a bucket hat.

The bucket hat

Sure, if you're a purist of elegance, you'll find it a little hard to admit that the bucket hat can be a fashionable headgear. It is too associated with the allure of anglers, hikers, group tourists, and pilgrims for any grace to be found in it. One would even suspect Woody Allen of wearing a bucket hat as a sign of self-mockery, and the hat's name itself implies something of an ugly duckling among fedoras, Panamas, and homburgs. And yet the bucket hat has recently conquered the catwalks and some brands, like Kangol, have made it one of their top products. Originally made of oilcloth, it was used for a long time by sailors who needed effective protection against rain and gales. The bucket hat had many advantages in this respect: it could be pushed down on the head to resist gusts of wind, its flexible, downward-slanting brim did not hinder manoeuvring, and above all, it was light and easy to dry. The hat could be put in a coat pocket as soon as the weather permitted. These qualities were recognised in the late 1940s

by the newly formed Israeli army, which equipped its soldiers with cotton bucket hats to protect them from the desert sun. The bucket hat was also worn by American soldiers during the Vietnam War. It is thus, contrary to appearances, a hat for men of action. Is it this association with a perilous and hostile environment that led hip hop stars to adopt the bucket hat in the late 1970s? Or, more prosaically, the fact that they could dance and move without fear of it falling off? It is a very convenient hat for rainy days or for walks in the forest or in the mountains and, of course, for sailing. You can wear it on a beach, with a swimsuit, without looking ridiculous or pretentious. If you would rather hide your ears, the bucket hat is perfect for that: just pull it down over them and *voilà*! The bucket hat's top crown can be rounded or flat, and it is produced in a great variety of fabrics ranging from natural fibres to synthetic materials.

Die Deerstalker-Mütze

In der Populärkultur wird die Deerstalker-Mütze meist mit der schlanken Silhouette Sherlock Holmes' assoziiert, obwohl Sir Arthur Conan Doyle dieses Kleidungsstück nie ausdrücklich erwähnt hat. Die Kopfbedeckung, eine Kreuzung aus Hut und Mütze, hätte in den Straßen Londons auch unpassend gewirkt. Die Deerstalker-Mütze war für die Jagd gedacht und wurde nur in ländlichen Gegenden getragen. Sie ist aus braun-, grün- und orangekariertem Stoff, so dass ihr Träger in der Herbstlandschaft geradezu verschwindet. Die Krone besteht aus sechs Stücken, vorzugsweise aus Tweed, die oben zusammenlaufen. Zwei Schirme, vorne und hinten, unterscheiden die Deerstalker-Mütze von anderen Mützen. Die hintere soll den Träger der Mütze davor bewahren, dass ihm Regenwasser in den Kragen läuft. Dass die Mütze keine Seitenkanten hat, werden Jäger ebenfalls zu schätzen wissen: Nichts hindert sie beim Durchqueren eines Gebüsches. Ohrenklappen, im Regelfalle hochgebunden, lassen sich bei kaltem Wetter herunterklappen. Die Eigenschaften, die einen guten Jäger ausmachen, Geduld, gute Wahrnehmung die Fähigkeit, nicht aufzufallen, und Furchtlosigkeit, erwartet man auch von einem Detektiv. Deswegen wählte Sidney Paget, der Illustrator der Werke Conan Doyles 1892 für die Illustrationen von *Silberstern*, das im idyllischen Dartmoor spielt, als Kleidung des Detektivs eine Deerstalker-Mütze. Seltsamerweise trägt der Detektiv in *Der Hund von Baskerville* von 1901, eine Geschichte, die ebenfalls in Dartmoor spielt, einen Homburg. Es lässt sich vermuten, dass Paget wollte, dass der Held der Erzählung durch das Moor streifen kann, ohne befürchten zu müssen, erkannt zu werden.

Sherlock Holmes und sein Deerstalker

Sherlock Holmes wearing a deerstalker

The deerstalker

The deerstalker is often associated in popular culture with the slender silhouette of Sherlock Holmes, although Sir Arthur Conan Doyle never explicitly mentioned it as an attribute of the detective's clothing. This headgear, which is like both a hat and a cap, would have been incongruous on the streets of London: the deerstalker was intended for hunting in the countryside and was only worn in rural areas. Its brown, green and orange checkered pattern helps hunters to blend in with the autumn landscape. The crown consists of six slightly rounded triangular panels, usually made of tweed, which meet at the top to form a semi-elliptical shape. Two stiff, rounded visors on the front and rear distinguish the deerstalker from the usual caps. While the use of the front visor is obvious, the use of the rear visor may seem mysterious, but you only have to imagine rain dripping down the back of a hunter's neck to understand its usefulness. The lack of edges on the sides is another advantage appreciated by hunters: well adapted to the shape of the head, the deerstalker does not hinder walking in the bushes. Earflaps, which are usually tied on the top, but can be easily untied in cold weather, offer valuable warmth. The qualities inherent in a good hunter: patience, a keen sense of observation, the ability to blend in with the environment and fearlessness are also those expected of a detective. This is no doubt why in 1892 the official illustrator of Conan Doyle's works, Sidney Paget, chose to sketch the detective dressed as a deerstalker in the novel *The Adventure of Silver Blaze*, whose plot takes place in the bucolic landscape of Dartmoor. Curiously for *The Hound of the Baskervilles*, published in 1901 and also set in Dartmoor, the illustrator decided to adorn the detective's head with a homburg. One might assume that Paget wanted to allow the hero to wander the moor without fear of being recognized.

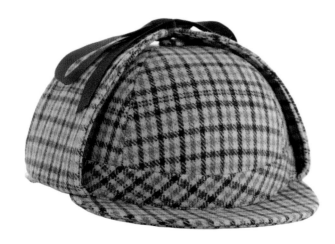

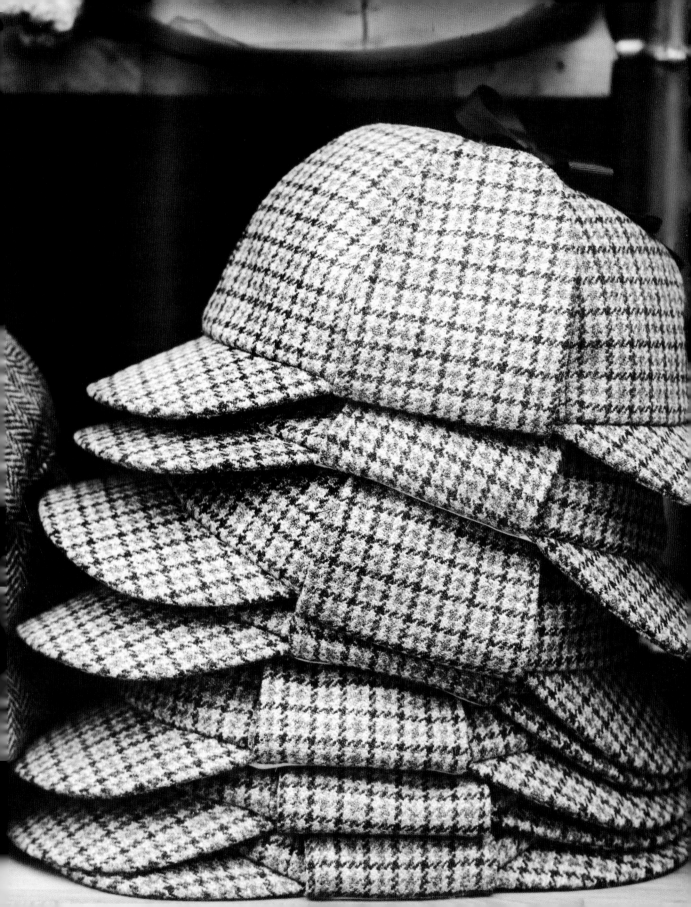

Der Docker's Skullcap

The docker's skullcap

Diese einfache und praktische Mütze wurde zuerst von Fischern und Hafenarbeitern getragen und stellt ein Must-Have für den modernen Mann dar, was auch dem Luc Besson-Film *Léon – der Profi* von 1994 zu verdanken ist. Die Hauptfigur, die von dem französischen Schauspieler Jean Reno gespielt wird, ist ein Auftragsmörder, der auf den Straßen New Yorks ein Docker's Skullcap trägt. Diese Mütze sitzt perfekt, fliegt auch bei starkem Wind nicht davon und behindert nicht die Sicht, was verglichen mit Mützen mit Schirmen von Vorteil ist. Docker's Caps aus Wolle bieten Wärme im Winter, leichtere Modelle aus Baumwolle, schützen im Sommer Kopf und Ohren vor der Sonne. Eine Docker's Cap wirkt cool, männlich und abenteuerlich, und lässt sich bei vielen Gelegenheiten verwenden: Bei einem Waldspaziergang, bei einer Grillparty auf dem Land, bei einem Open-Air-Konzert, bei einer Fahrt im Cabrio oder natürlich beim Segeln.

First used by fishermen and dock-workers, this simple and functional skullcap has become as must-have piece of casual dress for the modern man, partly thanks to Luc Besson's movie *Leon: The Professional* in 1994, where the main character, played by French actor Jean Reno, is a professional killer sporting his docker skullcap in the streets of New York. The cap is perfectly adjusted to the skull, and will not slip off even during strong gusts of wind. It does not obstruct the vision, which is an important advantage compared to caps with visors. Wool docker caps offer good insulation from cold temperatures in the winter, while lighter models, made of cotton, keep the head and the ears safe from the effects of sun in the summer. Wearing a docker gives men a touch of cool masculinity and a sense of adventure, and many occasions lend themselves to this outfit: a walk in the forest, a barbeque party in the countryside, an open-air concert, a cabriolet ride, or a sailing session, of course.

Die Fischer-
mütze

The Greek
fisherman's
cap

Diese flache Mütze mit steifem Rand und Schirm ist bei griechischen Seeleuten und Fischern seit der Mitte des 19. Jahrhunderts in Gebrauch. Die Krone ist vorne leicht erhöht und entweder weiß oder dunkelblau. Die steifen Teile sind traditionell blau und normalerweise gemustert. Diese Baumwollmütze eignet sich sehr gut zur Seefahrt und generell für sommerliche Aktivitäten. Sie erfreute sich sehr schnell großer Beliebtheit. Eine Filzversion mit etwas größerer Krone, die im englischen Sprachraum den Namen Fiddler Cap trägt, war Ende des 19. Jahrhunderts bei den Arbeitern besonders in Russland sehr beliebt. Aus diesem Grund trug sie auch Lenin. In den 1950er und 1960er Jahren gehörten diese Mützen zur Tankwartuniform und wurden später von den einfacheren Baseballcaps abgelöst. Die Mütze der Piloten ähnelt ebenfalls den Fischermützen, ist jedoch vorne in der Regel höher. Die Fischermütze, die sich bei professionellen und Amateurseglern immer noch großer Beliebtheit erfreut, hat als Fashion-Item ein Comeback erlebt, dank des Vintage-Trends und der John-Lennon-Nostalgie: Er gehörte zu den Promis, die eine solche Mütze trugen.

This flat, unstructured cap with a stiff brim and visor has been worn by Greek sailors and fishermen since the mid-19th century. The crown, which rises subtly in the front, is white or dark blue and the stiffened parts, traditionally in blue, are usually decorated with ornamental patterns. This cotton cap is well adapted for sea faring and, more generally, for outside summer activities, and its popularity spread rapidly. A felt version with a slightly larger crown, known as the fiddler cap, was in vogue among the working class at the end of the 19th century, especially in Russia: Bolshevik leader Vladimir Lenin adopted it as headgear, as did many other revolutionaries. The cap was part of the uniform of service station attendants in the 1950s and 1960s, before being replaced by the less sophisticated baseball cap. The airplane pilot's cap also borrows its overall structure and the decorations on the visor from the Greek fisherman's cap, but the front of the crown is generally higher. The cap, which remains popular among both professional and recreational sailors, has made a comeback as a fashion accessory thanks to the trend for vintage and the nostalgia around John Lennon, one of the celebrities who had been known for wearing one.

Der in Hamburg geborene Bundeskanzler Helmut Schmidt trug oft eine Seemannsmütze.

Hamburg-born German Chancellor Helmut Schmidt often sported a mariner's cap.

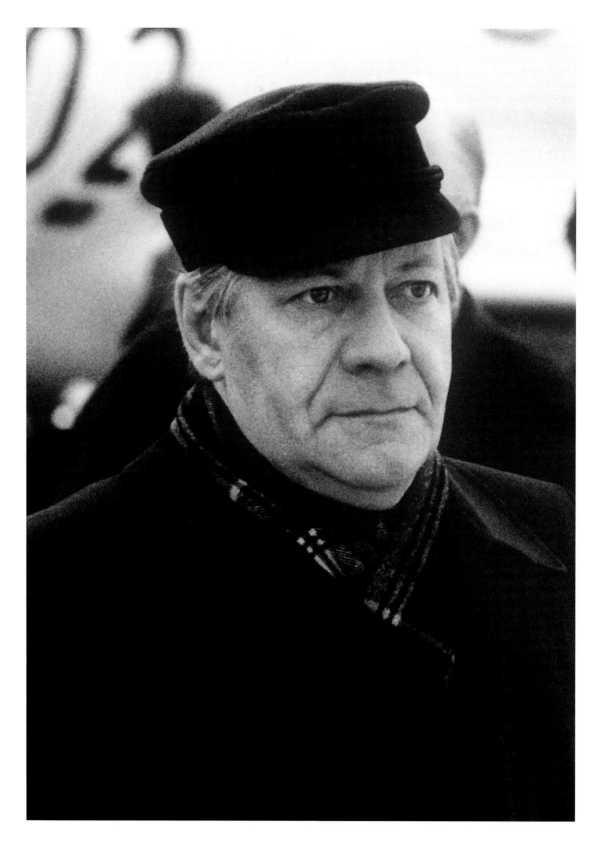

Die Schiebermütze

Diese Art von Mütze (im Englischen Ivy Cap oder Scully Cap) wurde von Bürgerlichen auf den britischen Inseln seit dem 14. Jahrhundert getragen. Damals hieß diese Kopfbedeckung „bonnet" und bestand aus Wolle, was angenehm warm war. Die einfache und geschmeidige Form passt sich der Schädelform perfekt an, die Ohren bleiben unbedeckt. Die Schiebermütze hat ein flaches Dach und einen schmalen Schirm, der normalerweise am Dach festgenäht ist. So behält die Mütze ihre Form, und man kann sie mühelos in der Hand halten. Schiebermützen werden oft mit Arbeitern assoziiert, sie wird aber seit Beginn des 20. Jahrhunderts von allen Klassen getragen: Dass sie so praktisch war, ihr klassisches Erscheinungsbild nicht zu vergessen, sprach anfänglich die Autofahrer an, Studenten, Urlauber, Musiker und Sportler, die in den 1920er Jahren zu ihrer Verbreitung wesentlich beitrugen. Gelegentlich wird die Schiebermütze auch als Golfmütze bezeichnet. Schiebermützen werden aus unterschiedlichem Material hergestellt, Tweed, Baumwolle, Leinen und Leder, und können zu jeder Jahreszeit getragen werden. David Beckham ist häufig mit einer Schiebermütze zu sehen. Sie wird im Allgemeinen als weniger alltäglich und eleganter als ein Basecap wahrgenommen. Wer mit unterschiedlichen Kopfbedeckungen experimentiert, dem werden das geringe Gewicht und die klaren Linien einleuchten.

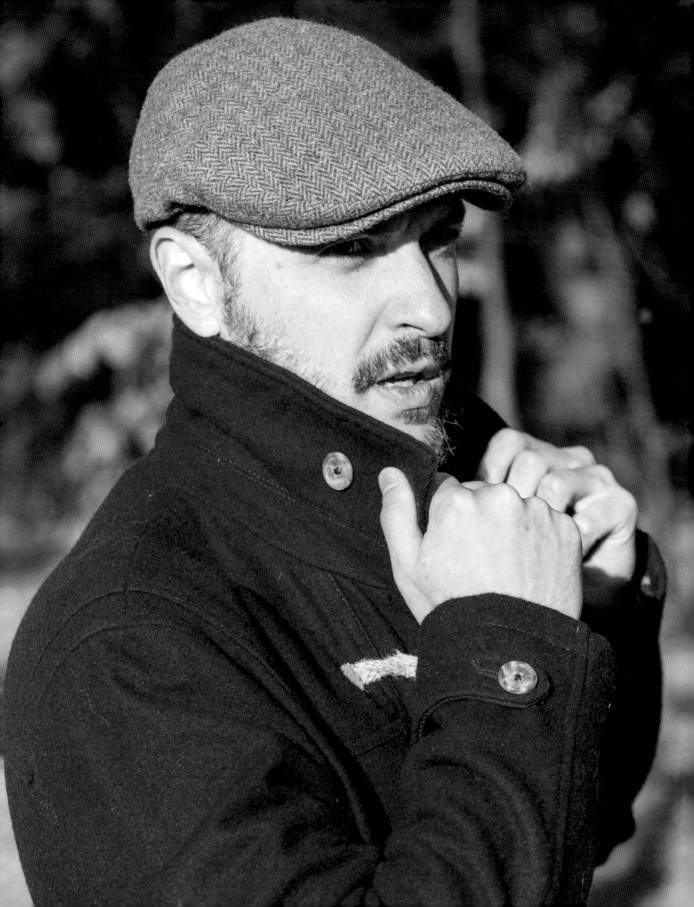

The ivy cap (aka scally cap)

The ivy cap, sometimes called the scally cap, is a variation of the flat cap, a headgear worn by commoners in the British Isles since the 14th century. At the time, it was known as the bonnet, and it was made of wool to provide comfortable warmth. The cap's simple and supple shape adapts perfectly to the top of the scalp, leaving the ears uncovered. The ivy cap chiefly consists of a flat panel with a rounded back. A narrow brim in the front, usually attached to the flat panel, allows the soft cap to keep its shape and to be held easily in the hand. Although often associated with blue-collar workers, the ivy cap has been worn since the beginning of the 20th century by all social classes: its practicality and classic style appealed to the first car drivers, to students, holidaymakers, musicians, and sportsmen who popularized it in the 1920s – it is sometimes even referred to as the "golf cap". The cap is now produced in a variety of materials including tweed, cotton, linen, and leather and can be worn in all seasons. It is one of David Beckham's regular fashion accessories, and it is generally perceived as less casual, more stylish than a baseball cap. Newbies will appreciate the cap's lightness and purity of line.

Die Strickmütze

Die ersten oben spitz zulaufenden Wollmützen wurden in Monmouth in Wales Ende des 14. Jahrhunderts gestrickt. Damals war die Gegend von Monmouth für ihre Wolle berühmt, und ihre Lage an der Severn Mündung begünstigte den Handel. Gestrickte Mützen wurden anfänglich von Seeleuten und Fischern getragen, die es zu schätzen wussten, am Kopf nicht zu frieren, aber auch von Soldaten, die lange Wache schieben mussten, aber recht bald wurden sie auch von allen anderen getragen, die sich dem Unbill des Wetters ausgesetzt sahen, Arbeitern, Landarbeitern, Markthändlern. Mützen wurden zu einer universellen Kopfbedeckung der arbeitenden Bevölkerung. Je nachdem, wie kalt es ist, kann man die Mütze über die Ohren ziehen oder die Kante hochklappen, so dass sie nur den Schädel bedeckt. Obwohl sich diese Mütze in den letzten sechs Jahrhunderten wenig verändert hat, gibt es unzählige Varianten, einige laufen unter dem Namen Beanie. Andere haben einen Bommel. Bevor sich die Skihelme durchsetzten, trugen die meisten Skifahrer eine solche

Pudelmütze. Auch zur Kleidung bestimmter Fußballfans gehören Pudelmützen. Möglicherweise nähten Seeleute Bommel an ihre Mützen, damit der Abstand zum Mastbaum größer wurde und die Gefahr, dass er einem gegen den Kopf knallte, geringer. Ein Bommel erleichtert auch das Abnehmen der Mütze. In den letzten Jahrzehnten kam dank David Beckham der Baggy Beanie auf. Diese ausladenden Mützen lassen die meisten Männer jedoch aussehen, als hätten sie die Mütze versehentlich drei Nummern zu groß gekauft. Wer auf klassische Eleganz wert legt, sollte sich an das Fischermodell der watch cap halten.

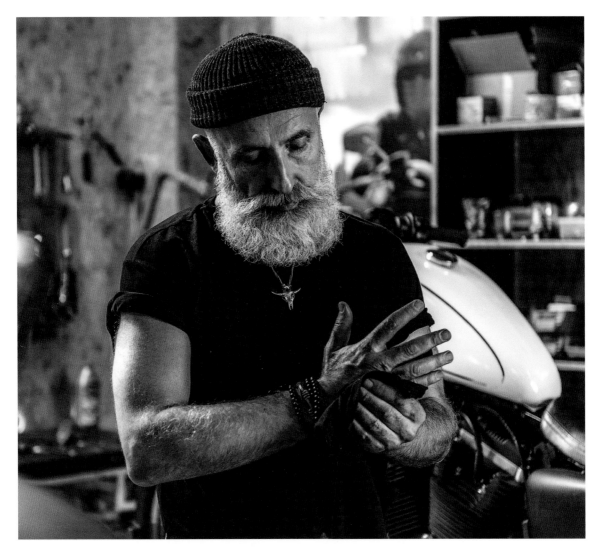

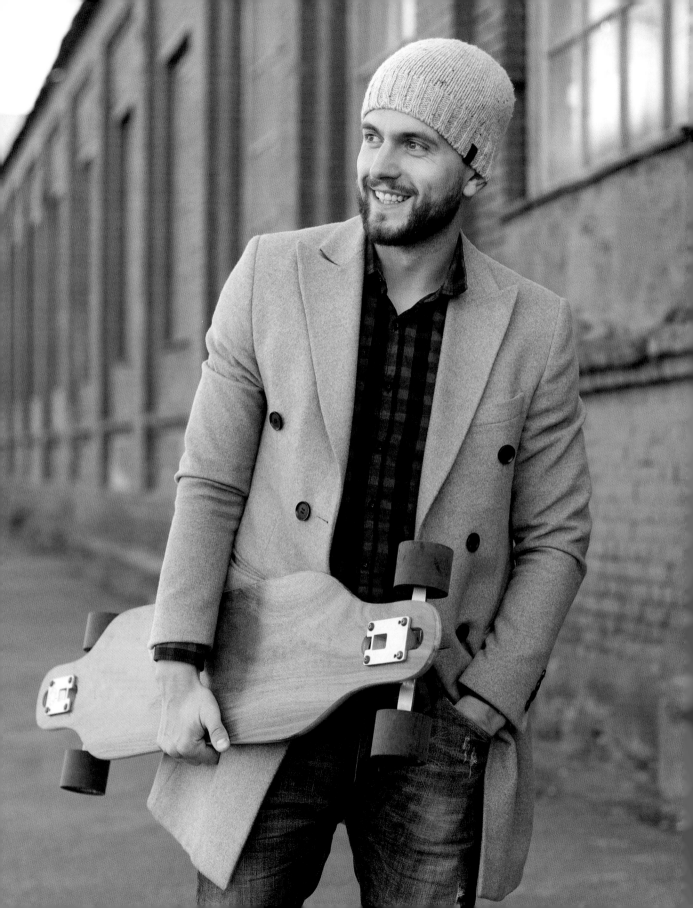

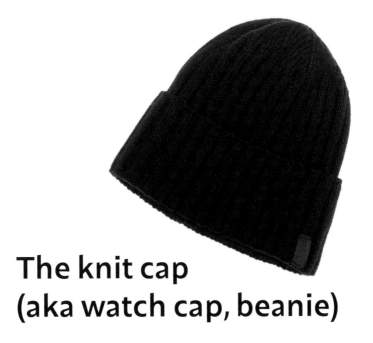

The knit cap (aka watch cap, beanie)

The first knitted woollen caps with a tapered shape were made in Monmouth, Wales, at the end of the 14th century. The area around Monmouth was then famous for the quality of its wool and the town's location on the Severn Estuary favoured trade. The knitted caps were initially used by sailors and fishermen who appreciated their protective warmth, but also by soldiers who kept watch for long hours, but their use quickly spread to other activities exposed to climatic variations: labourers, farm workers, street traders, to the point of becoming almost universal head-gear for the lower classes. Depending on the intensity of the cold, the border of the cap can be folded to cover the ears or alternatively, raised to protect only the skull. Although the general shape of the cap has changed little over the last six centuries, there are countless variations in fashion, sometimes known as "beanies". The bobble cap, for example, is nothing more than a knitted cap with a pompom on top; before the widespread use of helmets, most skiers wore a cap with a pom-pom. Supporters of some football clubs have made the bobble cap their emblem. It seems that sailors added the pom-pom to protect their heads from getting bashed when they bent down un-der sails. But whatever the reason, it makes removing the cap easier. Just grab it by the pom-pom and pull. The baggy beanie was another knitted cap trend in the 2000s, partly thanks to David Beckham. However, most men in their baggy beanies look as if they picked up an oversized cap by mistake. To keep a stylish and classic look, a fisherman beanie is the safest option.

Die Ballon-mütze

The Newsboy Cap

Jeder, der Chaplins *Der Vagabund und das Kind* gesehen hat, wird sich an Cackie Coogan erinnern, das vom Landstreicher adoptierte Kind und sein Komplize. Schuhe mit Löchern, geflickter Overall, Pullover mit Stehkragen und eine ramponierte, übergroße Ballonmütze. Die Ballonmütze ging aus einem flacheren Modell hervor, mit dem sie vieles gemein hat. Die sechs oder acht Stoffstücke stoßen oben zusammen. Dort sitzt ein charakteristischer Knopf. Ein Knopf verbindet die Mütze mit dem Schirm, der teilweise verschwindet. Ballonmützen werden aus Wolle, Baumwolle, Tweed und Leder hergestellt. Sie entstanden Ende des 19. Jahrhunderts in Europa und Nordamerika und waren bei jungen Arbeitern und Straßenverkäufern sehr beliebt. Moderne Illustratoren pflegen den jungen Oliver Twist, Charles Dickens Romanhelden, mit einer solchen Mütze abzubilden, die allerdings einen Anachronismus darstellt. Von der Arbeiterklasse aus eroberte die Ballonmütze die High Society, die diese Mütze für Freizeitaktivitäten wie der Jagd und beim Autofahren überaus praktisch fand. Der François-Truffaut-Film *Jules und Jim* aus dem Jahr 1962 zeigte die Schauspielerin Jeanne Moreau mit einer Ballonmütze und machte diese so zu einem Must-Have der modernen Frau.

Anyone who saw Charlie Chaplin's *The Kid* will remember the look of Jackie Coogan, who plays the tramp's adoptive child and accomplice: shoes with holes, patched overalls, a turtleneck jumper, and an oversized, worn-out newsboy cap. Initially a variant of the flat cap, with which it shares many features, the newsy cap is much fuller, and the stiff brim is slightly rounded. The six or eight panels it is made of join at the top, which is covered by a signature button. Another button ties the cap to the brim, which is partly hidden underneath the cap's body. Wool, cotton, tweed, and leather are the most common materials used for newsboy caps. The style emerged at the end of the 19th century in both Europe and North America, particularly popular among the young working class and street sellers. Interestingly, modern illustrators and moviemakers would show Charles Dickens' *Oliver Twist* wearing a newsboy cap, which is a pure, but telling anachronism. The cap made its way from the working class to High Society who found it convenient for leisure activities such as hunting or driving. François Truffaut's film *Jules and Jim* (1962) was the first one showing a female actress, Jeanne Moreau, wearing a newsboy cap, and thus contributed to making it a must-have accessory for the modern woman.

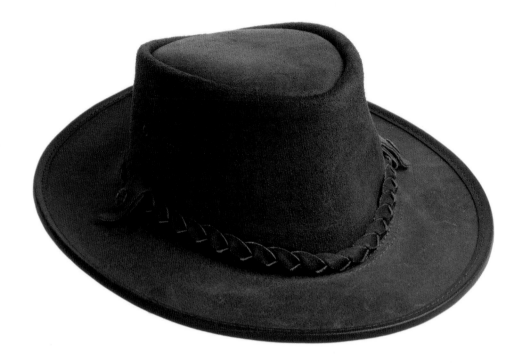

Der Akubra-Buschhut

Der Buschhut ist die australische Variante des Cowboyhuts, die für das Outback und die extreme Hitze, die dort herrscht, entwickelt wurde. Er hat eine breite Krempe und eine hohe Krone und besteht traditionell aus Kaninchenhaar. Er wurde zu Beginn des 20. Jahrhunderts von den beiden englischen Hutmachern Benjamin Dunkerley und seinem späteren Schwiegersohn Stephen Keir, die nach Australien ausgewandert waren, hergestellt. Ihre Erben betreiben das Geschäft noch heute. Der Name Akubra bedeutet in Pitjantjatjara, einer Sprache der Aborigines, Kopfbe-deckung. Im Jahr 1912 wurde der Name als Marke eingetragen. Im ländlichen Australien ist ein Akubra Buschhut Alltagskleidung. Um authentisch zu wirken, sollte er abgetragen sein und Flecken haben. Paul Hogan trug in *Crocodile Dundee* eine Variante des Akubra Hutes aus schwarzem Filz mit einem Hutband aus Krokodilleder, das mit sechs Krokodilzähnen verziert war. Die Firma stellt auch die berühmten Schlapphüte der australischen Armee her.

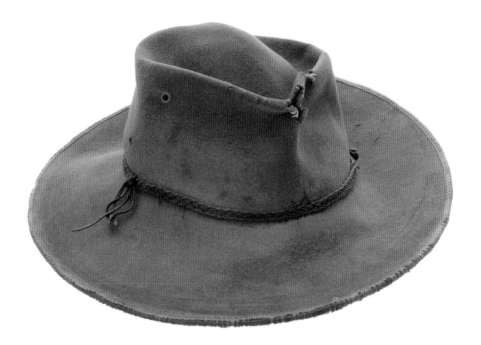

The Akubra bush hat

The Akubra bush hat is an Australian variant of the cowboy hat: as its name suggests, it is adapted to the bush, but also to the vast, arid spaces of the Outback and to the extreme heat that can prevail there. The wide-brimmed hat with a high crown is traditionally made of rabbit fur. It was originally designed at the beginning of the 20th century by two English hat-makers who settled in Australia, Benjamin Dunkerley and his future son-in-law, Stephen Keir, whose heirs still run the family business. The name Akubra, which is said to mean "head covering" in Pitjantjatjara, one

of the aboriginal languages, was registered as a trademark in 1912. In Australia's rural areas, the Akubra bush hat is part of the everyday clothing, and an authentic bush hat should look worn out, with stains, dents, and dirt adorning it. A variant of the Akubra hat in black fur, decorated with a band of crocodile leather and six crocodile teeth was made popular by Paul Hogan in the *Crocodile Dundee* movie trilogy. The company is also the official supplier of the famous slouch hats for the Australian army.

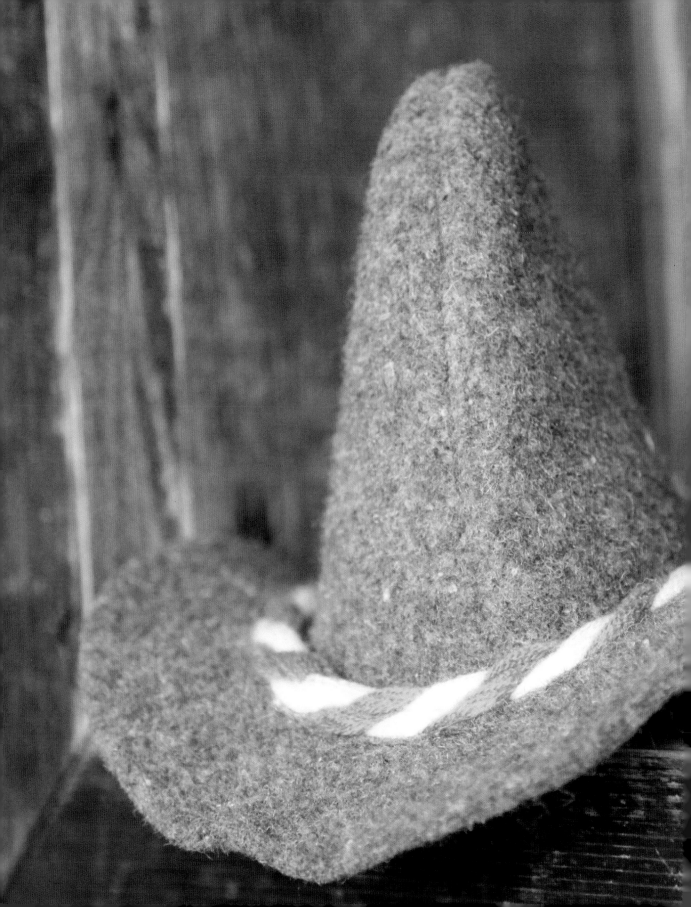

Der Seppelhut

Ähnelt dem Tirolerhut, hat jedoch keine Krempe. Er hätte ohne das Oktoberfest in München vermutlich nicht in die heutige Zeit überdauert. Hier ist er ein Muss. Seppel ist eine bayerische Kurzform von Josef. Eine Kordel passt den Hut an die Kopfgröße an. Seine absurde, schrullige Form passt zu der fröhlichen Atmosphäre des Oktoberfests, symbolisiert aber auch die Verbundenheit der Bayern mit ihren Traditionen.

The Bavarian seppelhut

This peasant's hat would probably not have survived the modern world had it not become the essential headgear for the Oktoberfest, the annual beer festival in Munich. The name "'Seppel" is the Bavarian diminutive of Joseph, a common first name in this prosperous region. The shape of the seppelhut is that of a grey felt hat body to which a cord is added to adjust the hat to the size of the head. Its unusual, quirky look makes it the ideal symbol to embody the cheerful atmosphere that prevails during the Oktoberfest, as well as a sign of the Bavarians' attachment to their traditions.

Der Boss of the Plains (auch Stetson)

Der Boss of the Plains genannte Hut ist ein Sinnbild des Wilden Westens, ein Symbol für das abenteuerliche und freie Leben der Cowboys im 19. Jahrhundert, das von Hollywood unsterblich gemacht wurde. Der Stetson entstand jedoch erst in den frühen 1860er Jahren. John B. Stetson, der Sohn eines Hutmachers aus New Jersey, unternahm eine Reise ins Herz der USA. Der junge Mann war an Tuberkulose erkrankt und würde wohl nicht mehr lange leben. Dieser Trip in den amerikanischen Westen war so etwas wie sein letzter Wunsch. Stetson hatte sich mit einem Hut mit schmaler Krempe, wie sie damals an der amerikanischen Ostküste Mode waren, auf die Reise begeben, musste jedoch feststellen, dass sich dieser Hut nicht für das Klima auf den Great Plains, den Ebenen östlich der Rocky Mountains, eignete. Stetson war ein praktischer und fähiger Mann und er entwarf einen neuen Hut mit dem Material und Gerätschaften, die er bei sich führte: Bieberpelz für den Filz, eine runde Pfanne als Form für die Krone und einen flachen Herd für die breite Krempe. Der Erfolg dieses wasserdichten Hutes stellte sich sofort ein, er eignete sich für lange Ritte über die Ebene und schützte Hals und Schultern vor Sonnenstrahlen. Wunderbarerweise wurde Stetson auf dieser Reise von seiner Tuberkulose geheilt. Er wurde 75 Jahre alt. Nach seiner Rückkehr aus dem Westen grün-

dete er in Philadelphia eine Fabrik, die immer noch seinen Namen trägt und in der der Hut hergestellt wird, den er erfand. Seine Form veränderte sich im Laufe der Jahre, aber einiges hat der Hut mit dem Original heute noch immer gemeinsam. Die hohe Krone, der Originalhut war zehn Zentimeter hoch, die wasserdicht genug ist, um darin notfalls Wasser zu transportieren. Die Krempe ist jedoch nicht mehr flach, sondern am Rand leicht hochgebogen. Legendäre Gestalten des Wilden Westens wie Buffalo Bill und alle Helden der Western Filme trugen den Boss of the Plains, einschließlich John Wayne und Clint Eastwood. Aber auch viele Präsidenten der USA ließen sich mit diesem Hut ablichten, beispielsweise Ronald Reagan mit anderen Staatschefs, denen er anschließend einen solchen Hut verehrte. Bill Clinton und George W. Bush ließen sich ebenfalls mit einem Stetson ablichten. Für Liebhaber der American Country Music ist ein Stetson ein Must.

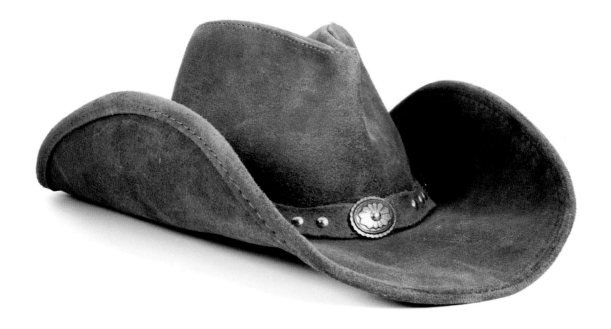

The Boss of the Plains (aka Stetson)

An icon of the American West, The Boss of the Plains is the strongest symbol of the adventurous and free life of cowboys in the 19th century as celebrated in Hollywood legend. The hat, however, only dates from the early 1860s when John B. Stetson, the son of a New Jersey hatter, undertook a trip to the heart of America. The young man, who was suffering from a severe form of tuberculosis, was not expected to live very long, and this trip to the American West was a kind of last wish. Stetson had gone on this journey wearing a short-brimmed hat that was fashionable at the time on the East coast, but he soon found it ill-suited to the weather conditions of the Great Plains. A practical, skilled man, Stetson designed a new hat with the materials and utensils he had with him on his journey: beaver fur for the felt, a rounded pan for the crown and a flat stove for the wide brim. The success of this water-proof hat, which was well suited for riding the western plains and protected the upper body from the sun's rays, was immediate. The other miracle of this journey was the healing of Stetson - who lived to be 75 years old. After returning to Philadelphia, he established a hat factory that still bears his name and whose brand is closely associated with the hat he created. Although the shape of the hat has evolved over time, some features of the original are still present today. It retains a

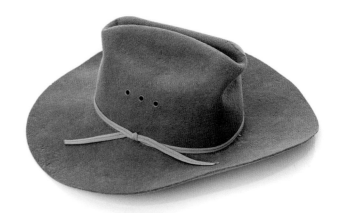

high crown—the original hat was four inches (ten centimetres) high —which is waterproof enough to hold water inside if needed, as well as a brim wide enough to cover the shoulders, although it is no longer flat but curves slightly upwards. Embraced by legendary figures of the American West such as Buffalo Bill, the Boss of the Plains was worn by all the heroes of western movies, including John Wayne and Clint Eastwood, but also by many presidents of the United States: Ronald Reagan posed with a Boss of the Plains on his head in the company of many heads of state, and offered these hats as a gift to his guests. Bill Clinton and George W. Bush also paid tribute to tradition. The hat is also a must-have for all lovers of American Country music.

Nach mehreren Auftritten in Western wechselte Ronald Reagan in die Politik, aber der 40. US-Präsident trug weiterhin gelegentlich einen Boss of the Plains.

After performing in several Westerns, Ronald Reagan switched to politics, but the 40th US President continued to wear a Boss of the Plains on occasion.

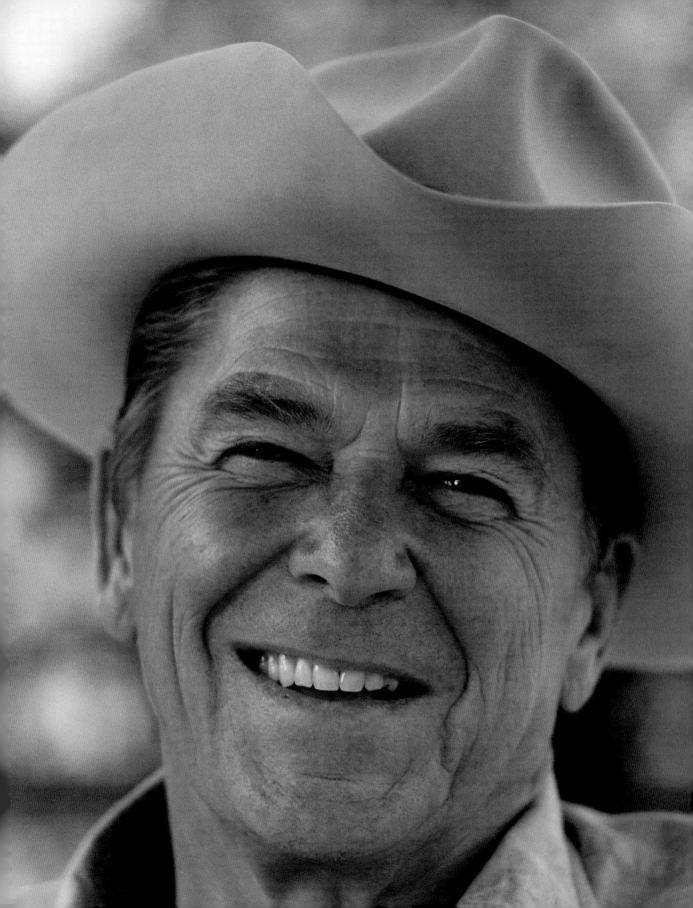

Der Pfadfinderhut

Dieser Hut hat eine breite, flache Krempe und unterscheidet sich vom Stetson nur dadurch, dass die hohe Krone an vier Stellen Kniffe und so in der Mitte eine Art Spitze hat. Dieser Hut war seit der Mitte des 19. Jahrhunderts bei der US-Kavallerie und bei der englischen Armee, besonders in Südafrika, in Gebrauch. Noch heute ist der Campaign Hat Teil der Uniform der Canadian Mounted Police, des Militärs in Neuseeland und in den USA der Nationalpark-Rangers und bei der Armee der Ausbilder der Rekruten. Sergeant Hartman trägt in Stanley Kubricks *Full Metal Jacket* einen Pfadfinderhut. Robert Baden-Powell, ein ehemaliger Offizier der englischen Armee, und Gründer der Pfadfinder, wählte ihn für die Pfadfinderuniform. Der Hut eignet sich hervorragend für Gebirgswanderungen, zum Campen im Wald oder zum Wandern in heißen, trockenen Landstrichen und für jede Outdoor-Aktivität, die Selbstdisziplin erfordert.

The campaign hat

This hat with its wide, flat brim and high crown differs from the Boss of the Plains only by the four symmetrical pinches at the top of the crown, which form a slight peak in the middle. The hat was used as early as the second half of the 19th century by mounted troops in the United States, as well as by the British army, in particular for its colonial battalions in South Africa. Even today, the campaign hat is still part of the uniform of the Canadian Mounted Police, the New Zealand army, and, in the United States, is worn by both the park rangers and by the drill instructors responsible for training new recruits. It is the hat Sergeant Hartman wears in Stanley Kubrick's *Full Metal Jacket*. The campaign hat was also adopted by the Scouting movement under the influence of its founder, Robert Baden-Powell, a former officer in the British army. It is an ideal headgear for hiking in the mountains, camping in the forest or walking in hot, arid places, or for any other outdoor activity that implies a certain self-discipline.

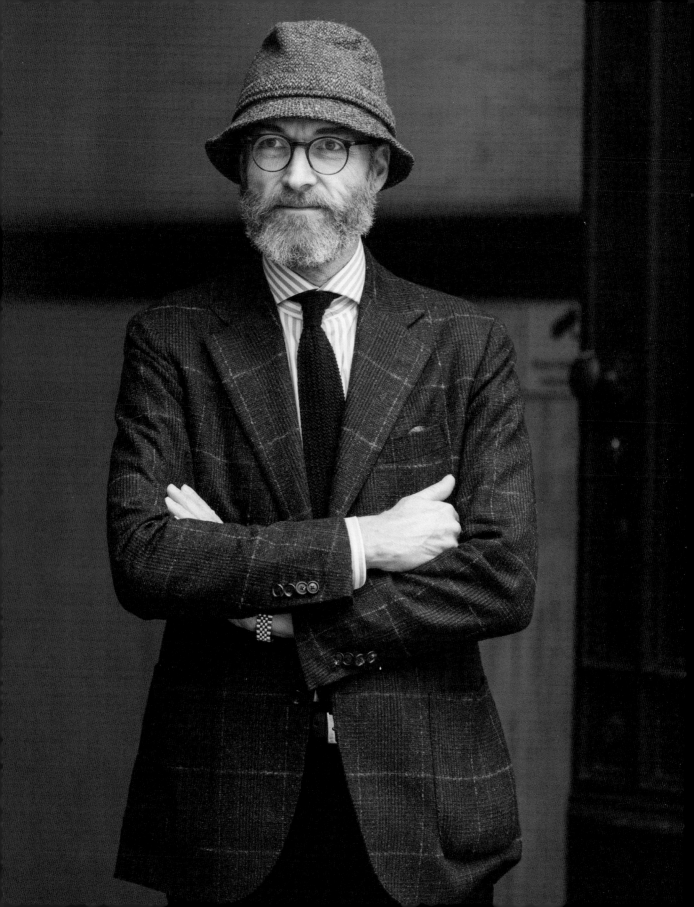

Der irische Wanderhut

The Irish walking hat

Dieser Hut ähnelt einem Bucket Hat, ist aber aus Tweed oder Wolle und in der Regel besser verarbeitet. In der Regel wird er von einem Hutband dekoriert und weist gelegentlich auch einen Kniff auf. Die vorherrschende Farbe ist Grün, aber es kommen auch braune und grüne Hüte vor. Gelegentlich wird eine Feder im Hutband getragen, damit die schlichte Farbe verstärkt wird. Es ist ein Hut für die Übergangszeit, der sich perfekt für Spaziergänge auf dem Land im Herbst eignet. Wie einen Bucket Hat kann man den Wanderhut bequem in der Manteltasche verstauen. Wie der Deerstalker erfreut er sich bei Jägern seit den 1930er Jahren großer Beliebtheit. Nichts hindert einen daran, diesen Hut in der Stadt zu tragen, wenn man aussehen will wie ein Landbesitzer. Seine einfache Form und sein Unisex-Charakter könnten dazu beitragen, dass er ein Revival als Alltagskopfbedeckung erlebt.

The Irish walking hat looks like a bucket hat made of tweed or wool, although the Irish walking hat has a much neater finish than the bucket. It usually includes a decorative band on the crown and sometimes even a crease. The dominant colour is green, but there are also brown or grey Irish walking hats whose plain colour is then enhanced by a feather. It's a mid-season hat that's perfect for country walks in the autumn and, like the bucket hat, it folds easily into a pocket. Along with the deerstalker, it has been a popular hat among hunters since the 1930s. Nothing prevents you from wearing this hat in the city where it will give your outfit a soft gentleman-farmer look. The simplicity of its shape and its unisex character could contribute to its revival as everyday wear.

Die Karakul-mütze

The karakul hat (aka astrakhan hat)

Diese ovale Mütze, die sich mühelos zusammenfalten lässt, kommt aus Zentralasien. Sie besteht aus dem Fell des Lammes des Karakulschafes (wobei Karakul in den Turksprachen so viel wie schwarzes Fell bedeutet). Das Fell des Karakullammes ist gekräuselt, extrem weich und durchdringend schwarz. Es wird auch für Mäntel verwendet. Von Pakistan bis zum Kaukasus wird diese Mütze von Männern getragen, die es sich leisten können, nicht weil sie sonderlich praktisch ist, sondern als Statussymbol. Als Statussymbol trugen sie auch die kommunistischen Staatschefs der Breschnew-Ära, vermutlich auf Veranlassung von Leonid Breschnew, der in den späten 1950er Erster Parteisekretär der Sowjetrepublik Kasachstan in Zentralasien gewesen war. Wenn man einen Mantel mit einem Astrachankragen trägt (der andere Name dieser Pelzsorte, Astrachan heißt die Stadt im Wolgadelta, die jahrhundertelang das Tor zu Zentralasien war), dann verleiht einem eine Karakulmütze ein exotisches, aber elegantes Aussehen. Eine rundere Variante dieser Mütze wird im Kaukasus und von den Kosaken getragen.

This oval hat, which forms a rounded triangle when put on the head, and folds easily, originates from Central Asia. It is produced with the wool of a local breed of lamb, the karakul, whose name means "black fur" in Turkic languages. The wool of a newly born karakul lamb is known for its softness, curliness and bright black hues, and it is also used for overcoats. Worn by upper-class, educated men from Pakistan to the Caucasus, the karakul is an indicator of social status rather than a utilitarian garment. As such, it was adopted by Soviet leaders of the Brezhnev era, probably at the instigation of Leonid Brezhnev himself, who led the Soviet Republic of Kazakhstan in Central Asia in the late 1950s. If you wear a coat with an astrakhan collar (the other name for fur, which derives from a Russian city in the Volga Delta that served as a gateway to Asia for centuries), wearing a karakul hat will add a slightly exotic, but stylish touch to your look. A rounder variant of the hat is worn in the Caucasus and by ethnic Cossacks.

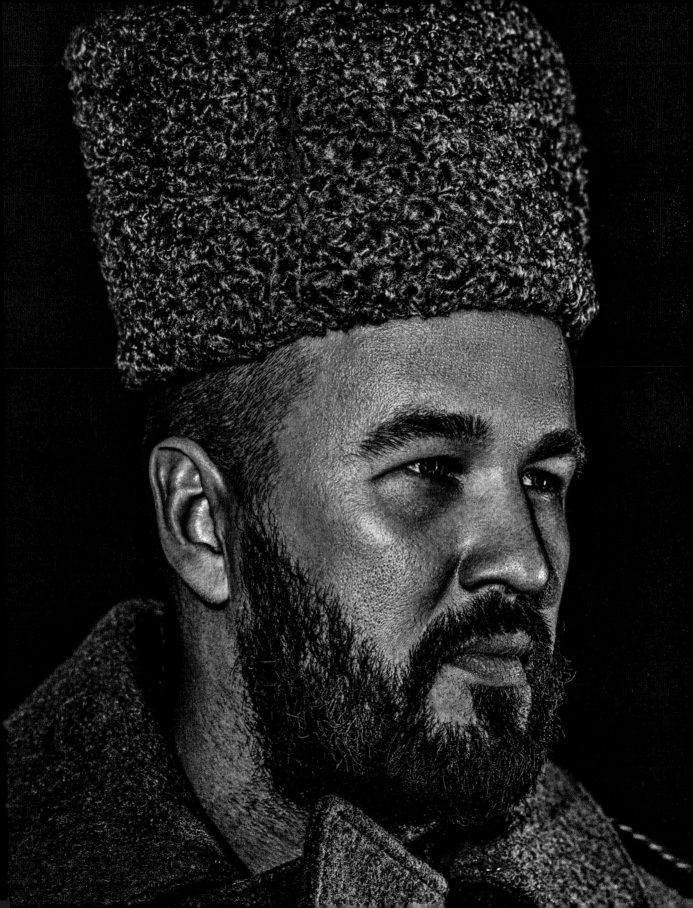

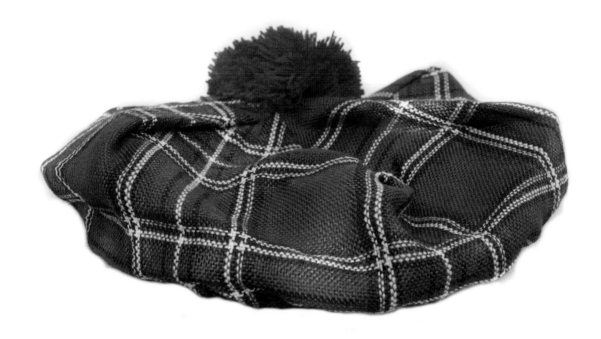

Die Schottenmütze

Diese traditionelle schottische Wollmütze ähnelt einem Barett, aber die Krone ist weiter und trägt einen Bommel als Abschluss. Ihr schottischer Name stammt vom Helden eines Gedichts Robert Burns, dem Dichter der schottischen Romantik, das 1790 erschien. Die Figur geht jedoch auf das 16. Jahrhundert zurück. Die Mütze, auch als „blue bonnet" (blaue Mütze) bekannt, war Teil der Alltagskleidung eines großen Teils der männlichen Bevölkerung Schottlands. Erst seit dem späten 19. Jahrhundert werden diese ursprünglich einfarbigen Mützen aus kariertem Stoff (Tartan, Schottenkaro) hergestellt. Die Mütze wird seit dem Ersten Weltkrieg von den schottischen Regimentern getragen. Sie ersetzte damals den Glengarry-Hut, die eleganter, in den Gräben jedoch weniger bequem war. Sie wird von einigen Regimentern in Großbritannien und Kanada jedoch noch bei der Parade getragen. Es gibt Schottenmützen, deren Krone aus einem Stück besteht, andere sind aus sechs dreieckigen Teilen zusammengesetzt, die am Bommel zusammenlaufen. Man kann eine einfarbige Schottenmütze an einem kalten, windigen Tag auf der Straße tragen, ohne deswegen verkleidet auszusehen.

The Tam o'Shanter

This traditional woollen Scottish cap has a shape quite similar to that of the beret, although the crown is slightly wider and looser, and a pompom invariably adorns its top. The name derives from the hero of a poem by Robert Burns, the bard of Scottish Romanticism, published in 1790, although its origins date back to the 16th century. The Tam o'Shanter was then known as the "blue bonnet", and it was the daily headgear for a large part of the male population in Scotland. It wasn't until the late 19th century that the tartan fashion added colourful patterns to this once mono-chrome cap. The Tam o'Shanter was adopted by the Scottish regiments engaged in the First World War to replace the Glengarry, which was more elegant but less comfortable in the trenches. It is still used as a parade cap in some regiments in the United Kingdom and Canada. There are as many Tam o'Shanter cap with a one-piece crown as there are versions with six triangular panels that join under the pompom. It is perfectly acceptable to wear a monochrome Tam o'Shanter on the street on a cold, windy day without looking disguised.

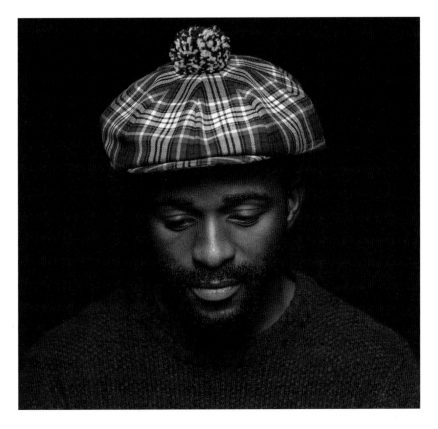

Der Tirolerhut

Dieser grüne Filzhut mit seiner breiten Krempe und hoher Krone mit Kniff gehört zur Tiroler Tracht. Die Gegend, in der dieser Hut getragen wird, reicht jedoch weit über Tirol hinaus. Tirolerhüte begegnen einem auch in Bayern, in den italienischen Alpen und im Osten der Schweiz. In Innsbruck, die frühere Hauptstadt Tirols, fällt auf, dass es so etwas wie einen einheitlichen Tirolerhut nicht gibt. Grün scheint die klassische Farbe eines Tirolerhuts zu sein, weil er von Jägern getragen wurde, die nicht auffallen wollten, aber braunen Filz sieht man auch. Die Form des Tiroler-huts verändert sich von einem Tal zum nächsten. Die Hutdekorationen sind jedoch überall die gleichen: Eine Kordel als Hutband, Federn, Blumen, Hutnadel und ein Gamsbart. Der Hut ist bei jedem Volksfest in Tirol, aber auch beim Oktoberfest de rigueur. Auch Jäger tragen ihn gerne. Leonid Breschnew, ehemaliges Staatsoberhaupt der Sowjetunion, besaß einen und ließ sich gerne auf der Jagd mit anderen Kommunistenführern wie Josip Broz Tito und Erich Honecker damit fotografieren.

The Tyrolean hat

This beautiful green felt hat with its wide brim and high, pinched crown has become a symbol of Tyrol, just like the Tracht, the traditional costume it complements. The geographical area where it is worn actually extends far beyond its region of origin: men in Tyrolean hats can be spotted all over Bavaria, Austria, the Italian Alps, and eastern Switzerland. And yet even in Innsbruck, the historic capital of Tyrol, some might tell you that there is no such thing as a "standard" Tyrolean hat. Green has emerged as the classic colour for Tyrolean hats because hunters wear them for camouflage, but grey or brown felt can also be found. If the shape of the Tyrolean hat varies a little from one valley to another,

the accessories that decorate it are the same everywhere: a corded hatband, feathers, flowers and pins, and the Gamsbart, the brush made of chamois goat's beard. The hat is de rigueur at every local festival in Tyrol, as well as for the Oktoberfest, Munich's world-famous beer festival that takes place every year at the end of September. It is also a popular hat for hunters around the world: even former Soviet leader, Leonid Brezhnev, owned one and was regularly photographed on hunting parties with other communist statesmen such as Josip Broz Tito or Erich Honecker.

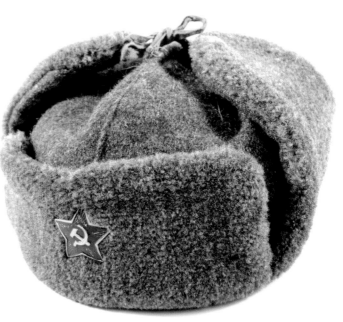

Die Uschanka (auch Schapka)

Diese warme Wintermütze mit Ohrenklappen ist seit Jahrhunderten in Nordeuropa und in den Bergregionen des Balkans verbreitet. Ihr Name wird vom Wort „Uschi" (Ohren) abgeleitet, das in den meisten slawischen Sprachen vorkommt. Traditionell werden diese Mützen aus Fell (Bären, Füchse, Hasen oder Bisam) hergestellt und schützen hervorragend vor der Kälte und zwar nicht nur wegen der Ohrenklappe, sondern weil sie auch über der Stirn eine Klappe besitzen, ein Bollwerk gegen die eisigen Winde. Diese Mützen werden von den russischen Bauern seit Jahrhunderten getragen und heißt in Russland auch Schapka, was einfach nur Mütze bedeutet. Sie ist zu einem Symbol für Russ-land geworden. Dort ist sie nach wie vor sehr beliebt, sie wird aber auch in Skandinavien und Kanada getragen. In Kanada ist sie Teil der Winteruniform der Polizei und des Militärs. Die Uschanka ist ideal für Aktivitäten im Freien an sehr kalten Tagen: für Waldspaziergänge, aber auch für das Skifahren und Schlittschuhlaufen. Die Ohrenklappen lassen sich mühelos hochbinden, dann ist nur der obere Teil der Ohren geschützt. Uschankas mit Abzeichen der Roten Armee oder der russischen Polizei, die seit der Perestroika sehr beliebt sind, sind in der Regel aus Webpelz. Sie sind weniger warm als die aus richtigem Pelz. Die teuersten Uschankas sind aus Nerz, Bieber, Waschbär oder Silberfuchs.

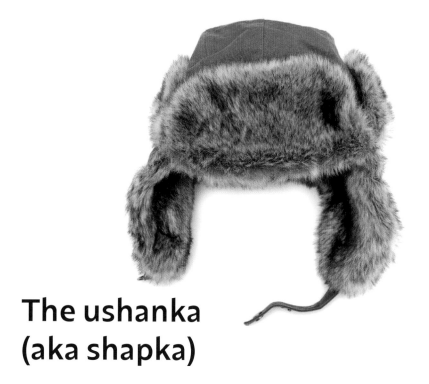

The ushanka (aka shapka)

This warm winter hat with its round crown and earflaps has been known for centuries throughout northern Europe and the mountainous regions of the Balkans. Its name derives from the word "ushi", which is common to most Slavic languages and means "ears". Traditionally made of animal fur (bear, fox, sheep, rabbit, or muskrat), the ushanka offers the best possible protection against the intense cold thanks not only to its foldable earflaps, but also to its double crown at the front that forms a bulwark against icy winds. Worn by Russian peasants for centuries, the ushanka, also called "shapka" ("bonnet" in Russian), has become a symbol of the country, where it remains very popular, but its use is also widespread in Scandi-navia and Canada, where it is part of the winter uniform of police forces and the military. The ushan-ka is the ideal hat for all outdoor activities on very cold days: walks in the forest, but also skiing or ice-skating. The earflaps can be easily tied up at the top of the crown: in this case, only the upper part of the ears is protected. Ushanka models with Russian army or police insignia, which have been in vogue since perestroika, are generally made of synthetic fur. Their thermal qualities are poorer than those of natural fur. The most luxurious ushankas are made of mink, beaver, raccoon or silver fox fur.

HATMAKERS

HUTMACHER

Von Akubra bis Stetson: Legendäre Hutmacher

Die Welt der Hutmacher ist weit davon entfernt, eine schlafende Schönheit zu sein. Sie ist ein dynamisches Universum, in dem jahrhundertealte Häuser organisch mit von jungen Enthusiasten gegründeten Unternehmen koexistieren und so dem Beispiel der Modewelt folgen. Anstatt sämtliche Akteure aufzuzählen, haben wir einige Unternehmen ausgewählt, die die Geschichte des Hutes besonders geprägt haben.

Akubra

Akubra wurde 1874 von Benjamin Dunkerley, einem jungen Hutmacher, der gerade aus England eingetroffen war, in Hobart, Tasmanien, gegründet. Dunkerley war der Erfinder einer Maschine, die das Fell von Kaninchen entfernen konnte, was im Vergleich zu einer manuellen Bearbeitung Zeit und Kosten einsparte. Der wachsende Erfolg seiner Kaninchenfellmützen veranlasste Dunkerley, sich Anfang des 20. Jahrhunderts in Sidney niederzulassen. 1904 gesellte sich sein zukünftiger Schwiegersohn Stephen Keir zu ihm, ein Hutmacher, der ebenfalls aus England kam und dessen Nachkommen das Familienunternehmen weiterführten. Die Marke ist vor allem für ihren ikonischen Akubra-Buschhut bekannt, aber sie liefert auch Hüte für die australische Armee und für die australische Nationalmannschaft bei sämtlichen Olympischen Sommerspielen. Es ist zudem eines der wenigen Unternehmen, das Zylinderhüte vermarktet.

Bailey

Die Bailey Hat Company, 1922 von George S. Bailey in Los Angeles gegründet, zählte einst alle großen Hollywood-Schauspieler zu ihren Kunden: Gary Cooper, Humphrey Bogart, Fred Astaire und Cary Grant. Ihre tadellos gearbeiteten Hüte sind zu Klassikern der männlichen Eleganz geworden und verkörpern das goldene Zeitalter der Hollywood-Filme. Bailey ist heute Teil der Bollman Hat Company. Ihr Katalog umfasst eine beeindruckende Auswahl an Filzhüten in einer Vielzahl von Farben, aber auch alle anderen Arten von klassischen Hüten: Melone, Porkpie- und Panamahüte sowie Mützen.

Borsalino

1857 von Giuseppe Borsalino in Alessandria in der italienischen Region Piemont gegründet, ist der Name Borsalino zum Synonym für den Fedora geworden, da die Marke sehr eng mit dieser besonderen Hutart verbunden ist. 1834 in einer bescheidenen Familie aufgewachsen, ging Giuseppe Borsalino im Alter von sechzehn Jahren als Lehrling nach Frankreich, um bei der Pariser Firma Berteil die Herstellung von Luxushüten zu erlernen. Als er 1856 im Alter von 22 Jahren nach Italien zurückkehrte, eröffnete er sein erstes Geschäft, das ständig größer wurde. Anfang 1900 hatte er mehr als 2.500 Mitarbeiter und produzierte fast zwei Millionen Hüte pro Jahr, von denen über die Hälfte vor allem in die Vereinigten Staaten und nach Großbritannien exportiert wurden. Das Logo der Marke Borsalino wurde von einem der besten italienischen Illustratoren der damaligen Zeit Marcello Dudovich, entworfen und war ein Symbol italienischer Eleganz. Auf seinem Höhepunkt in den 1930er Jahren zählte das Unternehmen selbst Al Capone zu seinen Stammkunden sowie zahlreiche Filmstars, darunter Humphrey Bogart und Ingrid Bergman aus *Casablanca*.

Trotz der sinkenden Nachfrage an Hüten in den 1960er Jahren verkörperte Borsalino in den 1970er und 1980er Jahren weiterhin Eleganz und Raffinesse, nicht zuletzt dank Jacques Derays Film *Borsalino* (1974), in dem Alain Delon einen Gangster spielt, der immer nach der neuesten Mode gekleidet ist und stets einen Borsalino auf dem Kopf trägt. Borsalino ist eine beispielhafte Marke italienischen Designs und erhielt 2017 zur Feier des 160-jährigen Bestehens des Unternehmens von der italienischen Post eine Sonderbriefmarke.

Kangol

Trotz der Känguru-Silhouette, die alle Mützen ziert, stammt die Marke Kangol nicht aus Australien, sondern aus dem Nordwesten Englands, wo sie 1938 unter der Leitung des polnisch-jüdischen Hutmachers Jacques Spreiregen gegründet wurde. Dieser beschloss, sich auf hochwertige Mützen zu spezialisieren. Seine ersten Modelle hatten dank einer Mischung aus Angora und Wolle (k-ang-ol steht für: Knitting Angora and Wool - Stricken von Angora und Wolle) einen unvergleichlichen Komfort und wurden von Mode-Ikonen wie dem Herzog von Windsor und Greta Garbo bewundert. In der Nachkriegszeit brachte das Unternehmen 1954 die legendäre Wollmütze Wool 504 auf den Markt, die als klassische Baskenmütze mit einem auf der Vorderseite angebrachten Visier geliefert wurde. Ab den 1980er Jahren wurde die Marke auch mit der Geburt des Hip-Hop in New York in Verbindung gebracht: Man sieht junge Musiker und Tänzer mit Caps, Stoffhüten und Porkpies, die von Kangol hergestellt wurden.

Lock & Co. Hatters

Die Adresse von Lock & Co. Hatters, 6 St. James Street in London, ist seit 1765 unverändert und damit das älteste Hutgeschäft der Welt. Als renommiertes und traditionsreiches Unternehmen zählte Lock & Co. die ersten Mitglieder des englischen Adels zu seinen Kunden, darunter Admiral Lord Nelson und Beau Brummell, aber auch Schriftsteller und Politiker wie Oscar Wilde und Winston Churchill. Einer der Höhepunkte in der Geschichte von Lock & Co. ist die Entstehung des Designs der Melone. Der ursprünglich "Coke-Hut" genannte Hut wurde von Lord William Coke III. und seinem jüngeren Bruder, dem Adeligen Edward Coke, in Auftrag gegeben, um die Wildhüter ihres Anwesens in Norfolk auszustatten. Obwohl er für die Jagd entworfen worden war, wurde der Bowlerhut, als dieser neue Stil bekannt wurde (benannt nach den Brüdern Thomas und William Bowler, die ihn herstellten) zum gewöhnlichen Hut der Stadtbewohner und ersetzte den eher unpraktischen Zylinder. Bis zum heutigen Tag ist Lock & Co. der Hutmacher für Berühmtheiten und gekrönte Häupter. Das Geschäft in der St. James Street bietet alle Arten von Hüten und Mützen zu Preisen an, die von erschwinglichem Luxus bis hin zu Einzelstücken reichen, die Tausende von Pfund kosten können.

Mayser

Die Mayser Hutmacherey wurde 1800 vom Hutmacher Leonhard Mayser im süddeutschen Ulm gegründet und entwickelte sich im Laufe des 19. Jahrhunderts auf spektakuläre Weise zum führenden Hersteller von Herrenhüten in Deutschland und zu einem der größten Arbeitgeber der Stadt. Nach drei Generationen des expandierenden Familienunternehmens wurde das Unternehmen Anfang des 20. Jahrhunderts von dem Münchner Hutmacher Anton Seidl übernommen und setzte seinen Aufstieg in den 1920er Jahren fort, als Seidl mit der Produktion von Damenhüten und Strohmodellen begann. In den vom "deutschen Wirtschaftswunder" geprägten Nachkriegsjahren stellte Mayser 1963 mit dreieinhalb Millionen produzierten Hüten an mehr als vierzig Standorten in ganz Westdeutschland einen neuen Produktionsrekord auf. Obwohl die Nachfrage nach Hüten in den folgenden Jahrzehnten stark zurückging, bringt Mayser heute immer noch mehr als 200 neue Hutmodelle pro Jahr auf den Markt, verteilt auf zwei Saisons und mit besonderem Augenmerk auf die Verarbeitung.

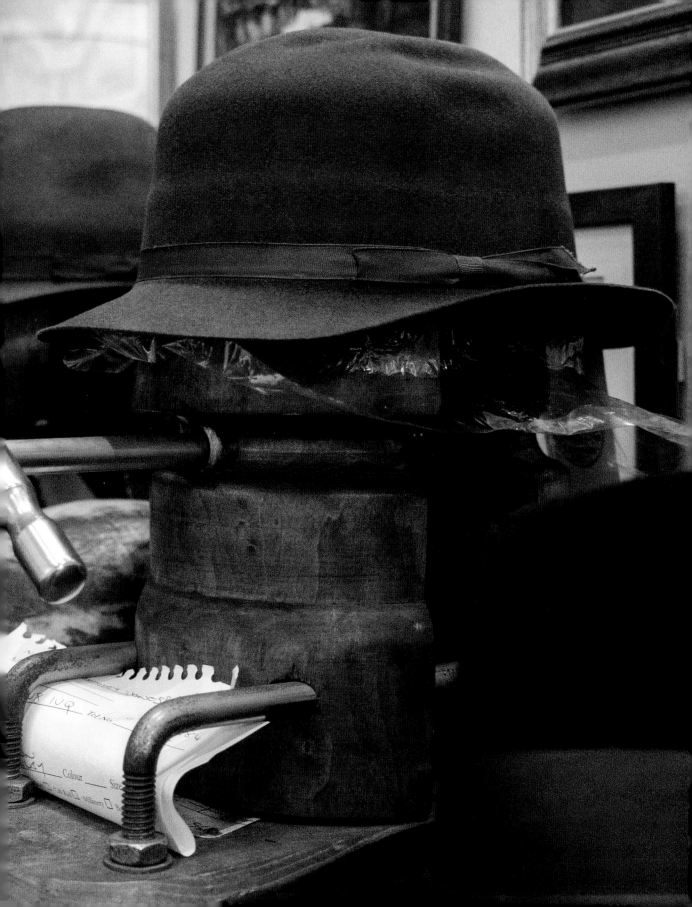

Mühlbauer

In bester Wiener Tradition bietet Mühlbauer Hüte an, die auf altmodische Weise hergestellt werden, aber einem modernen Touch haben. 1903 eröffnete Julianna Mühlbauer ihre Hutfabrik in Floridsdorf am Stadtrand von Wien, und vier Generationen später sind einige der ursprünglichen Holzklötze aus dieser Zeit noch immer in diesem Unternehmen im Einsatz, in dem die Hüte vollständig von Hand gefertigt werden. Die Vielfalt der Materialien und Farben zeigt eine bewusste Offenheit für aktuelle Trends, so der Urenkel des Gründers, Klaus Mühlbauer, der das Unternehmen seit 2001 leitet. Kaum ein anderer Hutmacher bietet ein Sortiment an Hüten an, das so originell und gleichzeitig vollkommen elegant und klassisch ist. Wenn Sie Ihrem Outfit den perfekten Hauch von Exzentrizität verleihen wollen, sind Sie bei Mühlbauer an der richtigen Adresse.

Signes

Das 1968 in der Nähe von Alicante, Spanien, gegründete Unternehmen Signes ist im Vergleich zu anderen kultigen Hutmarken relativ jung, aber die Qualität seiner Hüte und ihre erschwinglichen Preise haben dieses Unternehmen zu einem wichtigen Akteur in der heutigen Hutindustrie gemacht. Nüchtern und klassisch, haben die Hüte von Signes das jahrhundertealte Know-how der spanischen Hutmacher geerbt, denen es gelang, ihre Landsleute vor den Auswüchsen der Sonne zu schützen - eine sehr nützliche Expertise Zeiten der globalen Erwärmung. Für diejenigen, die lässige Eleganz mögen, kreieren die Hüte von Signes den perfekten Stil, der zu jedem Outfit passt. Sie bringen einen Hauch von mediterranem Flair und den Eindruck, im Urlaub zu sein.

Stetson

Stetson ist ein Stück amerikanischer Geschichte, und die Geschichte seiner Gründung verdankt er einem Wunder: dem Sohn eines Hutmachers an der Ostküste, John B. Stetson, dem die Ärzte wegen seiner zerbrechlichen Lungen ein kurzes Leben vorhersagten und der beschloss, den Rest seines Lebens auf Reisen in den Wilden Westen zu verbringen. Diese Reise in das Herz des amerikanischen Kontinents Anfang der 1850er Jahre war in mehrfacher Hinsicht vorteilhaft: Erstens half sie Stetson seine Brustschmerzen zu heilen, und zweitens machte ihm die Gesellschaft von Abenteurern und Forschern klar, dass gewöhnliche Hüte nicht zu ihrem Lebensstil passten. Es war notwendig, einen Hut mit einer Krempe zu schaffen, die breit genug war, um das Gesicht vor Regen, Schnee oder Sandstürmen zu schützen, aber vor allem mit einem Pelzfilz, der wasserdicht genug war, um auf der Innenseite der Krone zum Wasserziehen verwendet werden zu können. Nachdem er mehrere Prototypen dieses neuen Hutdesigns angefertigt und an den Cowboys, die er unterwegs traf, getestet hatte, ging Stetson zurück in den Osten, um die industrielle Produktion des Boss of the Plains, wie der neue Hut später genannt wurde, aufzunehmen. Ursprünglich nur in den zwei Farben Schwarz und Weiß produziert, war der Boss of the Plains ein schillernder Erfolg, der Stetson an die Spitze der Hutmacherszene katapultierte. Vierzig Jahre nach seiner Gründung produzierte Stetson mehr als zwei Millionen Hüte pro Jahr, und die Marke war weit über die Vereinigten Staaten hinaus bekannt. Obwohl sich die Marke seither diversifiziert hat, sind die Hüte im "westlichen" Stil nach wie vor das zeitlose Aushängeschild des Unternehmens. Sie werden täglich von Millionen von Menschen im Süden und Westen der Vereinigten Staaten getragen, und Berühmtheiten wie Johnny Depp und Leonardo di Caprio gehören zu ihren treuen Kunden.

From Akubra to Stetson: Legendary hatmakers

Far from being a sleeping beauty, the world of hatmakers is a dynamic universe where centuries-old houses organically coexist with young companies created by enthusiasts, thus following the example of the fashion world. Rather than enumerating all the players, we have chosen a few of thenames that have made the history of the hat.

Akubra

Akubra was founded in Hobart, Tasmania in 1874 by Benjamin Dunkerley, a young hatter who had just arrived from England. Dunkerley came up with the idea of a machine that could remove the fur from rabbit skins, which saved both time and costs compared to doing the process by hand.

The growing success of his rabbit fur hats prompted Dunkerley to settle in Sidney at the beginning of the 20th century. He was joined in 1904 by his future son-in-law, Stephen Keir, a hatter who also arrived from England and whose descendants continue to run the family business. The growing success of his rabbit fur hats prompted Dinkerley to settle in Sydney at the beginning of the 20th century. He was joined in 1904 by his future son-in-law, Stephen Keir, a hatter who also arrived from England and whose descendants continue to run the family business. The brand is best known for its iconic Akubra bush hat, but it also supplies hats for the Australian army and for the Australian Olympic team at all the summer games. It is one of the few companies to commercialize top hats.

Bailey

The Bailey Hat Company, founded in 1922 by George S. Bailey in Los Angeles, counted among its customers all the great Hollywood actors: Gary Cooper, Humphrey Bogart, Fred Astaire, and Cary Grant. Its impeccably crafted hats have become classics of men's elegance and embody the golden age of Hollywood movies. Bailey is now part of the Bollman Hat Company. Its catalog includes an impressive selection of fedoras in a wide range of colors, but also all other types of classic hat: bowler hats, porkpie and panama hats, as well as caps.

Borsalino

Founded by Giuseppe Borsalino in 1857 in Alessandria, in the Italian Piedmont region, the name Borsalino has become synonymous with the fedora, as the brand is very closely associated with this particular type of hat. Born into a modest family in 1834, Giuseppe Borsalino went to France as an apprentice at the age of sixteen to learn how to make luxury hats at the Parisian company Berteil. Returning to Italy in 1856 at the age of 22, he opened his first store, which grew exponentially. By the early 1900s, it had more than 2,500 employees and produced nearly two million hats a year, more than half of which were exported, notably to the United States and Great Britain. The Borsalino brand logo was designed by one of the best Italian illustrators of the time, Marcello Dudovich (who also signed several advertising posters for the hats) and was a symbol of Italian elegance. At its peak in the 1930s, the company counted Al Capone among its regular customers, as well as many movie stars, including Humphrey Bogart and Ingrid Bergman in *Casablanca*.

Despite the public's disaffection with hats in the 1960s, Borsalino continued to embody elegance and refinement in the 1970s and 1980s thanks to Jacques Deray's film *Borsalino* (1974), in which Alain Delon plays a gangster always dressed in the latest fashion, and who invariably wears a Borsalino on his head. An emblematic brand of Italian design, Borsalino received a commemorative postage stamp from the Italian Post Office in 2017 to celebrate the company's 160th anniversary.

Kangol

Despite the kangaroo silhouette that adorns all its caps, the Kangol brand does not originate from Australia but from the northwest of England where it was founded in 1938, under the guidance of a Polish Jewish hatmaker, Jacques Spreiregen, who decided to specialize in high-quality berets and caps. His first models had unequalled comfort thanks to a mixture of angora and wool (k-ang-ol stands for **k**nitting **ang**ora and wo**ol**) were admired by fashion icons such as the Duke of Windsor and Greta Garbo. The post-war era saw the company launch the iconic Wool 504 flat cap in 1954, which comes as a classic beret with a visor added on the front. From the 1980s, the brand also came to be associated with the birth of hip hop in New York: Young musicians and dancers are seen wearing caps, bucket hats and porkpie hats produced by Kangol.

Lock & Co. Hatters

The address of Lock & Co. Hatters, 6 St. James Street in London, has remained unchanged since 1765, making it the oldest hat shop in the world. A prestigious and traditional company, Lock & Co. has counted among its clients the finest members of the English aristocracy, including Admiral Lord Nelson and Beau Brummell, as well as writers and politicians such as Oscar Wilde and Winston Churchill. One of the highlights in the history of Lock & Co. is originating the design of the bowler hat. The bowler, initially called "Coke hat", was commissioned by Lord

William Coke III and his younger brother, nobleman Edward Coke, to equip the gamekeepers of their estate in Norfolk. Although designed for the hunt, the bowler hat, as this new style became known, was named for the brothers who crafted it, Thomas and William Bowler, and turned into the common hat of city dwellers, thus replacing the rather impractical top hat. To this day, Lock & Co. remains the hatter to celebrities and crowned heads. The shop at St. James Street offers all types of hats and caps at prices ranging from affordable luxury to unique pieces that can cost thousands of pounds.

Mayser

Founded in Ulm, southern Germany, in 1800 by hatter Leonhard Mayser, the Mayser Hutmacherey grew spectacularly throughout the 19th century to become the leading manufacturer of men's hats in Germany and one of the city's largest employers. After three generations of expanding the family business, the company was acquired at the beginning of the 20th century by the Munich hatter Anton Seidl and continued its rise in the 1920s when Seidl began producing women's hats and straw models. In the post-war years marked by the "German economic miracle", Mayser set a new production record in 1963 with three and a half million hats produced at more than forty facilities throughout West Germany. Although the demand for hats fell sharply in the decades that followed, Mayser still launches more than 200 new hat models per year, spread over two seasons, with particular attention to finishing.

Mühlbauer

In the best Viennese tradition, Mühlbauer offers hats made in the old-fashioned way but with a modern touch. In 1903 Julianna Mühlbauer opened her hat factory in Floridsdorf on the outskirts of Vienna, and four generations later some of the wooden blocks from that time are still in use in this company where hats are still made entirely by hand. But the variety of materials and colors shows a deliberate openness to current

trends, as claimed by the founder's great grandson, Klaus Mühlbauer, who has been managing the company since 2001. Few other hatters offer a range of hats that are so original and at the same time perfectly elegant and classic. If you want to add just the perfect touch of eccentricity to your outfit, Mühlbauer is the right address.

Signes

Founded in 1968 near Alicante, Spain, Signes is relatively young compared to other iconic hat brands, but the quality of its hats and their affordable prices have made it an important player in the high-quality hat industry. Sober and classic, Signes hats have inherited the centuries-old know-how of Spanish hatters, who succeeded in protecting their compatriots from the excesses of the sun-- a very useful expertise in these times of global warming. For those who like casual elegance, Signes hats create the perfect style to go with any outfit. They bring a touch of Mediterranean flair and the impression of always being on vacation.

Stetson

Stetson is a piece of American history, and the story of its founding owes much to a miracle: that of an East Coast hatter's son, John B. Stetson, who doctors predicted would have a short life due to his fragile lungs and who decided to spend what was left of his life traveling to the Wild West. This journey into the heart of the American continent in the early 1850s was beneficial in several ways: first, it helped to cure Stetson of his chest pain, and secondly, the company of adventurers and explorers made him realize that ordinary hats were not suited to their lifestyle. It was necessary to create a hat with a brim wide enough to protect the face from rain, snow or sandstorms but especially made with a fur felt that was waterproof enough to use on the inside of the crown for drawing water. After crafting several prototypes of this new hat design and testing them on the cowboys he met along the way, Stetson headed back east to launch the industrial-sized production of the Boss of the Plains, as the new hat was later named. Initially produced in two colors only—black and white—the Boss of the Plains was a dazzling success that propelled Stetson to the forefront of the scene. Forty years after its foundation, Stetson was producing more than two million hats a year and the brand was known far beyond the United States. Although the brand has diversified since then, its "western" style hats remain the timeless emblem of the company. They are worn every day by millions of people in the southern and western United States and celebrities such as Johnny Depp and Leonardo di Caprio are among its loyal customers.

Ein Interview mit Don Rongione, CEO der Bollman Hat Company, Amerikas ältestem Huthersteller

Die Bollman Hat Company ist heute der älteste Huthersteller in den USA, zu den Marken des Unternehmens gehören angesehene Namen wie Bailey, Helen Kaminski, Country Gentleman, Eddy Bros. und Kangol, um nur einige zu nennen. Was sind Ihrer Meinung nach die Hauptgründe für diese außergewöhnliche anhaltende Erfolgsgeschichte? Die Qualität? Die Innovation? Ihre Fähigkeit, alle Marktsegmente abzudecken?

Der Grund, warum wir so viele Veränderungen überlebt haben, liegt in unserer Unternehmenskultur: Wir sind ein Unternehmen, das sich im Besitz der Mitarbeiter befindet, und den Menschen liegt viel an der Organisation, an unserer Geschichte und an der Fortführung unseres Unternehmens. Das Unternehmen ist jetzt 152 Jahre alt, und diese Langlebigkeit hat uns inspiriert und motiviert, innovativ zu sein, uns anzupassen, um auch herausfordernde Zeiten zu überstehen und unseren guten Ruf zu bewahren.

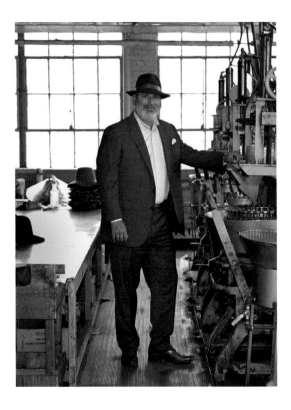

Unsere Geschichte beginnt am 1. Juli 1868, als unser Gründer George Bollman im Alter von 29 Jahren eine alte Whisky-Destillerie an der Main Street in Adamstown, Pennsylvania, mietete und mit der Herstellung von Hüten begann. Ziel war es, die beste Qualität herzustellen, die er produzieren konnte, sowie für seine Familie und die Familien seiner Arbeiter zu sorgen. Diese Ziele haben sich über die Jahre erhalten, obwohl sich seitdem vieles geändert hat. Die Welt hat sich verändert, und wir sind uns bewusst, dass wir als Eigentümer des Unternehmens etwas tun müssen, dass wir einen Weg finden müssen, das Erbe fortzuführen und auf die heutigen Bedürfnisse der globalen Kunden einzugehen. Als Eigentümer des Unternehmens müssen wir ständig darüber nachdenken, wie wir die Tradition an die moderne Zeit anpassen können, um das Unternehmen am Leben zu halten.

Zu Beginn verwendete das Unternehmen Wasser, um die Maschinen zum Laufen zu bringen, da in der Produktion kein Strom verwendet wurde. Das Land, das George Bollman erworben

hatte, lag gegenüber der gepachteten alten Whisky-Destillerie und umfasste eine 1809 erbaute Scheune. In dieser Scheune wurden Pferde gehalten, denn die Firma brauchte Pferde, um die Hüte zum Bahnhof zu bringen, um sie ins ganze Land zu versenden. Die Scheune steht heute immer noch, aber alles andere hat sich radikal verändert. Einige der Herausforderungen sind nach wie vor dieselben, werden aber anders angegangen: wie man Kunden in aller Welt erreicht und wie man mit Lieferanten kommuniziert. Ich glaube, dass wir uns zu einem Unternehmen entwickelt haben, das mit die beste Auswahl an Hüten und Mützen der Welt anbietet. Unsere Produkte sprechen sehr unterschiedliche Kunden mit unterschiedlichen Lebensstilen und Interessen an. Wir haben unsere Markenkollektion strategisch so zusammengestellt, dass wir unsere Zukunft etwas besser kontrollieren können. Das Unternehmen hat zwei Weltkriege überlebt, ebenso wie die Zeiten, in denen die Menschen aufhörten, jeden Tag Hüte zu tragen, und eine unserer jüngsten

Herausforderungen war die Anpassung an neue Einkaufspraktiken wie Online-Verkäufe. Einer unserer Vorteile ist, dass wir Mützen und Hüte für sämtliche Altersgruppen haben; das hat uns über die Jahre hinweg geholfen, Kunden zu halten. Pennsylvania war bekannt für Dutzende von Hutmacherfirmen, die hauptsächlich von deutschen Auswanderern gegründet worden waren. Wir waren nicht die ersten, die in Amerika Hüte herstellten, aber wir haben viele andere Hutmacher überlebt.

Wer ist Ihr typischer Kunde: der Oldtimer-Fan, der wie eine *Mad-Men*-Figur aussehen will? Der Hipster? Modebewusste Männer, die hochwertige Hüte zu erschwinglichen Preisen wollen? Oder junge, urbane Menschen, die eine bequeme Kopfbedeckung suchen?

Ich denke, das sind sie alle. Das Schöne an dem, was wir tun, ist, dass wir Menschen mit völlig unterschiedlichen Lebensstilen gleichermaßen ansprechen, und zwar deshalb, weil es in

unserer DNA liegt, den Kunden Hüte anzu-
bieten, die ihre Persönlichkeit widerspiegeln,
indem wir die Vielfalt der Marken beibehalten.
Damit unsere Marken stark sind, müssen sie
sich selbst, ihrem Vermächtnis treu sein. Es
kann zum Beispiel nicht sein, dass die Firma
Kangol versucht, jedwede Art von Hut herzu-
stellen, denn dann würde Kangol an Glaubwür-
digkeit verlieren, und Glaubwürdigkeit ist alles,
wenn es um eine Marke geht. Das diversifizierte
Markenportfolio spricht verschiedene modebe-
wusste Verbraucher an. Einige der Marken sind
eher hipster-orientiert, mit Produkten, die diese
Kundengruppe ansprechen, während andere
dies nicht tun würden. Kangol hat beispielswei-
se eine starke Verbindung zu Musik, Hip-Hop
und Rap; es hat ein Straßenkulturelement in
seiner DNA. Wir arbeiten mit Straßenmarken
zusammen, um neue Produkte zu schaffen und
gleichzeitig einige der ikonischen Produkte
wie die 504 Schirmmütze am Leben zu er-
halten. Alle Kunden, die Sie anfangs erwähnt
haben, sind unsere Kunden. Aber nicht alle sind
Kunden derselben Marke, denn jede Marke hat
ein bestimmtes Publikum und eine bestimmte
Richtung. Wir haben im Laufe der Jahre Akquisi-
tionen getätigt, um unseren Kundenstamm zu
erweitern, anstatt mit einer Marke zu versu-
chen, sämtliche Arten von Hüten und Mützen
herzustellen.

Wir legten den Schwerpunkt auf Innovation
und Qualität und möchten nicht nur die End-
kunden ansprechen, sondern auch die Einzel-
händler, die unsere Unterstützung benötigen
und ein Grundverständnis für unsere Marken,
um ihre Absätze zu steigern. Auch wenn wir
nicht all unsere Hüte und Mützen in unserer
Fabrik in Adamstown produzieren, so stellen
wir doch sicher, dass unsere Produktionspartner
die gleiche Qualität liefern, die wir von unserem
eigenen Werk erwarten würden. Qualität fängt
beim Design an, und wir stehen dafür, dass die

Details und Spezifikationen genau definiert
sind, ebenso wie die Auswahl der Materialien.

Vor kurzem haben wir etwas mit dem Namen
„Elite"-Wollfilz als Alternative zu Kaninchen-
und Biberfell entwickelt, weil die Menschen
sich um das Wohlbefinden der Tiere sorgen
und Schafwolle ein nachhaltiges Material ist.
Wir wählen superfeine Wolle, um die Quali-
tät von "Elite"-Filz unabhängig vom Preis hoch
zu halten, denn hier kommt es auf die beste
Verarbeitung, den besten Griff und das beste
Aussehen an. Auch im eCommerce haben
wir Neuerungen eingeführt: Ende der 1990er
Jahre erwarben wir die Domain hats.com, und
es gibt keinen besseren Domain-Namen für
den Verkauf von Hüten und Mützen seit wir sie
2001 eingeführt haben. Seitdem verkaufen wir
auch direkt an Endkunden, alle unsere Produkte
und auch andere Marken. Gleichzeitig glaube
ich, dass es keinen wirklichen Ersatz für richti-
ge Ladengeschäfte gibt, denn das Erlebnis des
Hutkaufs ist sehr persönlich: Man möchte ihn
anprobieren können, man möchte sichergehen,
dass er zu eigenen Profil und Kopf passt und
dass man die richtige Passform findet. Das ist
gerade für Erstkäufer besonders wichtig.

**Es sind bis zu 90 Schritte erforderlich, um
einen Hut herzustellen. Wie wichtig sind
handwerkliches Können und Erfahrung in der
Hutmacherei? Wie schaffen Sie es, qualitativ
hochwertige Hüte zu fairen Preisen anzubie-
ten? Ist die Mitarbeiter-Eigentümer-Kultur
generell ein Vorteil im Leben des Unterneh-
mens und in der Art und Weise, wie es seine
Geschäfte betreibt?**

Jeder Rundgang, den ich durch die Fabrik
mache, endet damit, dass der Besucher sagt:
„Ich hatte keine Ahnung, was alles nötig ist, um
einen Hut herzustellen." Die Menschen haben
dann eine größere Wertschätzung dafür, was

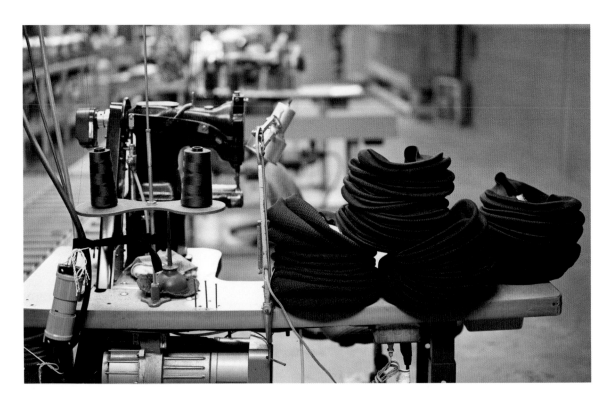

ein Hut ist, nachdem sie den komplexen Herstellungsprozess sowie das Können und den Stolz unserer Mitarbeiter gesehen haben. Die Anzahl der Arbeitsschritte und die Tatsache, dass einige der von uns verwendeten Maschinen schon seit der Gründung des Unternehmens hier stehen, hinterlässt bei unseren Besuchern starken Eindruck. Die Erfahrung der Mitarbeiter spielt hier eine Schlüsselrolle, weil wir zum Beispiel auch diese alten Maschinen warten müssen. Niemand auf der Welt ist in der Lage, unserer Maschinen herzustellen, deshalb brauchen wir geschulte Mitarbeiter, die sich um die Maschinen kümmern. Daher sind die Besitzkultur und die individuellen Fähigkeiten sehr wichtig. Die meisten Mitarbeiter verstehen, dass es sich hier nicht nur um einen reinen Job handelt, sie haben das Gefühl, Teil einer langen Geschichte zu sein. Ich führe neu eingestellte Mitarbeiter persönlich herum und spreche über die Geschichte des Unternehmens. Ich erkläre ihnen, dass es nun an uns liegt, dass unsere Auf-

gaben wichtig sind, und dass die Traditionen für die nächsten Generationen lebendig gehalten werden müssen. Wir sehen uns auch als Verwalter, die die Fabrik irgendwann an die nächste Generation übergeben werden.

Was die Preise betrifft, so konkurrieren wir nicht mit Billigherstellern, unser Ziel ist es, Hüte von höchster Qualität anzubieten, die lange halten, und sie zu einem einigermaßen erschwinglichen Preis zu verkaufen. Wir sind weit davon entfernt, die teuerste Marke zu sein und versuchen, unsere Preise im Rahmen zu halten. In der Vergangenheit, als das Tragen eines Hutes noch eine Notwendigkeit war, als man noch einen Hut haben musste, um nach draußen zu gehen, da war das Geschäft wesentlich einfacher. Jetzt, wo das Tragen eines Hutes mehr ein „Bedürfnis" als eine Notwendigkeit ist, konzentrieren wir uns auf die Entwicklung der Marken, auf Qualität, Innovation und Details, um neue Kunden zu gewinnen. Wir können keine Hüte

zu einem Preis zwischen 20 und 40 Dollar produzieren, was eine preisgünstige Einstiegsstufe wäre, aber wir können hohe Qualität zu einem einigermaßen moderaten Preis anbieten. Unsere integrierte Lieferkette hilft uns, die Kosten unter Kontrolle zu halten, da wir beispielsweise direkten Zugang zu Schafwolle haben. Und wir machen am Ende Gewinn, und nicht mehrer kleine Gewinne entlang der Lieferkette und der Produktion.

Eine unserer jüngsten Innovationen hat uns geholfen, die Retouren von Kunden, die Hüte online kaufen, zu reduzieren: Der Hauptgrund für Retouren ist, dass die Hüte etwas zu groß oder zu klein sind, da die Menschen nicht unbedingt ihre Kopfgröße kennen. Manchmal müssen Sie, je nach Gesichtsform, die nächste Größe wählen. Wenn sie sich also nicht sicher sind, ob sie zwischen den Größen liegen, sollten sie die nächsthöhere Größe wählen, und wir schicken ihnen einen Filzstreifen, den sie unter das Schweißband legen können. Der Streifen kann auf der Vorderseite, an den Seiten oder auf der Rückseite angebracht werden, so dass er ganz einfach zu verwenden ist. Den restlichen Filz haben wir verwendet, um Filzmasken zuzuschneiden und so den Abfall zu minimieren.

Ihr Unternehmen stellt auch Hüte für hochwertige Modedesigner her. Können Sie uns bitte mehr darüber erzählen?

Es gibt hier zwei Elemente. Das eine ist die Zusammenarbeit mit Modedesignern, die zu uns kommen und sagen: "Wir wollen gemeinsam an einem Hut arbeiten, wir werden gemeinsam an dem Entwurf arbeiten, er wird Ihr und unser Logo tragen, und wir werden ihn an unseren Kundenstamm vermarkten. Kangol war im Laufe der letzten Jahre unsere aktivste Marke bei der Zusammenarbeit mit führenden Modedesignern, weil sie selbst eine ikonische Marke ist. Sie ist berühmt für ihre lässigen Mützen und ihre einzigartigen Stoffe, was die Zusammenarbeit mit den besten Designern möglich macht. Während wir hier sprechen, arbeiten wir mit einer Straßenmodemarke namens Supreme zusammen. Und dann haben wir noch ein weiteres Element: Wir sind ursprünglich Hutmacher von Handelsmarken, was bedeutet, dass wir in den ersten 120 Jahren in der Geschichte von Bollman keine eigene Marke hatten, sondern ein Unternehmen waren, das Hüte für andere Marken herstellte. Das tun wir auch heute noch, für Marken wie Rag & Bone, Ralph Lauren oder Orvis. In diesem Szenario sind wir nicht in der Lage, selbst diese Hüte zu vermarkten. Der Verkauf der saisonalen Sortimente für alle unsere Marken, Kooperationen und Handelsmarkenprovisionen sind wichtige Bestandteile unseres Geschäfts. Auch wenn wir 120 Jahre alt werden mussten, bevor wir die erste unserer Marken herausbrachten, machen unsere Eigenmarken heute den größten Teil unseres Umsatzes aus.

Als wir unser 150-jähriges Jubiläum feierten, beschlossen wir, unsere dienstältesten Mitarbeiter-Eigentümer zu ehren: Wir haben zusammen mit diesen 24 Mitarbeitern - 12 Frauen und 12 Männer -, die mehr als 35 Jahre bei Bollman gearbeitet haben, Hüte entworfen und diesen Hüten die Namen unserer Mitarbeiter gegeben. Diese Hüte haben etwas Besonderes, denn man trägt nicht einfach einen Hut, sondern fühlt sich mit der Geschichte der Männer und Frauen verbunden, die sie tatsächlich herstellen. Diese „Makers' Collection" wird auf www.hats.com verkauft.

Was würde junge Männer dazu motivieren, heute einen Hut zu tragen? Der Hauch von Maskulinität, der mit klassischen Hüten verbunden ist? Der Komfort und die Eleganz, die er bietet? Die Tatsache, dass sich immer mehr Prominente für einen Hut entscheiden?

Es sind eigentlich all diese Dinge. Es fängt damit an, dass man den Mut haben muss, sich etwas auf den Kopf zu setzen, denn wenn man noch nie einen Hut getragen hat und die meisten Menschen um einen herum keinen Hut tragen, muss man bereit sein, anders auszusehen. Aber da immer mehr Menschen einen Hut tragen, überwindet man diesen ersten Schritt meist leicht. Und dann geht es darum, so gut wie möglich auszusehen und sich so gut wie möglich zu fühlen. Für mich hebt ein Hut die Stimmung, man fühlt sich besser, er unterstreicht die Persönlichkeit und stärkt den Charakter. Er wertet die Garderobe auf und zeugt von Stilgefühl. Viele Leute merken das und sprechen einen darauf an. Zum Beispiel bekomme ich dadurch regelmäßig Komplimente. Ein Hut definiert den Charakter. Manche Leute wollen sich persönlich branden, und ein Hut hilft dabei. Wenn Sie jemanden ansehen, sehen Sie zunächst in seine Augen und Sie bemerken, was die Leute auf dem Kopf tragen – eine Brille, einen Hut oder eine Mütze. Außerdem kann man verschiedene Hüte tragen, je nachdem, ob man zu einem formellen Abendessen, einer Hochzeit oder zu einem Treffen mit Freunden geht. Man muss sich nicht auf einen Hut festlegen. Bei einem Hut geht es darum, sein Aussehen zu unterstreichen, es geht darum, sich ein Stück weit zu verkleiden, und der Routine zu entfliehen. Und es geht auch darum, sich vor den natürlichen Elementen zu schützen, vor Sonne und Kälte, denn das Bedecken des Kopfes verringert den Verlust von Körperwärme. Das ist das funktionelle Element, wenn es um einen Hut geht. Ich sage gerne, dass Menschen Hüte aus Gründen der Mode, der Funktion, des Spaßes und der Uniformität tragen – aber das Wichtigste ist und bleibt die Mode und der Ausdruck Ihrer Persönlichkeit.

Im Gegensatz zu Mützen, die vielseitiger zu sein scheinen, haben sich die Hutdesigns seit dem Ende des 19. Jahrhunderts nicht so sehr verändert: Wir tragen immer noch Fedoras, Porkpies, Panamahüte … Können Sie sich ein völlig neues Hutdesign vorstellen, etwas, das der Hut für den Mann des 21. Jahrhunderts werden würde? Was wären die Voraussetzungen für eine weltweite Wiederbelebung der Männerhüte? Und: sind zukünftig wärmere Sommer eine Chance für Hutmacher?

Die Designer sind ständig auf der Suche nach neuen Formen, aber auch nach anderen Stoffen, Farben, Mustern und Behandlungen. All das beschäftigt unsere Designer und die Menschen, die an der Innovation beteiligt sind. Im Laufe der Jahre haben wir uns viele eklektische Looks ausgedacht, manchmal waren sie gut, aber in vielen Fällen haben sie noch nicht einmal die Markteinführung erreicht. Der klassische Look des Fedoras wird immer verfeinert und an die neuesten Trends angepasst werden – mehr Kniffe vorne, höhere Kronen oder eine andere Krempe. Wir mischen auch Stroh und Filz oder Tuch. Wir sind ständig auf der Suche nach Innovationen, auch wenn wir nicht jedes Jahr eine brandneue Form einführen, sondern die bewährten und erfolgreichen Formen modern weiterentwickeln. Wir versuchen, eine Belüftung für Sommerhüte anzubieten, denn wenn die Menschen am Strand sind oder Golf spielen, wollen sie, eine gewisse Frische spüren. Umgekehrt versuchen wir, wärmere Winterhüte zu entwerfen, zum Beispiel mit Filzohrklappen. Zusätzliche Funktionalität ist der Schlüssel zu unserem zukünftigen Erfolg.

Können Sie uns bitte aus dem Sortiment der Hüte und Mützen, die von der Bollman-Unternehmensgruppe produziert werden, Ihre fünf Lieblingshüte nennen, die jeder Mann zu Hause haben sollte? Tragen Sie selbst Hüte? Welche Erfahrungen haben Sie mit dem Tragen von Hüten gemacht?

Ich liebe Hüte auf jeden Fall, und ich bin nie draußen, ohne einen Hut zu tragen. Die Tatsache, dass ich seit einiger Zeit eine Glatze habe, ist sicherlich ein Teil meiner Motivation, aber ich mag das Gefühl, einen Hut auf dem Kopf zu tragen. Der Filzhut mit einer Krempe nach unten auf der Vorderseite von mindestens 2,5 Zoll steht mir ganz gut. Wenn ich joggen gehe, benutze ich eine Baseballmütze, ich liebe auch den Kangol 504 und generell traditionelle flache Mützen. Jeder Mann sollte einen Original Kangol 504 besitzen, er ist lässig, aber recht elegant. Für den Sommer sind die besten Hüte unsere Panamahüte mit ihren breiten Krempen zum Schutz vor der Sonne. Das ist etwas, was jeder Mann in seiner Garderobe haben sollte. Was den Pelzfilz anbelangt, so ziehe ich den „Draper" von Bailey vor, einen Hut aus Biber-Kaninchen-Lammfell, der Mad Men und der Bollman Makers Collection „Steve J." Tribut zollt. Einen Hut zu tragen ist eine sehr persönliche Sache, daher ist diese Liste vielleicht nicht für jeden Mann geeignet. Es geht wirklich darum, womit man sich wohlfühlt, was zu einem passt und was einem hilft, man selbst zu sein. Die Hüte, die ich erwähnt habe, sind klassische Hüte, die jeder in Betracht ziehen sollte. Aber man sollte sich auch nach Hüten und Mützen umsehen, die dem persönlichen Geschmack und Stil entsprechen.

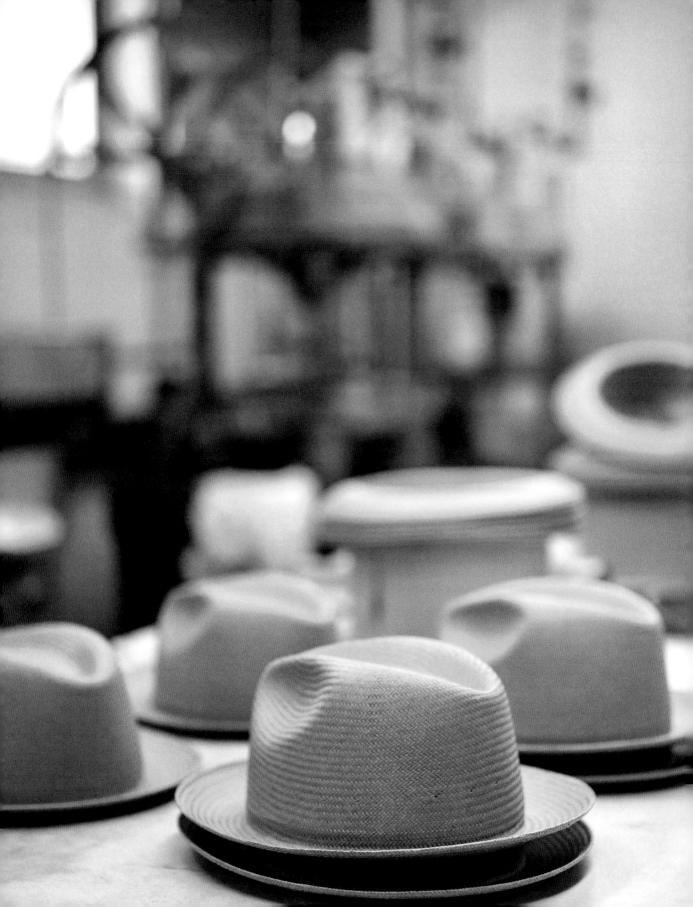

An interview with Don Rongione, CEO of BOLLMAN HAT COMPANY, America's oldest hat manufacturer still in operation

Bollman Hat Company is now the oldest hat manufacturer in the US, and the brands run by the company include some prestigious names such as Bailey, Helen Kaminski, Country Gentleman, Eddy Bros., and Kangol to name but a few. What, in your opinion are the main reasons for this exceptional, ongoing success story? Quality? Innovation? Your ability to cover all market segments?

The reason why we have survived so many changes is because of our ownership culture: We are an employee-owned company, and people care more about the organization, about our heritage, and about continuing our legacy of the company. The company is now 152 years old, and this longevity has inspired us, motivated us to innovate, to adapt to get through challenging times, as well as to keep our strong reputation.

Our story begins on July 1st, 1868, when our founder, George Bollman at the age of 29, rented an old whiskey distillery on Main Street in Adamstown, Pennsylvania and began making hats. The purpose was to make the best quality he could produce, and to provide for his family and for the families of his workers. These goals have survived through the years, although everything around has changed since then. The world has changed many times over, and we stay aware of what is changing, and what we as owners of the company have to do is to find a

way to continue the legacy that has been handed down to us, and to be responsive to the needs of global customers, as they are now. As the owners of the company, we must constantly think about how to adapt the tradition to modern times, to keep the organization going and viable, and to adjust it to our global customers.

At the beginning, the company used water to make the machines work, since there was no electricity used in manufacturing. The land that George Bollman acquired was across from the rented old whiskey distillery and included a barn built in 1809. That barn stalled horses, because the company needed horses to bring the hats to the train station, as there were no trucks to collect them and dispatch them throughout the country. The barn is still there, but everything else has radically changed. Some of the challenges are still the same but are dealt with differently: how to reach customers around the world and how to communicate with suppliers. I believe that we have evolved into a company that offers the best range of hats and caps in the world, and our products appeal to very different customers, with very different lifestyles, and interest levels. We have put our collection of brands together strategically, so that we control our destiny a bit better. The company has survived two world wars, as well as the times when people stopped wearing hats

every day, and one of our latest challenges was to adjust to new shopping practices, such as the rise of online sales, but there is a strong "can-do" attitude among the staff, and we want to address whatever happens to keep the company alive. One of our advantages is that we have caps and hats for all age groups, it has helped us keep customers throughout the years. Pennsylvania was known for dozens of hat-making companies, mainly founded by German emigrants. The availability of water, which was crucial to make the machines work, played an essential role here. We were not the first ones to make hats in America, but we have survived many other hatmakers.

Who is your typical customer: the vintage fashion fan who wants to look like a *Mad-Men-character*? The hipster? Fashion-conscious men who want high-quality hats at affordable prices? Or simply young urban people looking for comfortable headgear?

I think it is all of them. The beauty of what we do in our company, by keeping the diversity of brands, is that we appeal equally to people with completely different lifestyles, and this is because it is in our DNA to provide customers with hats that reflect their personality. For our brands to be strong, they must be true to their self, to their legacy. For example, you cannot have Kangol trying to make every type of hat, because it would lose its credibility, and credibility is everything when it comes to a brand, that connection, and that promise to the consumer. This diversified portfolio of brands will appeal to various fashion-conscious consumers. Some of the brands are more hipster-oriented, with products that appeal to this group of customers, while other brands would not. Kangol has a strong connection with music, hip-hop, and rap; it has a street-culture element in its DNA. We collaborate with street brands to create new products, and at the same time keep some of the iconic products such as the 504 Wool cap

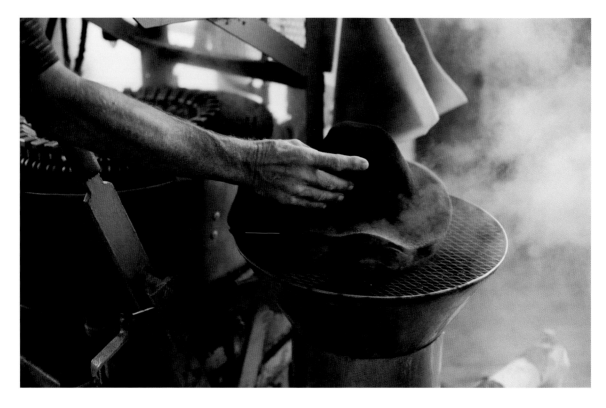

alive. All the customers you mentioned are ours, but not all of them are customers of the same brand, because each brand has a defined audience and direction. We have made acquisitions over the years to try to diversify and to broaden our customer base, instead of having one brand trying to produce all kinds of hats and caps.

We placed the emphasis on innovation and quality, and we tried not only to appeal to the end customers, but also to the retailers who need our support and the understanding of our brands to boost their sales. Even if we do not produce all our hats and caps at the factory in Adamstown, we make sure that our production partners deliver the same quality as we would expect from our own plant. Quality starts with design, and we make sure that the details and specifications are well defined, as well as the selection of materials.

We recently created something called "Elite" wool felt as an alternative to rabbit or beaver fur, because people feel concerned about the well-being of the animals, and sheep wool is a sustainable material. We select super fine wool to keep the "Elite Felt" quality high, regardless of the price, because the best finish, the best feel, and the best look are what matters here. We have also innovated in eCommerce: in the late 1990s we acquired the domain hats.com, and there is no better domain name for selling hats and caps, and we launched it in 2001. Since then we have sold to end customers directly, for all our brands, and other brands too. At the same time, I believe that there is no real replacement for the bricks and mortar stores, because the hat buying experience is very personal: you want to be able to try on, you want to make sure it fits your profile, and your head to find the right fit. This is quite important, especially for first-time buyers.

It requires up to 90 steps to make a hat. How important is craftsmanship and experience in hat making? How do you manage to offer high-quality hats at prices that seem absolutely fair? More generally, is the employee-owner culture an advantage in the life of the company and in the way it operates business?

Every tour I give of the factory ends with the visitor saying "I had no idea there is so much involved in making a hat". People then have a greater appreciation of what a hat is after seeing the complex process, and the skill and pride of our employees. The number of steps involved, and the fact that some of the machines we use have been here since the company was established, makes a strong impression on our visitors. The employees' experience plays a key role here, because, for example, we need to maintain all these old machines. Nobody in the world is able to build some of our equipment, therefore we need trained people to take care of the machines. So the ownership culture and the individual skills are very important. Most of the employees understand that it is not just a job, and they feel that they are part of a long history. I personally give new hired staff a tour, and I talk about the history of the company. I explain that it is on our watch now, that we have important jobs to do, and traditions to keep alive for the next generations to come. We see ourselves as stewards, who will hand over the factory to a new generation.

As for the prices, we do not compete with low-cost producers, our goal is to offer hats of the highest quality that will last and sell them at an affordable price. We are far from being the most expensive brands, we try to keep our prices reasonable. In the past, when wearing a hat was a necessity, when you had to have a hat to go outside, business was significantly easier. Now that wearing a hat is more a "want" than a need, we focus on innovation, on developing the brands, on quality, innovation, and details to

attract new customers. We cannot produce hats at $20-40, which is the low-price entry level, but we can offer high quality at a moderate price range. Our integrated supply chain helps us keep the costs under control, as we have direct access to sheep wool. And we make a profit at the end, as opposed to several profits along the supply chain and the production.

One of our recent innovations has helped us reduce the returns from customers who buy hats online: the main reason for returns is that the hats are slightly too big, or too small as people do not necessarily know their head size. Sometimes, depending on the shape of your face, you need to choose the next size. So, if they are not sure, if they are in-between sizes, they should go for the next size up, and we send them a felt strip to put underneath the sweat-band. The strip can be put on the front, the sides, or on the back, so it is quite easy to use. We used the rest of felt to cut felt face masks, thus limiting the waste.

Your company manufactures hats for high-end fashion designers. Can you please tell us more about this?

There are two elements here. One is the collaboration with fashion designers, who come to us, and say: "We want to collaborate on a hat, we will work jointly on the design, it is going to have your logo on it, and ours, and we will market it to our customer base, and sometimes we can also market it to your customer base. Kangol has been our most active brand in collaborating with some of the leading fashion designers over the years because it is an iconic brand itself. It is famous for its casual caps and its unique fabrics, which makes collaborations with the best designers possible. As we speak, we are working with a street fashion brand called *Supreme*. Then we have another element:

we are private label hatmakers, meaning that for the first 120 years in the history of Bollman we had no brand, we were a company making hats for other brands, and they were putting their name on them and marketing the hats. We continue to do that until today, for brands like Rag & Bone, Ralph Lauren, or Orvis. In that scenario, we are not able to market these hats. Sales of the seasonal ranges for all our brands, collaborations and private label commissions are all important parts of our business. Even though we were 120 years old before we acquired the first of our brands, our brands now constitute the largest portion of our sales.

To celebrate our 150th anniversary we decided to pay tribute to our longest-serving employee-owners: we designed hats with the 24 employees – 12 women and 12 men – who worked for more than 35 years at Bollman, and gave these hats the names of our employees. These hats have something special, because you do not simply wear a hat, you feel linked to the history of the men and women who make them. This "Makers' Collection" is sold on www.hats.com.

What would motivate young men to wear a hat today? The touch of masculinity associated with classic hats? The comfort and elegance it provides? The fact that more and more celebrities opt to wear a hat?

It is all of these things. It starts with having the courage to put something on your head, because if you never wore a hat before, and since most people around you do not wear a hat, you must be willing to look different. But, as more and more people are wearing hats, we easily overcome that first step. And then it is about looking and feeling your best. For me, a hat lifts your spirits, it makes you feel better, it elevates your personality and enhances your

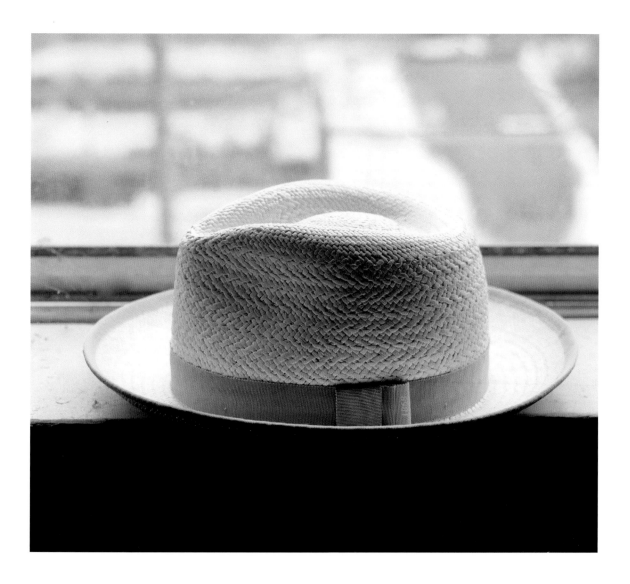

character. It upgrades your wardrobe, and your sense of style, people notice it, and you get compliments. I get compliments regularly, and others tell me the same. A hat defines your character, some people want to personally brand themselves, and a hat helps do this because when you look at somebody, you look in their eyes, and you obviously notice what people have on their heads – glasses, hats, or caps. Plus, you can wear different hats depending on whether you go to a formal dinner, a wedding or you meet with friends. You are not necessarily locked in with one kind of hat. A hat is about improving your look, your appearance, it is about dressing up, escaping the routine, and a hat lets you do this. Then, it is about protecting yourself from the natural elements: sun and cold since covering your head reduces the loss of body heat, this is the functional element when it comes to a hat. I like to say that people wear hats for fashion, function, fun and uniform, but the most important is fashion, and expressing your personality matters.

Unlike caps, which seem more versatile, hat designs haven't changed that much since the end of the 19th century: we still wear fedoras, porkpie hats, panamas etc … Can you imagine a completely new hat design, something that would become the hat for the man of the 21st century? What are the prerequisites for a global revival of men's hats? Are warmer summers an opportunity for hat makers?

Designers are constantly looking for new shapes, but also for different fabrics, colors, patterns, and treatments. All that is constantly on the minds of our designers and the people who are part of the innovation. We've come up with a lot of funky, and eclectic looks all over the years, sometimes they did well, but in many cases, they didn't even get to the launch stage. The classic look of the fedora will always be refined and adjusted to the latest trends – more pinches in the front, higher crowns or a different brim. We also mix straw and felt or cloth. We constantly keep innovating, although we do not necessarily introduce a brand-new shape every year but rather make the tried and successful shapes evolve. We try to offer ventilation for summer hats, because when people are at the beach or play golf, they want to feel an air flow, some freshness. Conversely, we try to design warmer winter hats, for example with felt earflaps. Additional functionality is key to our future success.

From the range of hats and caps produced by the Bollman group of companies, can you please tell us your favorite Top 5, the ones every man should have at home? Do you wear hats yourself? What is your experience of wearing hats?

I definitely love hats, and I am never outside without wearing a hat. The fact that I have been bald for a while is certainly a part of my motiva-tion, but I like the feel of a hat on my head. The fedora, with at least a 2.5-inch brim is what I think suits me, with the brim down on the front. If I go jogging, I use a baseball cap, I also love the Kangol 504, and generally traditional flat caps. Every man should own a Kangol 504, it is casual, but quite elegant. For the summer, the best hats are our panamas, with their wide brims for protection from the sun. This is what every man should have in his wardrobe. As for fur felt, my preference goes to the Bailey "draper", a beaver-rabbit-lamb felt hat that pays tribute to "Mad Men" and to the Bollman Makers' Collection "Steve J.". Wearing a hat is a very personal thing, so this list might not be right for every man. It is really about what you are comfortable with, what suits you, and what helps you be yourself. The hats I mentioned are classic hats everyone should consider, but then people should look for hats and caps in line with their personal taste and style.

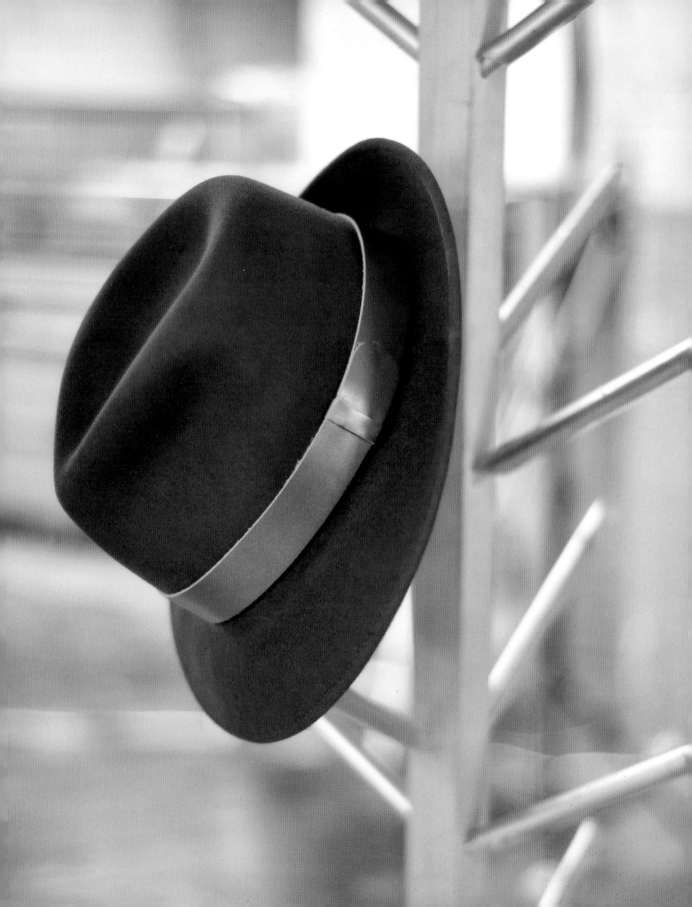

WEARING
A HAT TODAY

HEUTZUTAGE EINEN
HUT TRAGEN

Ein Gespräch mit Guillaume Bo, Gründer von Men Need More Style

Nach einer Karriere als Profisportler und DJ gründete Guillaume Bo die Facebook-Seite *Men Need More Style*, um der klassischen Eleganz zu einer Renaissance zu verhelfen. Innerhalb weniger Jahre wurde er die Personifizierung der Eleganz. Auf Instagram hat er über 75 000 Follower. Er ist ein Fan von Hüten und Mützen. Hier erklärt Guillaume Bo, wie man den richtigen Hut wählt und elegant trägt.

Unter den Experten und Influencern, die sich mit Männern und Eleganz beschäftigen, sind Sie derjenige, der am häufigsten einen Hut oder eine Mütze trägt. Was für Vorteile hat ein Hut für Männer, denen Eleganz wichtig ist?

Ich sehe mindestens drei gute Gründe, einen Hut zu tragen. Der erste ist die Ästhetik. Es ist einfach eine Frage der Eleganz. Früher musste ein Mann, wenn er einen Anzug trug, auch einen Hut tragen. Das war der klassische Dresscode. Der Hut gab dem Outfit das letzte Finish. Heute ist das Tragen eines Hutes mehr eine selbständige Entscheidung und keine Verpflichtung. Wer einen Hut trägt, hebt sich ganz klar von der Masse ab. Ein Hut zeichnet seinen Träger aus. Dieses Accessoire können sich alle leisten, denn wunderschöne sind erschwinglich. Der zweite Grund ist praktisch: Ein Hut schützt im Winter vor Kälte und Regen und im Sommer vor der Sonne. Man friert nicht am Kopf und an den Ohren und muss keinen Regenschirm bei sich haben. Auch der Hals bleibt mit einem Hut trocken. Das ist ein Vorteil gegenüber einer Mütze. Das ist jedoch nicht der einzige Schutz: Unter einem Hut kann man sich auch verstecken, obwohl es schwerfallen dürfte, mit einem Fedora nicht aufzufallen. Ein Hut verbirgt die Augen, er ist ein wenig wie ein Schirm, ersetzt die Sonnenbrille. Der gesunde Menschenverstand sagt einem, dass man entweder einen Hut oder eine Sonnenbrille trägt, aber nicht bei-

des. Mit Hut kann man mit zerzaustem Haar auf die Straße gehen, ohne nachlässig zu wirken. Allgemeiner lässt sich sagen, dass die gesamte Herrengarderobe in der Regel eher praktisch ist, da sie hauptsächlich von Uniformen und Arbeitskleidung abgeleitet wurde. Ästhetische Kriterien spielen zwar eine Rolle, aber zu guter Letzt entscheidet immer ein praktischer Aspekt. Der Hut ist deswegen kein überflüssiges Accessoire. Ganz und gar nicht! Er ist nicht weniger wichtiger als ein Paar Schuhe. Das galt vor fünfzig oder sechzig Jahren, als sowohl Herren als auch Damen Hüte auf der Straße trugen, seither hat man vergessen, wie komfortabel Hüte sind. Der dritte wesentliche Grund, einen Hut zu tragen, ist psychologisch. Der Hut, wie alle andere Kleidung, ist ein Spiegel der Persönlichkeit, er ist ein Signal des Trägers an alle um ihn herum. Huttragen ist nicht unwichtig. Man ist Teil einer Story. Du zeigst, dass du Teil eines Urban Tribe, eines Klans, bist und dass du eine besondere Lebensform pflegst.

Welchen Rat würden Sie Leuten geben, die nie einen Hut getragen haben? Welche Art von Hut sollte man als erstes wählen? Farbe? Größe? Gibt es Hüte, die sich besser für eine bestimmte Kopfform eignen?

Ich glaube nicht, dass es Hüte gibt, die sich besonders für bestimmte Kopfformen eigenen. Es zählt, dass man sich selbst mit Hut auf dem

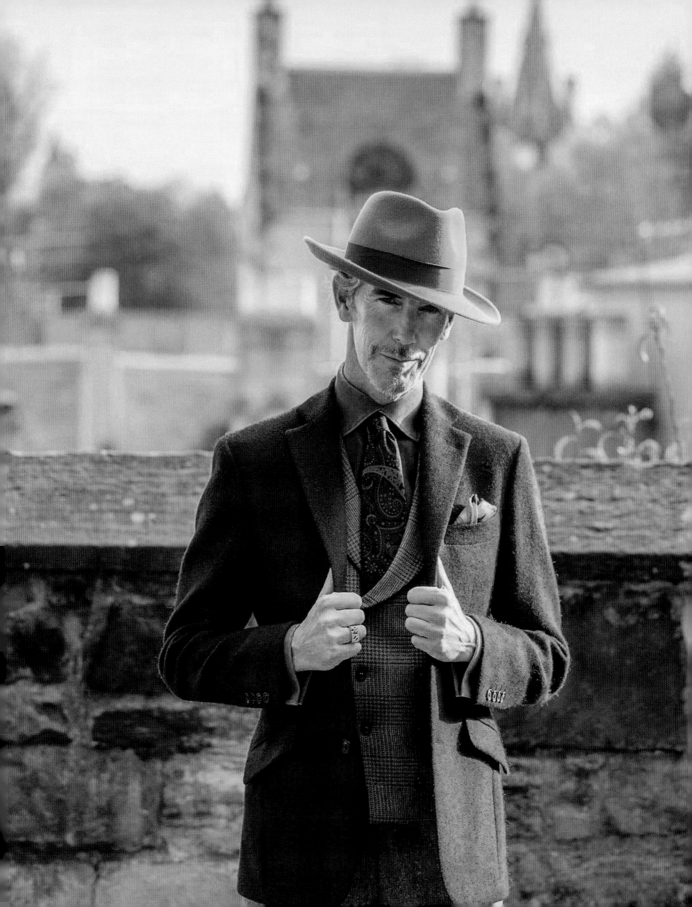

Kopf gut findet. Wenn man beginnt, sich mit Sorgfalt zu kleiden, fällt einem die Reaktion der Passanten auf. Aber irgendwann vergisst man, dass man einen Hut trägt. Dann kommt es einem komisch vor, wenn man barhäuptig ist. Ich glaube, diese psychologische Barriere ist nur schwer zu durchbrechen, wenn man jung ist. Wenn man älter wird, tut man einfach, wozu man Lust hat! Es gibt Leute, die von Baseballcap über Mütze zum Hut wechseln. Alles in kleinen Schritten. Heute ist es noch eine Mütze, morgen schon ein Hut. Am Leichtesten lässt sich im Sommer mit einem Sonnenhut, einem Bucket Hat oder schönen Strohhut, beginnen. Im Winter wählt man am besten einen klassischen Fedora, einen Hut, der zu allem getragen werden kann. Wer Mut hat, greift zum Porkpie oder Homburg, solange sie auch als die gesetzten Herren erscheinen wollen, die mit diesen Hüten assoziiert werden. Zylinder und Melone eignen sich eher für feierliche Anlässe. Ich bin kein Fan von „overdressed". Die Kleidung muss dem Anlass entsprechen, zu grandios wirkt aufgesetzt. Ein Hut darf nicht zu klein sein, sonst sieht man aus wie Stan Laurel oder Oliver Hardy, und der Hut verfehlt seine primäre Funktion. Es ist wie mit einem Schlips: Wenn du einen trägst, dann sollte auch der Knoten etwas hermachen. Anfängern empfehle ich, einen Hut zu wählen, der ein wenig zu groß ist. Man kann ihn anpassen, indem man beispielsweise einen Leder- oder Stoffstreifen unter das Schweißband klemmt. Was die Farbe betrifft, würde ich als erstes immer Braun wählen. Für Schuhe gilt das auch. Weil Braun zu allem passt. Im Übrigen Grau, aber nicht zu dunkel. Ich persönlich habe etwas gegen Schwarz. Marineblau ist ebenfalls eine Farbe, die sich gut tragen lässt.

Sollte man einen Hut gerade, etwas in die Stirn gezogen oder keck ein wenig schief wie Frank Sinatra tragen?

Ein Hut sollte leicht nach unten gezogen und etwas schräg getragen werden. Jeder wird einen Winkel nach seinem Geschmack finden.

Zu Anfang kann man, bevor man ausgeht, in den Spiegel schauen, um den richtigen Winkel zu finden. Dann gewöhnt man sich, so wie man sich an seine übrigen Kleider gewöhnt. Sie werden eins mit uns. Man bildet mit seinem Hut eine organische Einheit. Frank Sinatra trug den Hut etwas gekippt, weil er wie ein Verführer wirken wollte. Dagegen ist nichts einzuwenden. In Südeuropa sind Kleider ein wesentlicher Teil der Verführung, in Nordeuropa ist das weniger der Fall. Der Hut spiegelt auch die Stimmung seines Besitzers.

Wie viele Hüte und Mützen sollte der elegante Mann in seiner Garderobe haben? Welche Hüte und Mützen liegen in ihrem Kleiderschrank?

Jahrelang habe ich nur fünf Hüte besessen: Zwei Sommer- und drei Winterhüte. Für meinen Panamahut gab es Hutbänder in verschiedenen Farben, die ich regelmäßig wechselte. Für Mützen gilt das auch: Man braucht nur eine Mütze aus Tweed für den Sommer und eine aus Leinen für den Sommer. Dann kannst du sie an deine übrige Kleidung anpassen. Inzwischen habe ich das Glück von beiden etwa fünfzig zu besitzen, aber eigentlich braucht man nur wenige gewählte Stücke, die zum eigenen Stil passen.

Welche Hüte (und Mützen) eignen sich mehr für den Gebrauch in der Stadt und welche für Spaziergänge auf dem Land?

Regeln für die Mode sind in dieser Frage sehr klar: Je glatter ein Hut, desto förmlicher ist er. In der Stadt sollte man deswegen normalerweise einen Hut tragen, der sehr wenig Struktur aufweist. Je mehr Struktur, desto mehr näherte man sich dem Tweed und damit einer Kopfbedeckung fürs Land. Je bunter ein Hut, desto legerer ist er. Früher konnte Braun nur auf dem Land getragen werden, aber die Regeln ändern sich, und heutzutage kann auch ein Blazer sehr elegant sein. Ein grüner Hut mit einem Kinnriemen aus Leder kann auf dem Land großartig

wirken und passt perfekt zu einer Barbour-Jacke, ein blaugrauer Fedora hingegen ist ganz klar ein Stadthut. Als Gentleman-Landwirt kann man sich jedoch sehr elegant kleiden.

Hüte werden auch im Sommer getragen. Was bevorzugen Sie im Sommer? Einen Panamahut, einen Cowboyhut oder einen Boater?

Ohne zu zögern wähle ich den Panamahut. Ich schätze den Kontrast zwischen weißem Stroh und sonnengebräunter Haut. Echte Panamahüte lassen sich außerdem leicht zusammenfalten und nehmen in einem Koffer so gut wie keinen Platz ein. Ein Boater sieht zu einem beigen Anzug sehr gut aus oder zu anderer legerer Kleidung. Er wirkt sehr retro und ruft die 1920er und 1930er Jahre in Erinnerung. Damals trugen alle, auch in der Stadt, einen Boater. Was den Cowboyhut betrifft: Mit Ausnahme von Gary Cooper konnte ihn niemand tragen, ohne auszusehen, als hätte er sich verkleidet. Auch auf dem Pferderücken ist eine Mütze praktischer.

Kann es sein, dass ein Mann mit Hut besser aussieht als ohne? Man kann diesen Eindruck gewinnen, wenn man sich amerikanische Filmklassiker ansieht. Sieht Humphrey Bogart in Fedora nicht noch unwiderstehlicher aus?

Ja, durchaus! Fragen Sie die Damen! Ein Hut lässt Sie zum Teil einer Geschichte werden. Er beschwört die Hollywood-Filme herauf, Gangsterfilme und legendäre Schauspieler wie beispielsweise Alain Delon. Der Hut steht für ein sehr männliches Universum. Es gibt natürlich auch Frauen, die gegen die Etikette verstoßen und Männerhüte tragen.

Kann es elegant wirken, ein Baseballcap zu tragen? Oder ein Barett? Und können wir nicht auch lächerlich wirken, wenn wir auf der Straße einen Zylinder oder eine Melone tragen?

Das hängt alles von Form und Farbe ab. Man kann auch mit einem schönen Baseballcap und legeren Outfit schick sein. Aber Eleganz ist etwas anderes, und der gute Geschmack würde es einem vorschreiben, dass man auf ein Basecap verzichtet. Mit einem Barett kann man aussehen wie ein Landjunker, aber dann kommt es immer noch sehr darauf an, was man dazu trägt. Noch etwas zum Basecap: Diese Kopfbedeckung wirkt immer etwas kindisch. Es lässt sich beobachten, dass sich Leute heute kleiden wie ihre Kinder. Wer sein Alter akzeptiert, wählt einen Hut oder eine klassische Mütze. Auf der Straße einen Zylinder oder eine Melone zu tragen, wäre absurd, denn dann wirkt man nur exzentrisch und nicht elegant, sofern man nicht auch einen Maßanzug trägt, aber das ist schon nicht mehr, was ich alltägliche Eleganz nennen würde. Ein Zylinder entspricht dem Irokesenschnitt der Punks, er fordert die Welt heraus. Man sollte das Tragen von Zylindern also lieber den Zauberern überlassen und nie der Versuchung nachgeben, ein pompöses hyperklassisches Outfit zu tragen, weil das einfach nur nervt. Eleganz ist immer eine Frage des Gleichgewichts und der Mäßigung.

Was meinen Sie? Besteht die Möglichkeit, dass der Hut für Herren im 21. Jahrhundert wieder zu einer alltäglichen Kopfbedeckung wird? Was könnte zu einem dauerhaften Revival beitragen?

Für dieses Revival tue ich alles! Ich träume davon, dass das Tragen von Hüten sich wieder allgemein durchsetzt, wieder in Mode kommt, weil es für eine glückliche Männlichkeit steht. Ein Mann mit Hut ist ein Mann, der Verantwortung übernimmt und mit sich selbst in Einklang ist. Außerdem gewöhnt man sich schnell an die Bequemlichkeit. Im Sommer sieht man immer mehr Leute mit Hut, und das war vor einigen Jahren noch nicht der Fall. Da Mode in Zyklen verläuft, können wir die Möglichkeit nicht ausschließen, dass auch im Alltagsleben Hüte wieder eine Rolle spielen werden. Dann werde ich allerdings keinen mehr tragen! (Er lacht.)

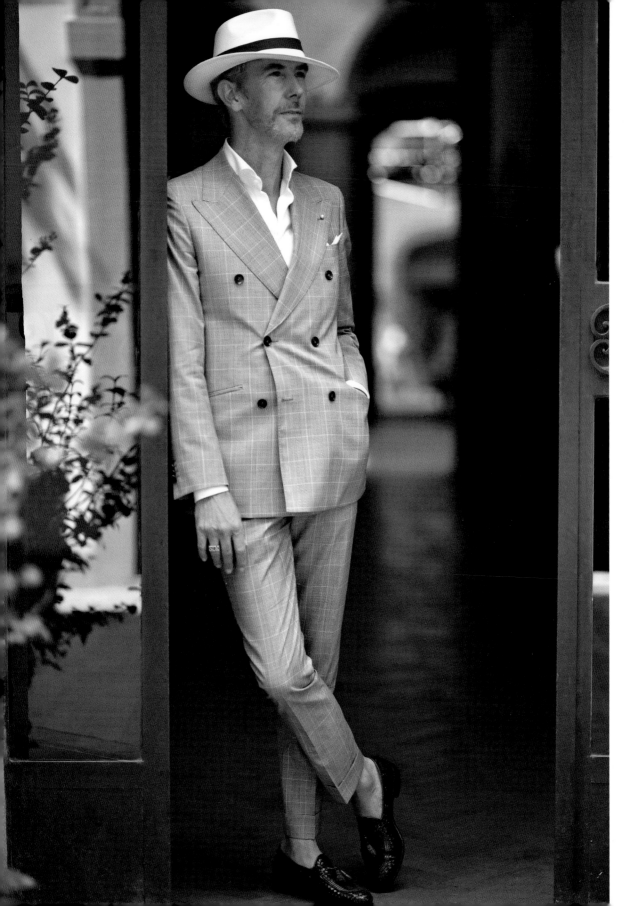

A conversation with Guillaume Bo, of MEN NEED MORE STYLE

After a career in sports and then as a DJ in the hip-hop scene, Guillaume Bo launched the Facebook page Men Need More Style to promote classic elegance. In just a few years, he became the personification of men's style. His Instagram page has more than seventy-five thousand followers. An avowed supporter of hats and caps, Guillaume Bo shares with us useful advice on how to choose the right hat and wear it elegantly.

Among the experts and "influencers" on masculine elegance, you are the one who most frequently shows up wearing a hat or cap. What does a hat bring to men who care about elegance?

I see at least three good reasons to wear a hat: The first is aesthetic, it's a question of elegance. In the old days, when a man wore a suit, he had to have a hat. In the classic dress code, the hat gave a kind of finishing touch to the outfit. Today, wearing a hat is more of a choice than an obligation. Those who do clearly stand out from the crowd. The hat gives an original look to its wearer. It is an accessory accessible to all because beautiful hats can be found at affordable prices. The second reason is practical: the hat protects as much from the cold and rain in winter as it does from the sun in summer. You keep the top of your head and your ears warm without having to carry an umbrella. The hat also keeps the neck dry, which is an advantage over a cap. This is not the only protection it offers: a hat also serves to conceal yourself, even if it's hard to go unnoticed with a fedora on your head. The hat hides the eyes, it acts as a screen, a bit like sunglasses: besides, common sense dictates that one wears either a hat or sunglasses, but not both together. With a hat, you can go out with your hair tousled without looking sloppy. From a more general point of view, the whole male wardrobe tends towards practicality,

since it chiefly originates from military costume and utilitarian wardrobe. Aesthetic criteria play an important role, but in the end it is always the practical aspect that predominates. The hat is therefore not a superfluous accessory, far from it, it is no less important than shoes. This made sense fifty or sixty years ago, when both men and women wore hats in the street, but the comfort that a hat provides has been forgotten. The third, essential notion is psychological: the hat, like all other clothing, is a mirror of personality, a signal sent by the wearer to those around him. It is a way of expressing who you are. Wearing a hat is not insignificant, you are part of a story. It's a way of showing that you belong to an urban tribe, a clan, or that you follow a particular way of life.

For those who have never worn a hat before, what advice would you give for getting into the game: Which type of hat to wear first? Colour? Size? Are there hats that are more suitable for a specific head shape?

I don't believe in the idea that some hats are more specifically adapted to this or that head shape, what really counts is to accept yourself with a hat on your head. At the beginning, when you start to dress carefully, you have to face the eyes of the passers-by. But then you forget that you're wearing a hat, it's going bareheaded that seems curious. I think this psychological barrier

is difficult to overcome when you're young. As you get older, you end up doing what you want! Some people gradually switch from baseball cap to hat, in small steps: one day you put a nice cap on your head, then the hat follows. The easiest way to start is in the summer, with a bucket hat or a nice straw hat. In the winter, the best is to take a classic fedora, it's the kind of hat that goes with everything. The brave can try the porkpie or the homburg, as long as they assume the status of a mature man that these hats confer. The top hat or bowler are reserved for very formal occasions. For my part, I am not a fan of "overdressed" style. Clothing must be in line with the times: too pompous an outfit will necessarily sound false. As for the size, the hat must not be too small, otherwise you look like Laurel and Hardy and it doesn't fulfil its primary function. It's like a tie, if you wear one, then you might as well tie a nice knot, the untied tie is an absurdity. I advise beginners to take a hat that is a little too big. You can adapt it to your head size by putting cotton or leather straps under the inner band, for example. As for the colour, my first choice would be brown: it's like for shoes, it goes with everything, or else grey, but not too dark, since I'm personally against black. Navy blue is also a colour that is easy to wear.

Should the hat be worn straight and slightly pulled down, or tilted in the Frank Sinatra style?

A hat should be worn slightly pulled down on the head and tilted. Everyone will find the right inclination according to his taste. At first, you can look in the mirror before going out and find the right angle. Then you get used to it and it's like the rest of the clothes: they become one with us. You form a small organic bubble with your hat. Frank Sinatra wore the hat tilted to take on a seductive allure; I see no harm in that. In Latin countries, clothes are a natural part of the seduction game, but it is not yet the case in Anglo-Saxon countries. The hat is also a mirror of the mood and state of mind of its owner.

How many hats and caps does an elegant man need to own in order to have a complete outfit? What hats and caps do you have in your dressing room?

For years, I had five hats: two summer and three winter hats. I had several ribbons of different colours for my Panama hat, and I could change them regularly. The same goes for the caps, all you need is one tweed cap for winter and one linen cap for summer. Then you adjust them to your clothing. Now, I'm very lucky to have more than fifty of each, but again, you only need a few well-chosen pieces that fit your style.

Are some hats (and caps) made more for city use and others more for country walks?

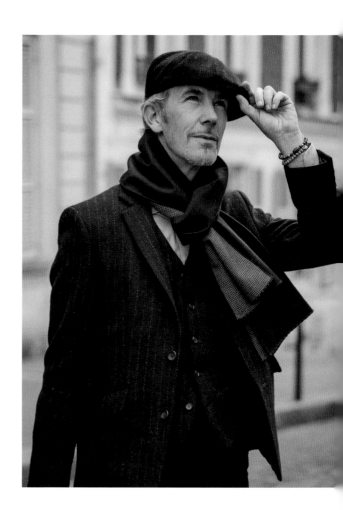

The fashion standards are very clear about this: the smoother a hat is, the more formal it is. In the city, therefore, one should normally wear hats with very little texture. The more texture, the more you go towards tweed, the more it's for the countryside. Similarly, the more colourful a hat is, the more casual. In the past, brown was reserved for hats that were worn in the countryside. But, the rules are changing: the simple fact of wearing a blazer today is a very strong sign of elegance. A green hat with a leather strap will look great in the countryside, it will go perfectly with a Barbour jacket; a blue-grey fedora, on the contrary, is clearly a city hat. But one can be very elegant as a gentleman farmer.

Hats are also worn in the summer: what is your preference between the Panama hat, the cowboy hat and the boater?

I choose without hesitation the Panama hat, to create a contrast between the white straw of the hat and the tanned skin. Moreover, real Panama hats fold very easily and take up almost no space in a suitcase. A boater will look good with a beige suit, or with a casual outfit, it brings a retro touch as it refers to the 1920s and 1930s when everyone had their own boater, even in the city. As for the cowboy hat, apart from Gary Cooper, few men have been able to wear it without looking like they are disguised. Even on horseback, a cap is more practical.

Can a hat make the man who wears it look better? We often get this impression when we look at the American classics: Humphrey Bogart looks even more irresistible wearing a fedora?

Yes, absolutely. Ask the ladies and they'll tell you. Wearing a hat makes you part of a story, it evokes Hollywood films, gangster movies and cult actors, like Alain Delon for example. Like the costume, the hat refers to a very masculine universe. And of course, the same goes for women who break codes and wear male hats.

Can you be elegant wearing a baseball cap? Or a beret? And don't we risk ridicule by wearing a top hat or bowler hat in the street?

It all depends on the shape and colour, you can be stylish with a nice baseball cap, have a casual outfit. But elegance is something else, and good taste would dictate that you refrain from wearing a baseball cap. A beret can make you look like a gentleman-farmer, and then it all depends on what you wear with it. One more remark about the baseball cap: it gives a bit of a "childish" feel to it, it's a current trend to see adults dressing like their offspring. If you accept your age, you take a hat, or a classic cap. Putting a top hat or bowler hat on the street is quite absurd, you fall into the eccentric side, not necessarily elegant, unless you wear a custom-made suit, but then again, you're outside of what I would call everyday elegance. Putting on a top hat is like what punks do with their hair ridge on their head, you challenge the surrounding world. It's better to leave the top hat to magicians! You should never fall into the trap of the pompous hyper classic outfit., which can be terribly boring. Elegance is always a question of (right) measure and balance.

Does the hat have a chance of becoming again an everyday accessory for the man of the 21st century? What could contribute to a revival?

I'm doing everything for it! My dream is that the wearing of hats will become more democratic and fashionable again, because hats reflect a happy masculinity. A man who wears a hat is a man who takes responsibility and feels good about himself. And also, because one quickly gets used to comfort. You see more and more people in hats during the summer, whereas a couple of years ago this was not the case. Since fashion is a matter of cycles, we can't rule out the possibility that hats will come back in force in everyday life. And then, I won't be wearing one anymore! (laughing)

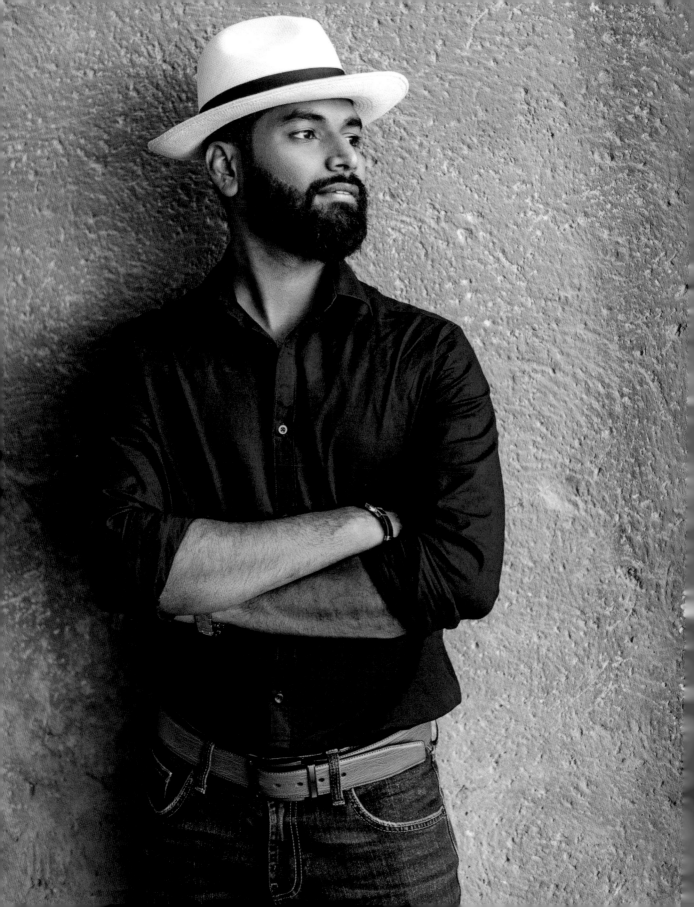

Warum sollte der moderne Mann einen Hut tragen?

Ein Hut ist sowohl praktisch als auch ein Mode-Accessoire. Es gibt also viele praktische und ästhetische Gründe, einen Hut zu tragen.

Weil es bequem ist.

Bequemlichkeit ist die *Raison d'Être* des Huts. Er schützt den Kopf vor Regen, Sonne und Wind. Im Winter bietet er Wärme, im Sommer hält er den Kopf kühl. Ohne Hut muss der Körper mehr Energie aufwenden, um die Körpertemperatur konstant zu halten. Der weiche Filz, der den Kopf umschließt, aber auch Gewebe oder Stroh, erzeugen ein Gefühl des Wohlbehagens, das noch dadurch erhöht wird, dass ein Hut nicht am Kopf „klebt" wie eine Mütze.

Weil es elegant ist.

Man muss kein Dandy sein, dem Anzüge mit Weste gefallen, um einen Hut zu tragen. Ein Hut kann auch zu T-Shirt und Jeans getragen werden. Ein Hut signalisiert, dass man seine Kleidung mit besonderer Sorgfalt gewählt hat. Im Unterschied zu Schuhen, Armbanduhren oder modischen Accessoires spielt die Marke keine Rolle, obwohl richtig gute Hutmacher einem bei Experten Achtung einbringen.

Weil es einem eine bestimmte Persönlichkeit verleiht.

Es ist nicht leicht, ohne Hut wie ein überzeugender Ganove zu wirken. Auch ein Dandy wirkt ohne Homburg oder Fedora nachlässig. Wie der Rest der Kleidung ist der Hut Ausdruck der Persönlichkeit, ein Trilby oder Porkpie lässt einen jünger und künstlerischer wirken als ein Fedora oder Homburg. Fedora und Homburg wirken eher ernsthaft, aber auch eleganter. Legt man auf einen abenteuerlicheren Stil wert, dann sollte man einen Panamahut oder Cowboyhut wählen. Es ist aber auch wichtig, wie der Hut auf dem Kopf platziert wird, ist der Hut nach hinten gekippt, sieht man aus wie ein Detektiv im Film. Frank Sinatra trug seinen Hut leicht zur Seite und nach hinten gekippt, was ihm die Aura eines Lebemanns verlieh, auf die er großen Wert legte (im Englischen ist von einem „rakish angle", einem kessen Winkel, die Rede).

Weil er die exzentrischen Seiten betont.

Ein bunter Hut oder eine Fasanenfeder, die seitlich von der Krone herabhängt, sorgen dafür, dass man auffällt. Trägt man jedoch einen Zylinder auf der Straße, dann sollte man darauf achten, auch im Übrigen überaus elegant gekleidet zu sein. Sonst wirkt man nicht exzentrisch, sondern lächerlich. Ein Hut kann zu einer gewissen Exzentrizität beitragen, aber falls man richtig auffallen will, sollte man sich kleiden wie Elton John.

Weil er kleine anatomische Fehler und ungekämmtes Haar versteckt.

Falls Sie an verfrühtem Haarausfall leiden oder hervorstehende Ohren haben, kann ein Hut diese kleinen Fehler verbergen, wenn Sie sich auf der Straße aufhalten. Falls Sie keine Zeit hatten, Ihre Frisur zu richten, oder falls es überfällig ist, die Haare zu waschen, dann verbirgt ein Hut diskret diese Nachlässigkeit. Kleine Männer lässt ein Hut einige Zentimeter größer erscheinen, verwandelt sie aber nicht in Riesen.

Für den Retro-Look.

Falls Sie ein Fan von „Mad Men" oder anderen Fernsehserien sind, die in die Zeit von 1900 bis etwa 1970 spielen, können Sie als Hommage an ihre Lieblingsfigur deren Kopfbedeckung tragen. Manchmal ist nicht mehr als ein Hut nötig, um sich in eine bestimmte Zeit zurückzuversetzen.

Weil man ihn als Fächer und zur Aufbewahrung von allem Möglichen verwenden kann.

An heißen Tagen kann man sich mit einem Hut Kühlung zufächeln. Das ist schick, und wenn Sie keine Kühlung mehr brauchen, können Sie Ihren Hut auf dem Kopf verwahren. Im Zuge der globalen Erwärmung steht dem Hut eine großartige Zukunft bevor. Mit einem Hut lassen sich aber auch noch andere Dinge tun, in ihm lassen sich kleine Gegenstände wie Schlüssel, Stifte, Portemonnaies, Handys, Münzen und Gürtel verwahren, wenn man die Sicherheitskontrolle am Flughafen passiert. Alles findet in der Krone eines umgekehrten Hutes Platz, und man verliert nichts. Ein weiteres Plus ist das Dunkel, das sich ausbreitet, wenn man einen Hut in die Stirn schiebt: Ein Nickerchen auf einer langen Bahn-, Bus- oder Flugreise lässt sich so besser genießen.

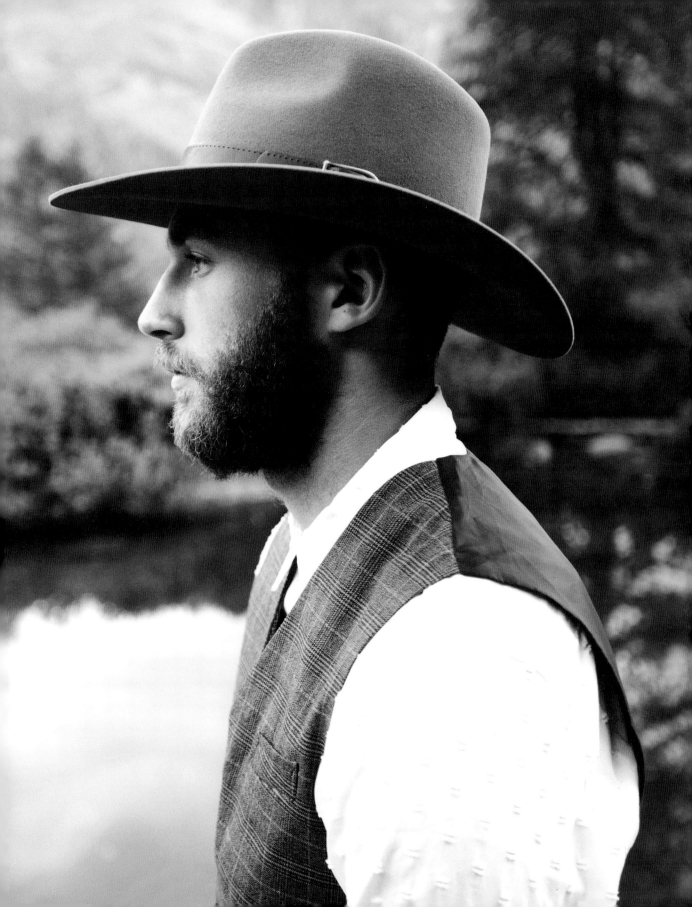

Why should modern men wear a hat?

A hat is both a functional piece of clothing and a fashion object. There are, therefore, many practical and aesthetic reasons to wear one.

For the comfort it provides

Comfort is the raison d'être of the hat: it covers the head to protect it from rain, sun and wind; it offers warmth in winter and coolness in summer. Without a hat, your body has to expend more energy to keep the head at a constant temperature. The softness of the felt embracing the head (but also of woven cloth or straw) provides a feeling of comfort, which is also because the hat does not "stick" to the head as a cap might.

For elegance

You don't have to be a dandy who likes three-piece suits to wear a hat, it's an accessory that can be worn just as easily with a t-shirt and jeans. The addition of a hat will signal that you have chosen your clothes with particular care and originality. Unlike shoes, watches or other fashion accessories, it doesn't matter what brand makes your hat, although the signature of a top hatmaker will ensure that you are held in high esteem by the experts.

For giving yourself some personality

It's hard to be a bad boy without a hat on your head. Similarly, the dandy will look sloppy without a Homburg or a Fedora. Like the rest of your clothing, the hat is a reflection of your personality; wearing a trilby or a porkpie will make you seem younger and more artistic than a Fedora or a Homburg. These latter ones add a touch of seriousness to those who wear them as well as a certain refinement. For a more adventurous style, one should rather choose a Panama or Cowboy hat. Finally, think about how to place the hat on your head: if it's tilted backwards, you'll look like a movie detective. The best advice comes from Frank Sinatra who liked to wear his hats slightly tilted back and to the side, which is the famous "rakish angle" that he greatly contributed to promoting.

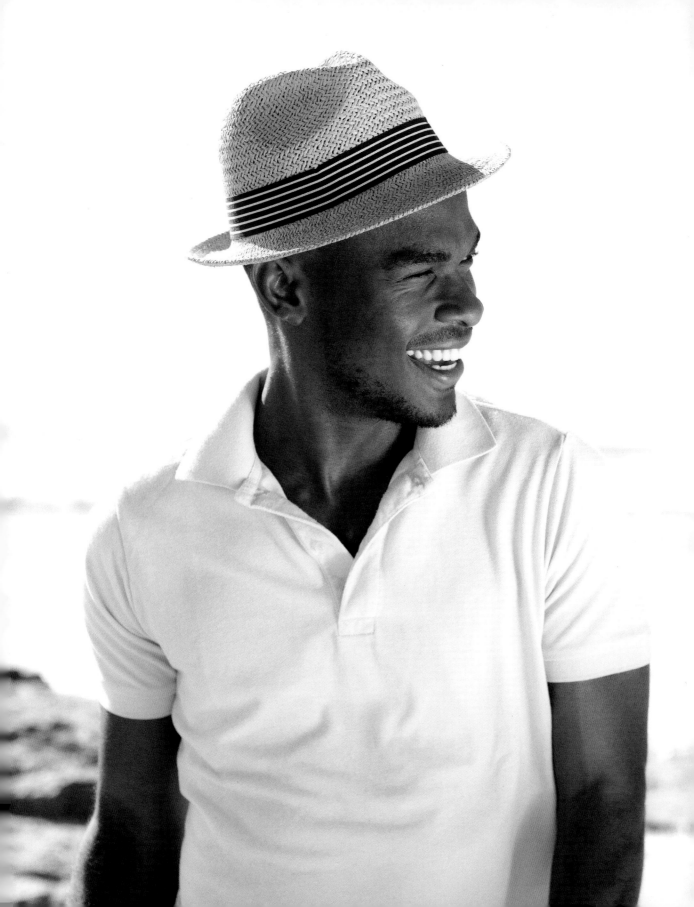

For the eccentric side

A brightly coloured hat or a pheasant feather hanging from the crown will ensure that you don't go unnoticed. However, when wearing a top hat on the street, it is best to dress with the utmost elegance, otherwise you risk going from "eccentric" to "ridiculous". A hat can add a touch of eccentricity, but if you really want to stand out, Elton John's style is the one to adopt.

To hide small anatomical flaws or messy hair.

If you suffer from premature baldness or protuberant ears, the hat can disguise those little flaws while you're on the street. If you haven't had time to do your hair, or shampooing your hair is well overdue, the hat will discreetly cover up your neglect. For short men, the hat will add a few extra inches, but it won't make them into giants.

For the retro look

If you're a fan of Mad Men or any other series set between the 1900s and 1970s, you can identify with your favourite characters by copying their headgear. A hat is sometimes all you need to immerse yourself in the atmosphere of an era.

To use it as a fan and as a catch-all bag

You can use your hat to fan your face on hot days. It is more chic and when you don't need it you can store it on your head. With global warming, the hat has a bright future. A hat can do a lot of small things: for example, it can be used as a catch-all when going through security checks at airports and other places: key rings, pens, wallets, purses, smartphones, coins, belts and other accessories will fit easily into the crown of an upside-down hat, and you limit the risk of losing them. Another benefit is the soft darkness of a hat tilted down over your eyes: there is nothing better for enjoying a nap on a long train, bus, or plane journey.

Vier Fragen an Bernhard Roetzel

Der Experte für Herrenkleidung und klassische Eleganz Bernhard Roetzel schrieb 1999 den Bestseller *Der Gentleman: Handbuch der klassischen Herrenmode*. Er wurde in über 20 Sprachen übersetzt und in mehreren Millionen Exemplaren gedruckt. Diesem gefeierten Modespezialisten haben wir Fragen gestellt, wie wichtig Hüte für die Herrenmode von heute sind.

Welche Herrenhüte verkörpern, Ihrer Meinung nach, die klassische Eleganz am besten?

Der Huttyp, der auf Englisch mal als Fedora, mal als Trilby bezeichnet wird. Wenn ich ihn als „Bogart-Hut" bezeichne, weiß jeder, was gemeint ist. Mit etwas größerer Krempe ist er aus dem Film Indiana Jones bekannt. Es ist kein Zufall, dass Hüte heute oft mit Filmen in Zusammenhang gebracht werden. Hüte stehen – wie viele Filme – für Träume, Verwandlung und auch Verkleidung.

Wirken Männer männlicher, wenn sie einen Hut tragen? Und falls das so ist, wie kommt dieser Unterschied zustande?

Der Hut allein macht es nicht. Allerdings kann der Hut einen ohnehin sehr männlichen Typ noch männlicher wirken lassen. Wobei man den Begriff „männlich" natürlich diskutieren könnte. In den Köpfen steckt bei diesem Thema noch viel 19. und frühes 20. Jahrhundert. Der Hutträger Cecil Beaton wirkte nach dem alten Konzept nicht männlich, ich würde heute einen weiteren Begriff von Männlichkeit bevorzugen.

Haben Sie einen Lieblingshut oder eine Lieblingsmütze? Wie viele Hüte und Mützen sollte man im Schrank haben?

Ich wähle Hüte und Mützen passend zu Jahreszeit und Anlass aus. In der kühleren Zeit ist ein Hut aus Hasenhaar die beste Wahl, er isoliert gut und schützt hinreichend vor Regen und Wind. Im Sommer ist ein Panamahut ideal zu förmlicherer Kleidung, z. B. einem Leinenanzug. Auf Reisen und zu sportlicher Kleidung trage ich bei Wärme gern leichte und waschbare Stoffhüte. Wenn ich einen einzelnen Hut als Lieblingshut auswählen soll, dann wäre das ein Hut aus irischem Tweed, den ich vor ca. 30 Jahren in München gekauft habe und bis heute viel trage.

Glauben Sie, dass der Hut ein Revival als alltägliches Mode-accessoire erlebt?

Der Hut ist schon lange wieder da, allerdings als Teil einer ganz anderen Alltagskleidung. Allerdings wird der Hut insgesamt sehr viel weniger getragen, weil die Lebensgewohnheiten heute anders sind. Bis in die 1960er Jahre waren die Menschen viel mehr unter freiem Himmel unterwegs, auf dem Weg zur Arbeit, in der Freizeit und bei allen möglichen Besorgungen. Da war der Hut wichtig als Schutz. Darüber hinaus war die Hutmode natürlich auch ein Produkt des Klassengegensatzes. Die Besitzenden grenzten sich von den Arbeitern und Bauern durch die Hutmode ab. Hüte waren für die damals üblichen Grußrituale wichtig, heute muss niemand mehr vor dem Chef oder Gutsherrn den Hut ziehen.

Four questions to Bernhard Roetzel

An expert in menswear and classic elegance, Bernhard Roetzel is the author of the best-selling book *Gentleman: A Timeless Guide to Fashion*, first released in 1999, which has sold millions of copies, and has been translated into more than twenty languages, as well as many other publications and interviews on tailor-made clothes and accessories. We asked the acclaimed fashion specialist four questions about the importance of hats in contemporary male clothing.

Which men's hats, in your opinion, personify classic elegance best?

The hat style that is referred to as fedora, or sometimes as trilby. I simply call it the "Bogart hat," and everybody understands what I mean. It has been also popularised, with a slightly larger brim, by the character of Indiana Jones. It is no coincidence that hats today are often associated with movies. Hats stand—as do many films—for dreams, transformation and also disguise.

Do men look more masculine when wearing a hat? If so, what, in your opinion, makes the difference?

The hat alone won't do it. However, a hat can make an already male type look even more masculine. Besides, we should question the concept of "masculinity". The way of thinking about masculinity that prevailed in the 19th and early 20th centuries is still very present in people's minds. According to this old concept, a hat-wearer like Cecil Beaton would not appear masculine, that's why I would advocate a more open approach to masculinity today.

What is your favourite hat? Your favourite cap? How many hats and caps should a man have in his wardrobe?

I choose hats and caps according to the season and occasion. In the colder months a hat made of rabbit fur felt is the best choice; it insulates well and protects sufficiently against rain and wind. In the summer, a Panama hat is ideal with more formal clothing, such as a linen suit. When travelling and wearing sports clothes I like to have hats made of light and washable fabric, particularly when it is warm. If I were to choose a single hat as my favourite hat, it would be a hat made of Irish tweed, which I bought in Munich about 30 years ago and still wear a lot today.

Do you think that there might be a revival of the hat as an everyday fashion accessory?

The hat has been back for a long time, but as part of a completely different everyday clothing. However, hats are worn much more rarely because of the modern lifestyle. Up until the 1960s, people were much more likely to be out in the open, on their way to work, in their leisure time and doing all kinds of errands. The hat was therefore important for protecting the head. In addition, hat fashion was of course also a product of social status. The owners distinguished themselves from the workers and peasants by the hat fashion. Hats were important for the greeting rituals customary at that time. Today nobody has to take off their hats to their boss or landlord.

Die Ära der Unisex-Hüte

Wie beim Fedora, Porkpie und Trilby zu sehen war, gibt es Hüte, die für Damen entworfen wurden, dann aber Herrenhüte geworden sind. Umgekehrt sind Kopfbedeckungen, die ursprünglich für Herren bestimmt waren wie Baskenmützen nun Teil der Palette der Damenbekleidung. Keiner der Hüte, die traditionell von Herren getragen werden, ist strikt männlich. Heutzutage können Frauen einen Homburg oder einen Zylinder tragen, ohne dass das unpassender wirken würde, als hätte ein Mann diese Hüte getragen. Schließlich und endlich sind viele Hüte auch einfach unisex: Das gilt beispielsweise für den Stoffhut. Es ist vorstellbar, dass die Hutrenaissance mit Hilfe der Frauen erfolgen könnte: Sie könnten die Männer ermuntern auch wieder Gefallen an Hüten zu finden. Wer weiß, vielleicht könnte dieses Revival dazu beitragen, die Unterschiede zwischen Herren- und Damenmode aufzuheben? Vielleicht sind in Zukunft klassische Herrenhüte unisex, und ein Mann kann einen Glockenhut tragen, ohne dass es so wirkt, als hätte er ihn von seiner Großmutter geliehen. Aber niemand braucht damit zu warten, einen Hut zu tragen, man muss nur einfach den richtigen aussuchen.

The era of unisex hats

As we have seen in the case of the fedora, the porkpie or the trilby, some hats that were originally designed for women have become men's hats: similarly, some headgear once reserved for men, such as the beret or the cap, are now part of the women's panoply. None of the hats traditionally worn by men are actually strictly masculine: these days a woman can wear a homburg or top hat without it seeming any more incongruous than if a man did the same. Finally, many hats are simply unisex: this is the case of the boater or the bucket hat, for example. One can reasonably dream that the comeback of men's hats will happen through their appropriation by women who will thus encourage men to regain a taste for hats. Who knows if such a revival will not go even further in breaking down the barriers between men's and women's fashion? Perhaps the future will make all classic men's hats unisex, and a man will be able to wear a cloche hat without looking like he borrowed one from his grandmother. But no one has to wait to start wearing a hat. You just have to select the right one.

Bildnachweis
Picture Credits

Danksagung

Vielen Dank an die Hutmacher und Modeexperten, die dieses Projekt von Anfang an enthusiastisch unterstützt haben: Besonderer Dank gilt Guillaume Bo, dem Gründer von MenNeedMoreStyle, einem Experten für Eleganz und Stil, sowie Bernhard Roetzel, dem Autor maßgeblicher Bücher über Männermode und Maßkonfektion für Männer, sowie an Don Rongione, CEO der Bollman Hat Company.

Mein Dank gilt auch Amélie Le Roux, der Gründerin von Béton Ciré, einem Unternehmen mit Sitz in Paris, die wunderbare Matrosenhüte herstellt, an Jon Holt von der Massey-Partnerschaft für die Bilder des Geschäfts von Lock & Co., und an Ryann McDeVitt von der Bollman Hat Company für ihre wunderbare Bildauswahl.

Dieses Buch wäre ohne die Geduld und Hartnäckigkeit von Berrit Barlet von teNeues nicht möglich gewesen. Herzlichen Dank für ihren stets klugen Rat und ihre Ermutigung. Dank auch an Lee V. Ripley, die den englischen Text des Buches sorgfältig gelesen und gekonnt redigiert hat.

Doch nichts wäre möglich gewesen, hätte ich mich nicht auf meine Frau Agata verlassen können, die dieses Buch mit Liebe, einem großen Sinn für Eleganz und immensem Talent gestaltet hat.

Acknowledgements

Many thanks to the hatmakers and fashion experts who enthusiastically supported this project from its early days: Special thanks to Guillaume Bo the founder of "MenNeedMoreStyle", an expert of elegance and style, to Bernhard Roetzel, the author of authoritative books on men's fashion and bespoke menswear, and to Don Rongione, CEO of Bollman Hat Company.

My gratitude also goes to Amélie Le Roux, the founder of Béton Ciré, a Paris-based company that produces wonderful sailor hats, to Jon Holt of the Massey Partnership for the pictures of the Lock & Co. shop, to Ryann McDeVitt, of the Bollman Hat Company, for her selection of beautiful images.

This book would not have been possible without the tenacity and patience of Berrit Barlet of teNeues. She is to be warmly thanked for her always judicious advice and encouragement. Thanks also to Lee V. Ripley who carefully read, and skillfully edited the English text.

Had I not been able to rely on my dear wife Agata, who laid out this book with love and a great sense of elegance, and on her immense talent, nothing would have been possible.

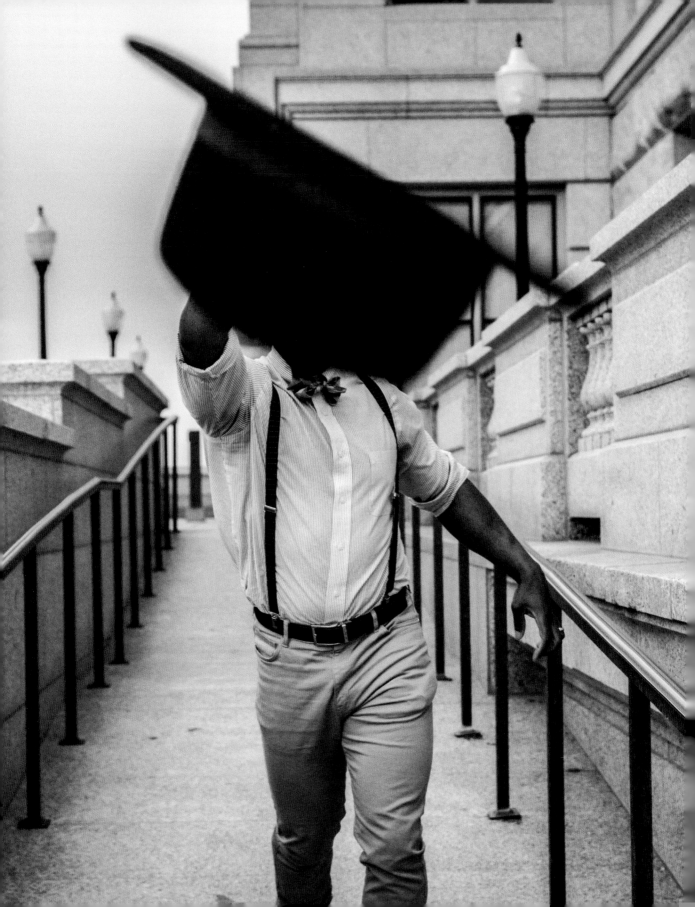

Imprint

© 2020 teNeues Media GmbH & Co. KG, Kempen

Text by © Pierre Toromanoff
German Translation by Holger Wolandt
Copy-editing (English) by Lee V. Ripley
Editorial coordination by Berrit Barlet
Layout and Design by Agata Toromanoff
Production by Alwine Krebber
Color separation by Jens Grundei
Coverdesign (front) by Agata Toromanoff,
(back) by Wolfram Söll, designwerk

ISBN 978-3-96171-284-7 (English Cover)
ISBN 978-3-96171-285-4 (German Cover)

Library of Congress Number: 2020935967

Printed in the Czech Republic by Tesinska Tiskarna

Bibliographic information published by the
Deutsche Nationalbibliothek. The Deutsche
Nationalbibliothek lists this publication in
the Deutsche Nationalbibliografie; detailed
bibliographic data are available on the
Internet at http://dnb.dnb.de.

Published by teNeues Publishing Group

teNeues Media GmbH & Co. KG
Am Selder 37, 47906 Kempen, Germany
Phone: +49-(0)2152-916-0
e-mail: books@teneues.com

teNeues Media GmbH & Co. KG
Munich Office
Pilotystraße 4, 80538 Munich, Germany
Phone: +49-(0)89-90 42 13-200
e-mail: bkellner@teneues.com

teNeues Media GmbH & Co. KG
Berlin Office
Mommsenstraße 43, 10629 Berlin, Germany
Phone: +49 (0)152 08 51 10 64
e-mail: ajasper@teneues.com

teNeues Publishing Company
350 7th Avenue, Suite 301, New York
NY 10001, USA
Phone: +1-212-627-9090
Fax: +1-212-627-9511

teNeues Publishing UK Ltd.
12 Ferndene Road, London SE24 0AQ, UK
Phone: +44-(0)20-3542-8997

www.teneues.com

teNeues Publishing Group
Kempen
Berlin
London
Munich
New York

teNeues